And I swear
every word is true."

—Iolaus (from the screenplay)

The
Art &
Making
of

HERCULES

Introduction by BRETT RATNER

A NEWMARKET PICTORIAL MOVIEBOOK

HARPER DESIGN
An Imprint of HarperCollins Publishers

Dedicated to the memory of Steve Moore (1949–2014)

MGM

Comic book panels from *Hercules: The Thracian Wars* graphic novel, courtesy of Radical Studios, Inc.

The article "Hercules, the Human Warrior" by Steve Moore, previously appeared in the graphic novel *Hercules: The Thracian Wars*, reprinted by permission of Radical Studios, Inc.

A NEWMARKET PICTORIAL MOVIEBOOK
An Imprint of Newmarket Press
In association with RatPac Press

Esther Margolis, Project Director
Text by Linda Sunshine
Designed by Timothy Shaner, NightandDayDesign.biz

HarperCollins books may be purchased for educational, business, or sales promotional use. For information please e-mail the Special Markets Department at SPsales@harpercollins.com.

First published in 2014 by:
Harper Design
An Imprint of HarperCollinsPublishers
195 Broadway, New York, New York 10007
Tel: (212) 207-7000 Fax: (212) 207-7654
www.harpercollinspublishers.com
harperdesign@harpercollins.comm

Distributed throughout the world by:
HarperCollinsPublishers
195 Broadway, New York, New York 10007

Library of Congress Cataloguing-in-Publication Data has been applied for.

ISBN 978-0-06-235835-6

Printed in the United States of America

First Hardcover Printing, 2014

PAGE 1: Concept drawing, Hercules' shield, by Renató Cseh. PAGES 2-3: Weta Workshop, art by Gus Hunter. PAGES 4-5: One of the first concept paintings created for the project by Radical Studios, Inc. and Weta Workshop's Greg Broadmore. THIS PAGE: Concept art, Mythical Greece Meadow by Mathilde Abraham.

CONTENTS

Introduction

MY HERCULES by Brett Ratner8

Prologues

THE FIRST SUPERHERO by Evan Spiliotopoulos14
THE SETTING & THE STORY18
THE PLAYERS20

Part One: THE CHARACTERS' BACKSTORIES22

Part Two: CONQUERING THE BESSI44

Part Three: THE RHESUS BATTLE ON MOUNT ASTICUS96

Part Four: ATTACK AT THE CITADEL132

Epilogue

THE BIRTH & DEATH OF HERCULES IN MYTHOLOGY.....166

Afterword

ORIGINS: THE GRAPHIC NOVEL....................168
HERCULES, THE HUMAN WARRIOR by Steve Moore...172

Credits and Acknowledgments176

My Hercules

by Brett Ratner

Since childhood, it has been a dream of mine to direct a "sword-and-sandal" epic. It just so happens that as a young boy, I loved creating comic books. I drew a comic book of Hercules versus Superman so I guess I was destined to direct this epic tale.

When Jon Glickman at MGM sent me the graphic novel *Hercules: The Thracian Wars*, he said, "I think you are going to love this." He was right. My initial reaction was that finally someone had come up with a sword-and-sandal movie that was grounded in reality. Here Hercules is haunted by the past and that allows him to see things not normally seen in this kind of story. As a modern character in Ancient Greece, Hercules' struggle is everyman's struggle. My aim from the very beginning was to make a film about the man behind the legend and do for the "legend" genre what *Unforgiven* and *The Wild Bunch* did for the western.

This version of the story demystified Hercules by not treating him as a demigod but, instead, as a human being. We made Hercules more accessible and sympathetic and surrounded him with strong characters of tremendous depth, emotion, and individuality. Within this group, I think of Hercules as the muscle; Amphiaraus, the soul; Autolycus, the brains; Iolaus, the silver tongue; Tydeus, the

RIGHT: Ratner with the soldiers of Cotys' army.

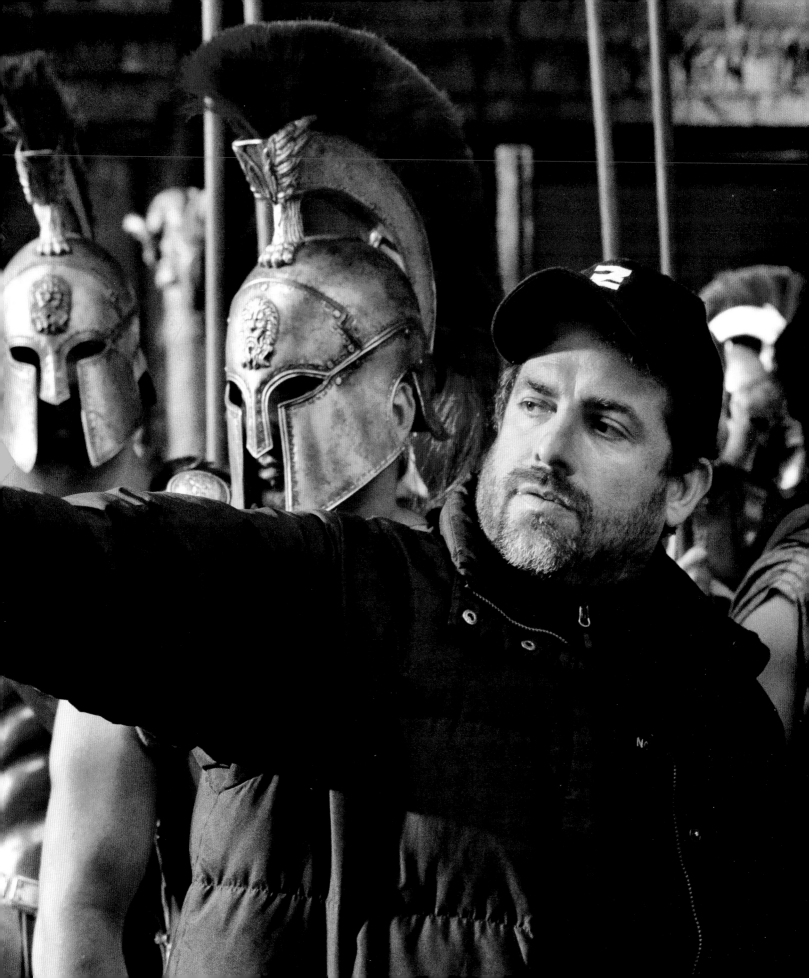

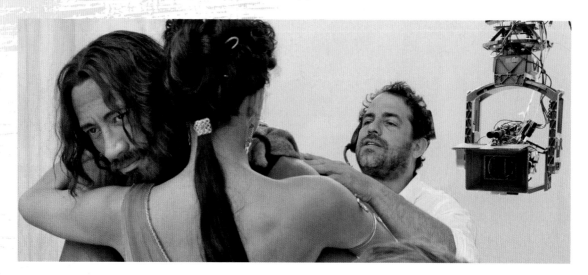

id unleashed; and Atalanta, the heart. For me, the graphic novel refreshingly put Hercules at the center of an ensemble of mercenaries with individuality, specific skill sets, and, most important, purpose. All of them were obviously unique but in total they created a world that was identifiable to everyone.

Ryan Condal did the first screenplay adaptation of Radical's graphic novel by the late Steve Moore. Then we asked Evan Spiliotopoulos, a true Greek, whose knowledge of the myths and understanding of the culture enabled him to create a universe where these characters were grounded and realistic.

When Dwayne Johnson arrived at my house for our first meeting, he looked in my eyes and said, "I was born to play Hercules." I believed him. His statement became a reality when we met again in London for the initial fitting of the glorious costumes and lion's head by Jany Temime, the brilliant wigs designed by Aldo Signoretti, the subtle makeup by Paul Engelen, and the iconic wooden club embedded with the claws of the Nemean lion created by Simon

ABOVE: Dwayne Johnson, Irina Shayk, and director Brett Ratner on location in Hungary. OPPOSITE: Askel Hennie, Ingrid Bolsø Berdal, and Johnson marching towards a battle with the Bessi warriors.

Atherton. I stood behind Dwayne and watched as he looked at himself in the mirror. In costume and makeup, something came over him—a kind of transformation before my eyes. I no longer saw Dwayne Johnson or The Rock—what I witnessed was the birth of this generation's Hercules.

From the very start, my producer Beau Flynn was there through casting, table reads with actors, prop meetings, and even scouting locations. Every single aspect of mounting this film was under Beau's purview. He is an old-school producer in every sense of the word. He was my Knute Rockne—by my side every second of every day during the making of this film. He believed in my vision, supported me, and fought every fight necessary to accomplish what we did. A very special thanks to Richard Taylor and his entire team at Weta Workshop for all their research, hard work, and imaginative early design work; Hiram Garcia and Jamie Freitag, who went far beyond the roles of coproducers in their constant inspiration; Barry Levine and Radical for starting it all with the graphic novel; and, of course, Ross Fanger, my executive producer, who never said NO to me and somehow was always able to keep the studio happy.

Jean-Vincent Puzos was my production designer

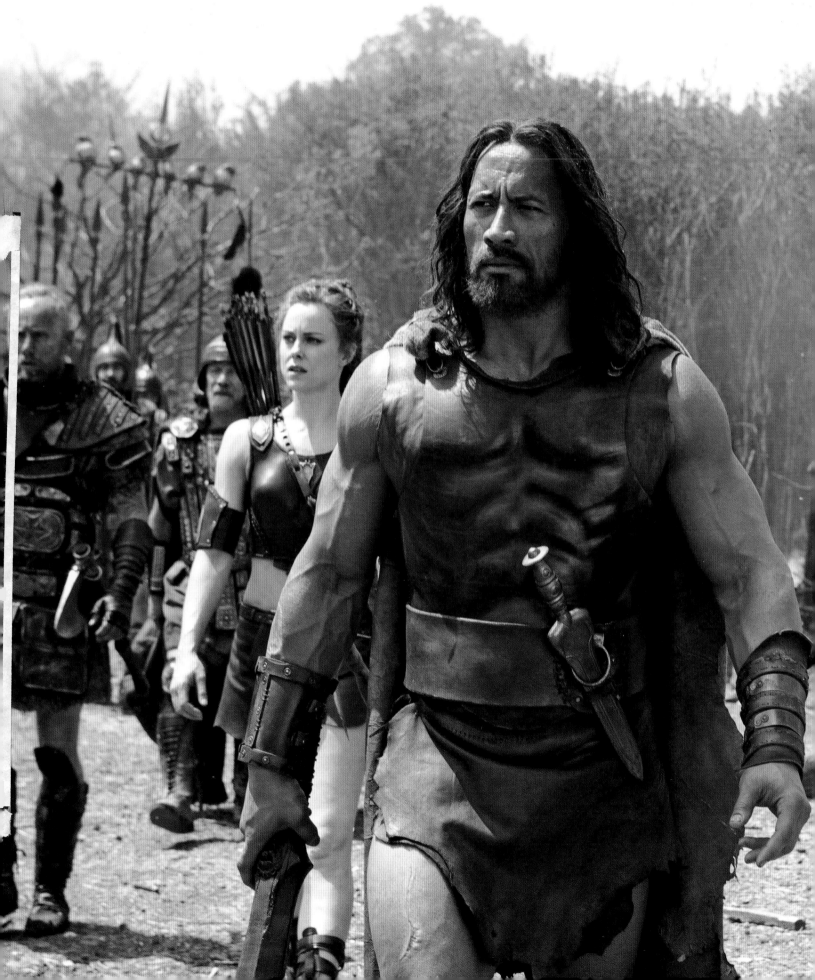

1.

2.

3.

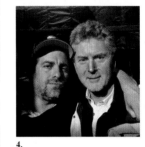

4.

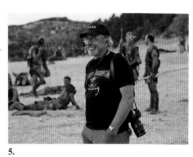

5.

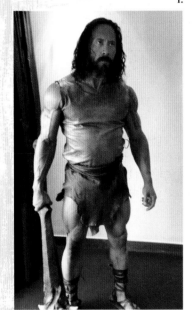

10.

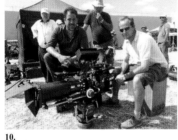

11.

9.

1. Legendary cinematographer Vilmos Zsigmond visits set, with Dante Spinotti; 2. Ratner spreading fake blood on Bessi warriors; 3. Ratner, Dwayne Johnson, MGM Executive VP of Production, Adam Rosenberg, and MGM President, Motion Picture Group Jonathan Glickman; 4. Ratner and second unit director Alexander Witt; 5. special effects supervisor John Bruno on set; 6. film editor Mark Helfrich with prop of a dead horse; 7. Alexander Witt, still photographer David James, and Dante Spinotti; 8. prop master Graeme Purdy; 9. Kasia Nabialczyk, Brett Ratner's assistant, and the director on location in Hungary; 10. Ratner, camera crew, and the big camera; 11. Dwayne Johnson in costume for the first time in London. (Candid photos courtesy of Brett Ratner except #6 courtesy Mark Helfrich; #5 and #8 stills from MGM archives.)

8.

7.

6.

whose passion for history was apparent in his early designs. It was not an obvious choice to hire the guy who did Michael Haneke's *Amour* (2012) for *Hercules*, but the designs Jean-Vincent created were so realistic that he transformed our film and transported us to 340 B.C. Visually, our film demystifies Ancient Greece. This is not a land of impeccable marble temples or sunny meadows. Jean-Vincent's phenomenal design of the sets were brought to life by Dante Spinotti's cinematography. Their collaboration was probably as important as any in creating a world the actors could believe in and, at the same time, in which they could express themselves.

Contemporary versions of these kinds of films have been fantasy-heavy and our goal was the antithesis of that. Every aspect of our movie—from Graeme Purdy's props to Neil Corbould's special effects—were all meant to deemphasize the use of visual effects and focus instead on the tangible in-camera execution. That rule was passed through every department from building the chariots to decorating the sets—everything had to be consistent in order for this world to be believable.

I owe a tremendous debt of gratitude to the second unit director Alex Witt. In the past I have been more of a micromanager with my second unit but here, for the first time, I was able to hand over crucial elements to Alex. In large measure this was because of the synergy between Alex and Greg Powell, the stunt coordinator, and their ability to focus on story and not the stunts. Visual effects supervisor John Bruno's approach—building as much as possible and using a greater ratio of the in-camera build versus special effects—is rare in today's digital world and added a great deal to what we set out to accomplish. This vision was apparent from the first storyboards he drew to the execution of the Third Floor animatics supervised by John Wassug who did a brilliant job.

Last but not least, without my editors, Mark Helfrich and Julia Wong, my vision would never have been fulfilled. Their tireless but almost annoying challenges focused me in the right direction for story and character. Mark has edited every film of my career and I consider him a great filmmaker as well. Julia and Mark are a great team and I am proud of their work on this film. Everyone in the entire cast did an outstanding job, despite a brutal ninety-seven-day shoot with weather ranging between freezing and 105-degree heat. I applaud their perseverance, hard work, and professionalism.

Today we live in a world where people aren't sure they should believe in a higher power and are forced to go on faith. Within this Hercules story, the theme is the same. Hercules has to find a belief, something greater than himself, in order to succeed. What could be more relevant to us than that?

ABOVE: Dwayne Johnson in his Hercules makeup for the first time in London. (Candid photo courtesy of Brett Ratner)

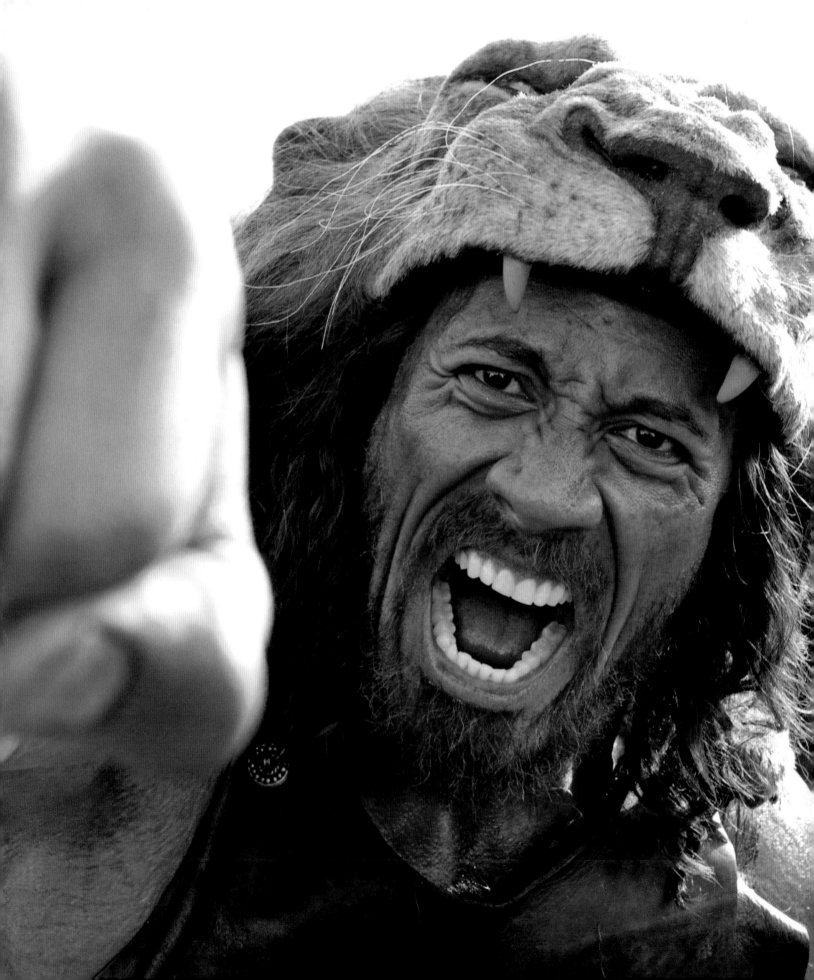

The First Superhero

by Evan Spiliotopoulos, Screenwriter

"Though they were brothers, these were not of one spirit; for one was weaker but the other a far better man, at once terrible and strong, the mighty Heracles. Him she bore through a union with Zeus, leader of all the gods."

—HESIOD, AROUND 600 B.C.

This account of Hercules' birth was written around 600 B.C. by historian and mythographer Hesiod. It represents one of the first attempts to put into writing the legend of Hercules and his Twelve Labors. Up to that point the epic had been told and retold orally by storytellers who made their living by traveling the ancient Hellenic world entertaining kings and commoners alike with adventures of mythic heroes, gods, and monsters.

That desire to entertain by spinning a great yarn links those ancient storytellers to modern filmmakers. Today we may have the benefit of CGI, big budgets, and slick production values but it means very little without a compelling plot and a relatable, appealing protagonist. And there is no protagonist quite like Hercules.

Motion pictures discovered Hercules in 1958. The Italian production *Le Fatiche di Ericole* (literally translated as *The Labors of Hercules*) starring Steve Reeves

and directed by Pietro Francisi was a visually impressive pastiche of several Hercules legends. The film was successful enough to spawn over eighteen sequels in an eight-year period; some of interest, such as *Hercules in the Haunted World*, directed by Italian horror legend Mario Bava. Most of these sequels however were dismal, placing the hero in increasingly silly situations including battling extra-terrestrials (*Hercules Against the Moon Men*) and meeting time-travelling film crews (*Hercules in the Valley of Woe.*)

The early 1980s brought us *Hercules*, starring Lou Ferrigno, primarily memorable to me for the surreal

ABOVE: Producer Beau Flynn and screenwriter Evan Spiliotopoulos (right) on the Bessi set.

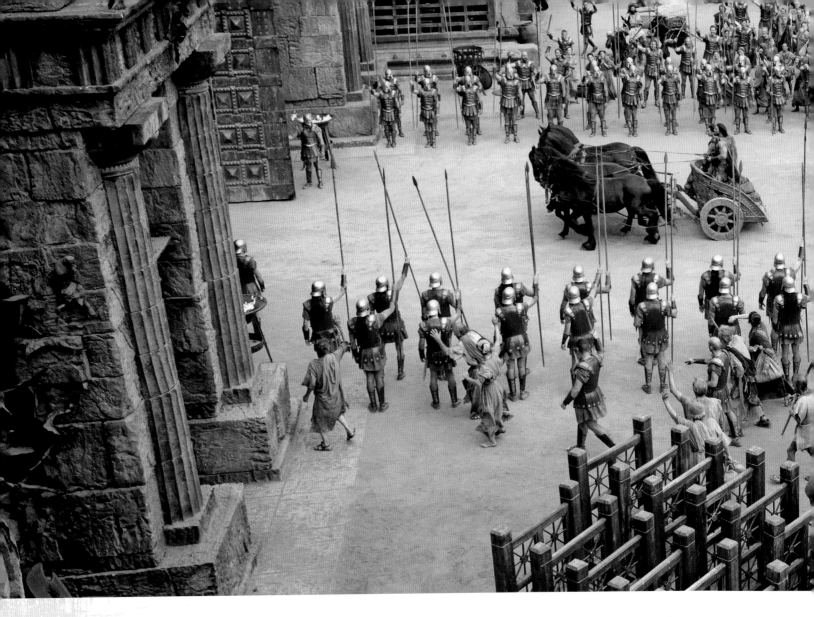

scene in which Hercules wrestles a man in a bear suit then flings him into outer space where he becomes the constellation Ursa Major. The affectionately remembered TV show *Hercules: The Legendary Journeys* aired from 1994 to 1999 and the successful Disney animated feature *Hercules* was released in 1997. January of 2014 saw the brief release of *The Legend of Hercules,* which re-imagined the Greek hero's origins as an anachronistic Roman-style gladiator.

So what is it about the character of Hercules that makes him so appealing that his legend not only has survived for close to three thousand years but, in fact, continues to thrive? In the words of our star Dwayne Johnson, "Hercules was the first superhero." Like Superman, Hercules holds up a mirror to ourselves. He represents what we aspire to be: strong, brave, pure, noble. He inspires us by example.

Our version of Hercules began as an idea hatched by Barry Levine, Jesse Berger, and his Radical Studios publishing crew, and was then fleshed out by writer Steve Moore into the graphic novel *Hercules: The Thracian Wars*. In this tale, Hercules and his companions roam an ancient Greece far removed from the idyllic world of myth—a brutal environment in which innocents are routinely victimized, might makes right, and even heroes have blood on their hands.

When director Brett Ratner came aboard, he used the comic book as a launching-off point for his own

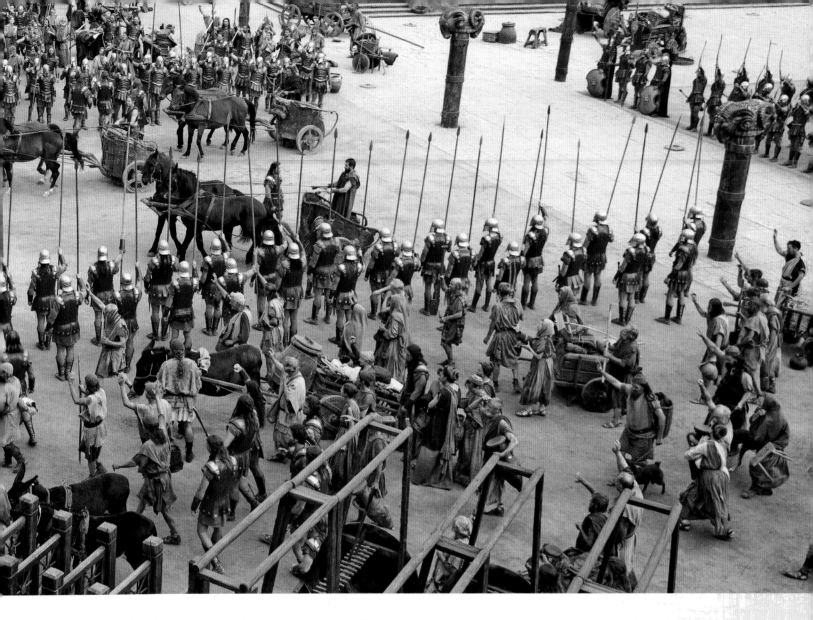

original vision, a take that was completely different from any prior incarnation of Hercules. No gods. No overt superhuman powers. Here was a complete deconstruction of the myth.

In this version, Hercules is mortal. His Twelve Labors are not supernatural but based on grounded, real-life missions, the kind any soldier might take. Everything from sets and costumes to the visual look of the film is authentic—as if someone took a camera back to the year 358 B.C.

Hercules begins our tale as a mercenary running from a bloody past. He uses his legend as a tool of propaganda to frighten enemies and destroy their resistance. Unlike the classic myth, our Hercules is not alone; he is accompanied by five loyal companions, his own *Wild Bunch*.

Yet Hercules finds that in order to defeat evil, in order to save innocent lives and end the bloody conflict in Thrace, he must transform from man into demigod; he must transcend his own mortal limitations and become the Hercules of myth. In doing so, he inspires himself. And he inspires us.

As a Greek, I am proud to add my own voice to those of the ancient storytellers and craft a new Hercules myth for this modern age. As a screenwriter, I am honored to have been included in this adventure by a filmmaker of Brett's vision and talent.

The Setting & THE STORY

Our story takes place in the year 358 B.C., when Greece stretched from territories that are today part of Albania, Serbia, Bulgaria, and Turkey. Although the Greeks were united as one people who spoke the same language and embraced common gods, they were fractured into dozens of autonomous city-states that were usually in conflict with each other and alliances were constantly shifting.

Athens was the wealthiest and most powerful city-state in Greece, due to its fortunate geographical position and the secure and wealthy Athenians developed art, music, theater, and philosophy, making them among the most sophisticated people on earth at this moment in history.

In contrast to Athens, the territory of Thrace was considered a rural backwater in the far north. The people were mostly farmers, with a small merchant class, and little interest in the arts. However, because of its location on the border of barbarian land, Thrace was strategically important, functioning as a bulwark against invasions from nomadic, warlike tribes.

Thrace was ruled by Lord Cotys, a cruel, ambitious man who was both clever and devious. He married into a wealthy family and when his daughter, Ergenia, came of age, married her to the young King of Thrace. Ergenia genuinely loved her husband and soon gave birth to a son, Arius. Then Cotys secretly poisoned the king and

wedged himself onto the throne. (Since Arius was the legitimate heir, as his grandfather, Cotys became "lord protector"—and de facto ruler.)

Though Ergenia suspected that her father had murdered her husband, she kept silent to protect her son Arius. Cotys ascended to power and over the course of six years, gradually consolidated his power with little interference.

Only one person in Thrace understood the evil heart of Cotys. His name was Rhesus and he had been the assassinated king's best friend. Eventually, Rhesus took to the mountains to organize a campaign of guerilla warfare against Cotys.

As our film opens, Rhesus is slowly but surely winning. Lord Cotys needs a champion to lead his army if he is to crush Rhesus and fulfill his ambitions. Not any champion will do. It must be the greatest warrior of all! The half man/half god, Hercules, was the powerful son of the god king Zeus. After twelve arduous labors and the loss of his family, this dark, world-weary soul turned his back on the gods. Over the years he warmed to the company of five similar souls, their only bond being their love of fighting and presence of death. These men and women never question where they go to fight or why or whom, just how much they will be paid.

Coerced by her father and fearing what Cotys may do to her young son Arius if she refuses, Ergenia travels

"Kingdoms are won with armies but empires are made by alliances." —King Cotys (from the screenplay)

to Macedonia to meet Hercules. She manipulates him and his companions to serve Cotys in exchange for a handsome payday. Ergenia demonizes Rhesus leading Hercules to believe that by supporting Cotys, he is championing a just cause. But gradually doubts grow. Suspicion sets in. As Hercules trains Cotys' army, he becomes alarmed by the brutal tactics employed by Cotys' chief enforcer, Sitacles.

Then during a campaign to aid the Bessi, a primitive yet fiercely independent tribe, Hercules and his allies find themselves under attack by the very people they had come to protect. The result is a massacre in which Cotys' army—and Cotys himself—only survive thanks to Hercules' strength and experience.

Most telling of all is the battle of Mount Asticus, an assault directly on Rhesus' mountain stronghold. Hercules is victorious but instead of the war criminal and "demon" he had expected, he discovers Rhesus is in fact a noble charismatic leader who has the full support of the people of Thrace.

Now realizing the full truth—that he has been deceived by Cotys and has been fighting for the wrong side—Hercules rallies his companions to set matters right. Overwhelmed by Cotys' forces, Hercules and his companions are imprisoned in a dungeon. Chained to the wall, Hercules is tortured and forced to watch as Ergenia is condemned to execution by her own father. To save her, his companions, and Thrace, Hercules must believe in himself and become the Hercules of legend, the demi-god son of Zeus. Finding the strength within, Hercules shatters his chains, rescues Ergenia, and frees his comrades. United, our heroes confront Cotys' army of thousands—an army they themselves trained never to surrender. Hercules triumphs by achieving the impossible—he collapses a massive Temple of Hera on Cotys and his personal guard and convinces the surviving soldiers to lay down their arms.

With Cotys destroyed and Thrace liberated, Hercules and his friends return to Athens in search of more glory and new adventures.

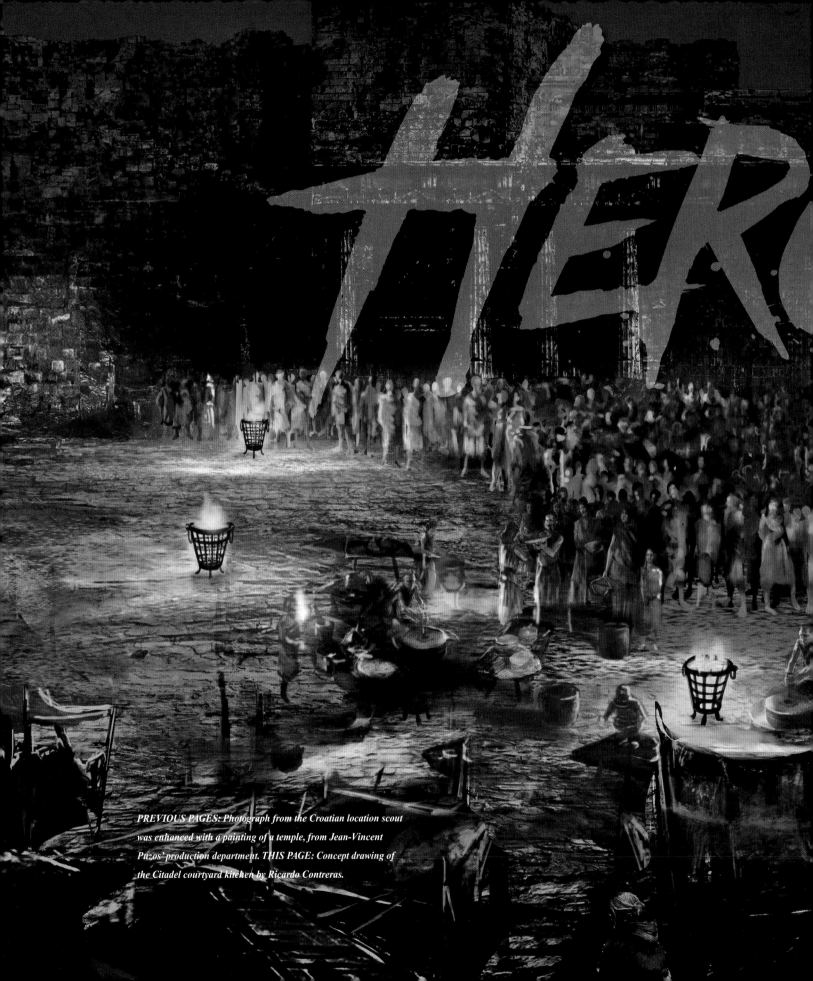

PREVIOUS PAGES: *Photograph from the Croatian location scout was enhanced with a painting of a temple, from Jean-Vincent Pazos' production department.* THIS PAGE: *Concept drawing of the Citadel courtyard kitchen by Ricardo Contreras.*

THE PLAYERS

THE MERCENARIES

 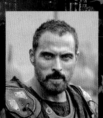 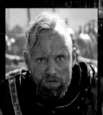 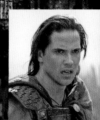 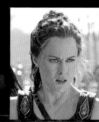 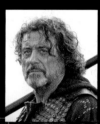

HERCULES **AUTOLYCUS** **TYDEUS** **IOLAUS** **ATALANTA** **AMPHIARAUS**

THE KINGS THE REBEL LEADER

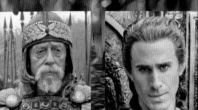 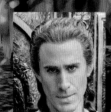 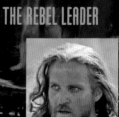

LORD COTYS **KING EURYSTHEUS** **RHESUS**

THE THRACIANS

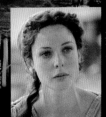 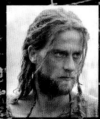 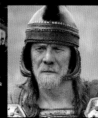

ERGENIA **PHINEUS** **SITACLES** **STEPHANOS** **DEMETRIUS** **NICOLAUS**

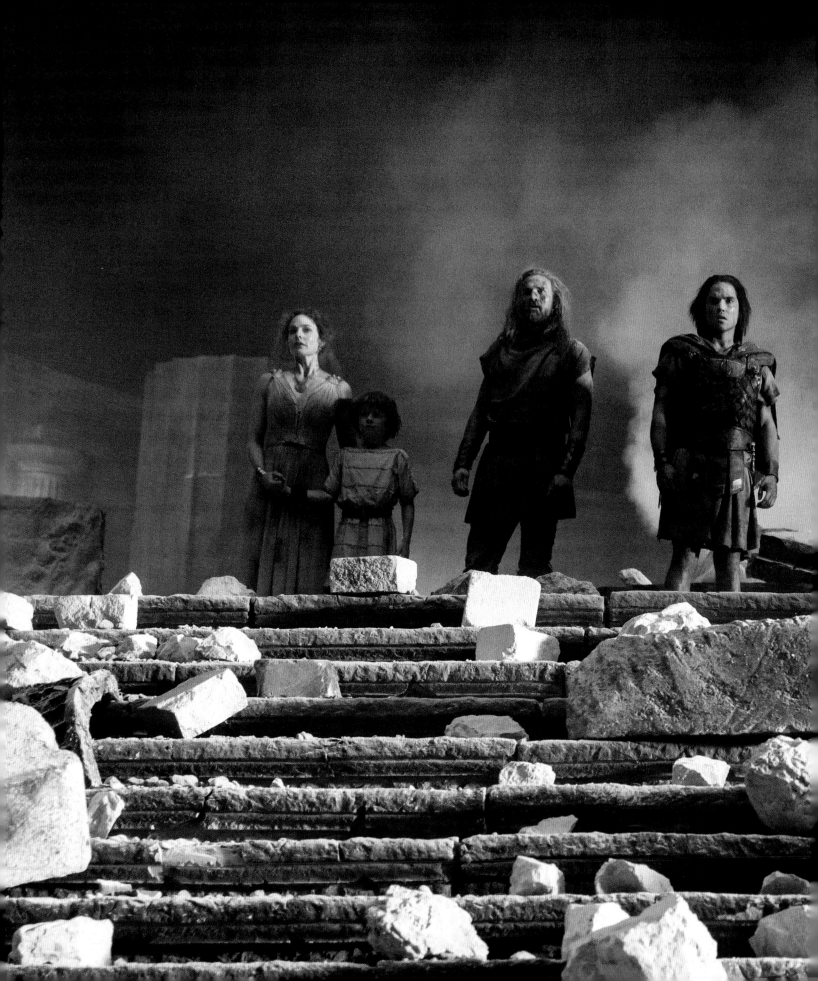

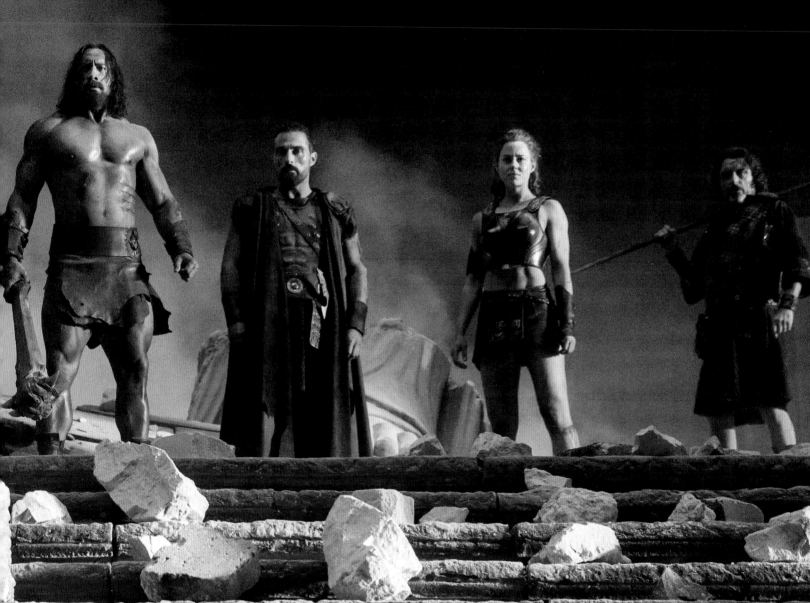

Part One
THE CHARACTERS'
Backstories

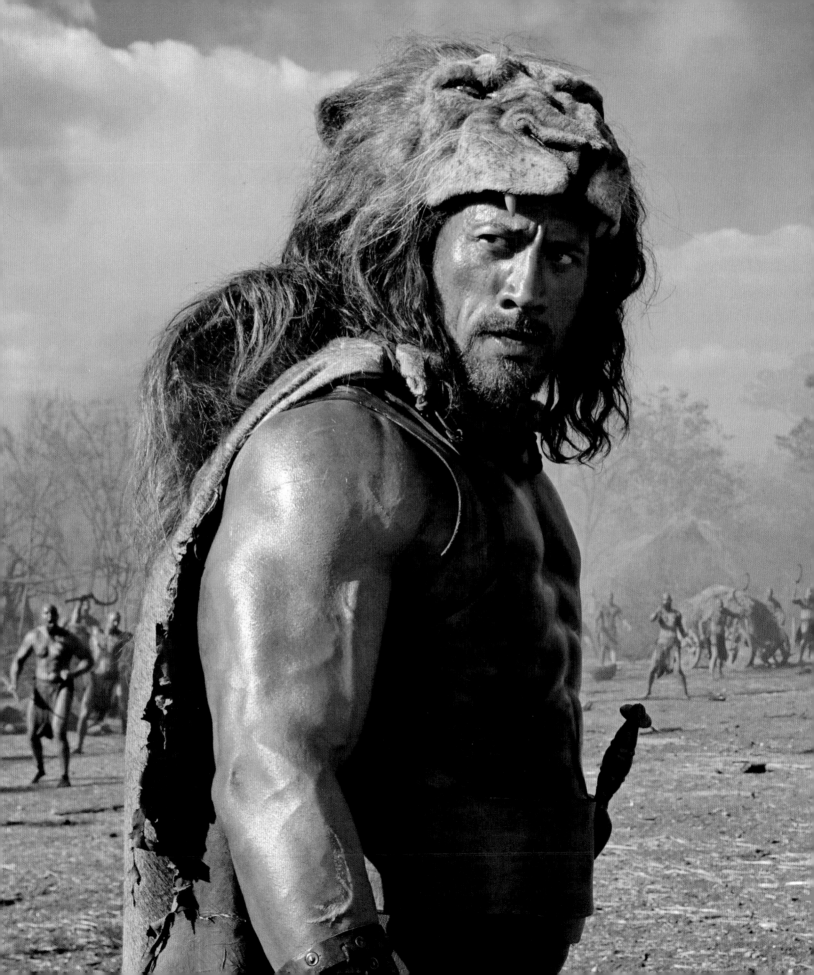

"To death or victory..."
—Hercules
(from the screenplay)

Dwayne Johnson
Hercules

In this version of the epic story of Hercules, we meet a very different kind of hero. Here, the filmmakers have totally deconstructed the myth of Hercules as a half-god, half-man. This Hercules is a mortal who rejects the myths that glorify him. He is a broken man, destroyed by the death of his family and the belief that he killed them. His mission in this film is to find his way again and rid himself of his demons.

In many ways, Dwayne Johnson was born to play Hercules. "Dwayne had dreamt of playing this role for at least a decade," says producer Beau Flynn. To the delight of the filmmakers, Johnson brought a certain charm and charisma to this angst-driven revenge drama and added a sense of humor to the character. "Once Dwayne came aboard it was felt that the script needed a tonal uplift because whilst it was terrific story-wise it was very, very dark," explains screenwriter Evan Spiliotopoulos. "It was more of a grim, revenge, angst-driven drama and as Dwayne has such a charismatic personality it was felt he could definitely carry the dramatic parts, but we wanted the audience to enjoy

PREVIOUS PAGE: This photo of the eight characters on the steps was taken on the last day of shooting. OPPOSITE: Johnson claims that he was born to play this role. RIGHT: Weta Workshop art showcasing ideas for Hercules' tattoos. Art by Aaron Beck.

his humor, his charm and the fun of an action summer movie about Hercules."

Designing an outfit for Johnson was fairly easy for costume designer Jany Temime, "because Dwayne uses his Hercules image to make a living," she says. "I dug deep into mythology and gave him the lion's head, the lion-skin cape, and the big belt. This is everything people would expect to see in Hercules and it worked because he could carry it. From the moment he put on

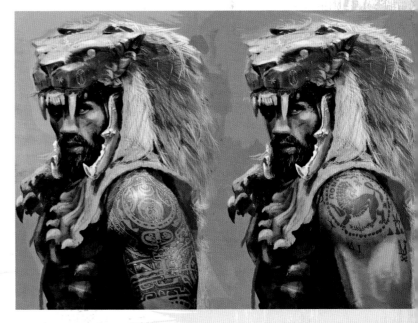

the lion's head, Dwayne was Hercules. The long hair was created because it required a certain balance and he looked beautiful in it." The look did not come easy. Johnson spent four hours in hair and makeup each morning, a transformation that included covering his own tattoos and having scars glued to his torso.

Creating Hercules' look was fairly simple, except for the lion's head. "Of course, we couldn't use a real lion's head so we had a prosthetic made and every single hair was glued on," explains Jany Temime, who wanted the eyes to look empty but not be made of glass. "Finally, I found an antique stone of dark agate, which gave them some life, but not too much. We had to allow Dwayne's own eyes to be prominent without being overshadowed by the lion's head."

ABOVE: Costume concept drawing for Hercules' lion's head helmet.
OPPOSITE: Hercules trains Cotys' army.

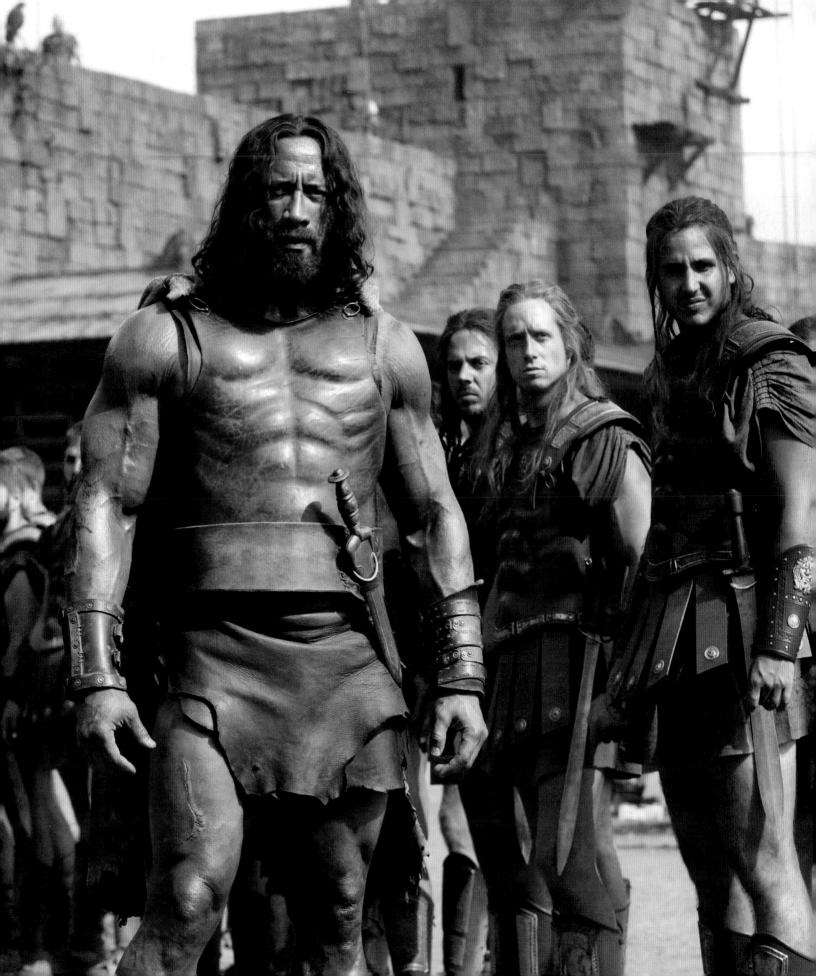

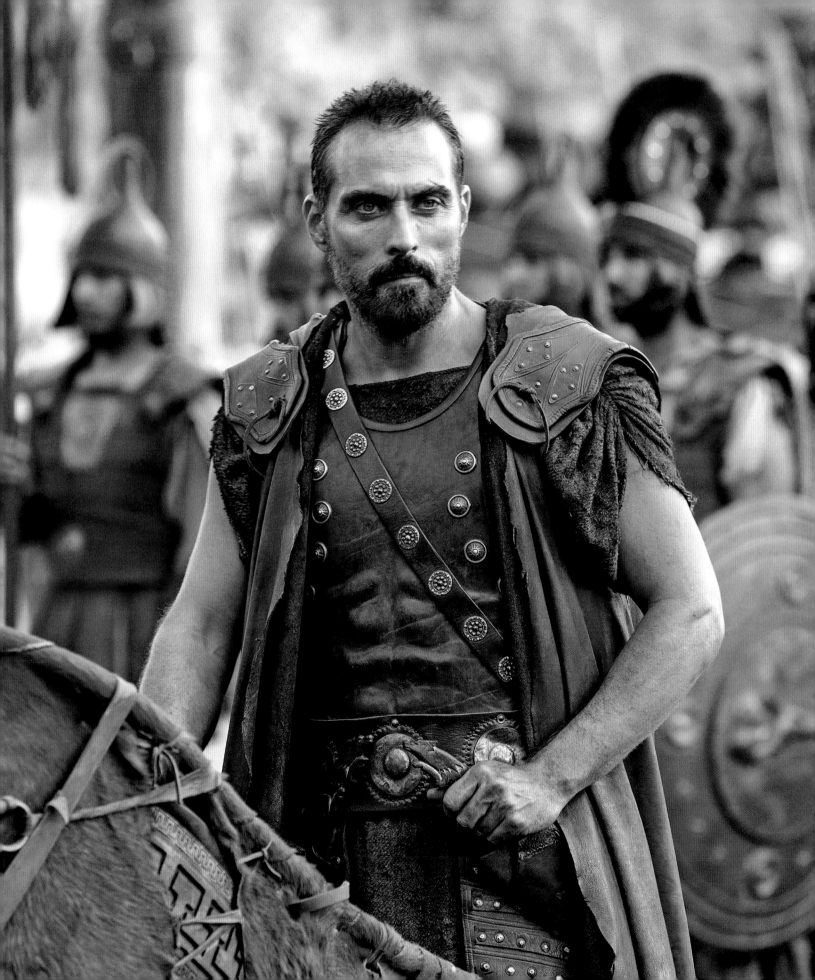

"Don't just stand there. Kill someone." —Autolycus [from the screenplay]

Rufus Sewell
AUTOLYCUS of Sparta

ercules and Autolycus were orphans on the streets of Athens when they found each other and then, together, found a home in the army. "I believe Hercules is the finest man I've ever known," says Autolycus. "And my friend." In their many adventures together, they saved each other countless times.

"They go way back," explains actor Rufus Sewell. "And they have a kind of communication that doesn't always need to be signaled. They understand each other; they've always worked together. Hercules, because of his enormous size, would get singled out by the kings of Athens and always took Autolycus with him, which was a great source of pride for my character. He is Hercules' point man and knows him better than anyone else."

Although lacking in Hercules' physical strength, Autolycus is a master strategist with a sharp brain. "Autolycus is the one-liner guy," says Brett Ratner. "He's the wisecracker, the strategist. His name carries the Greek word for wolf because he is such a predator."

To prepare for the role, Sewell did an enormous amount of training. "If you're going to be standing next

OPPOSITE: Rufus Sewell as Autolycus. ABOVE: Early costume design for the character.

to Dwayne Johnson, you need to be believable as, well, part of the same species, let alone his friend or fellow fighter," confesses Sewell. "At the end of the day though, no matter how many sit-ups you do, when you end up next to Dwayne, it slightly diminishes your sense of achievement."

Costume designer Jany Temime put Autolycus into a cape. "Autolycus is the guy who decides, thinks, and plans," explains Temime. "I decided to give him a long leather great cape that he's had for years. It's a part of his life. He keeps all his weapons under it; he sleeps under it."

Indeed, Autolycus is an expert with knives that can be concealed underneath the cape. "I have a couple of knives that I keep under my cloak, kind of like a back-street salesman of knives," says Sewell. "I can reach and throw one, very expertly, at any given time. However, I've discovered I can't sit comfortably in a chair without removing them, otherwise I kind of impale myself."

Aksel Hennie
Tydeus of Thebes

When Tydeus was eight-years-old, his city Thebes was attacked and, for the next five years, a vicious war ensued. Thebes had natural springs so water was plentiful, but food became scarce after the first year and eventually the city resorted to cannibalism.

Hercules came upon Tydeus when the boy was thirteen, the lone survivor in a city of the dead. Even though the boy was barely even human, Hercules decided to rescue him. "Hercules took Tydeus in when everyone else saw nothing but a wild animal," explains Iolaus in the screenplay. Tydeus soon became part of the Hercules' inner circle of companions.

"Tydeus never speaks of what he saw," Hercules says in the script. "He never speaks at all." No one knows exactly how Tydeus survived those five harrowing years but surely it was horrific. Even though Tydeus remains silent, his experiences dominate his dreams every night. The boy, now twenty-five, is haunted, mentally unbalanced, and tortured. He must be chained at night to prevent him from injuring himself or others.

For obvious reasons, he is a most efficient killer. To quote from the screenplay, during battle: "He wields TWIN AXES. His eyes are insane. He is like a child with lethal skills. And he fights in a berserker rage."

Tydeus had to become a killing machine in order to survive in Thebes and Hercules has shown him how to hone his skills on the battlefield. Hercules trained Tydeus, for lack of a better word, like a dog. And Tydeus, in turn, displays the loyalty of an obedient canine.

As a result, Tydeus is no longer quite a beast, but he is not entirely human either. He is restrained by his love for Hercules. But when he is unleashed, the beast takes over.

"Tydeus is my most loyal warrior."
—Hercules (from the screenplay)

OPPOSITE: Askel Hennie as the crazed Tydeus. ABOVE: Early costume design.

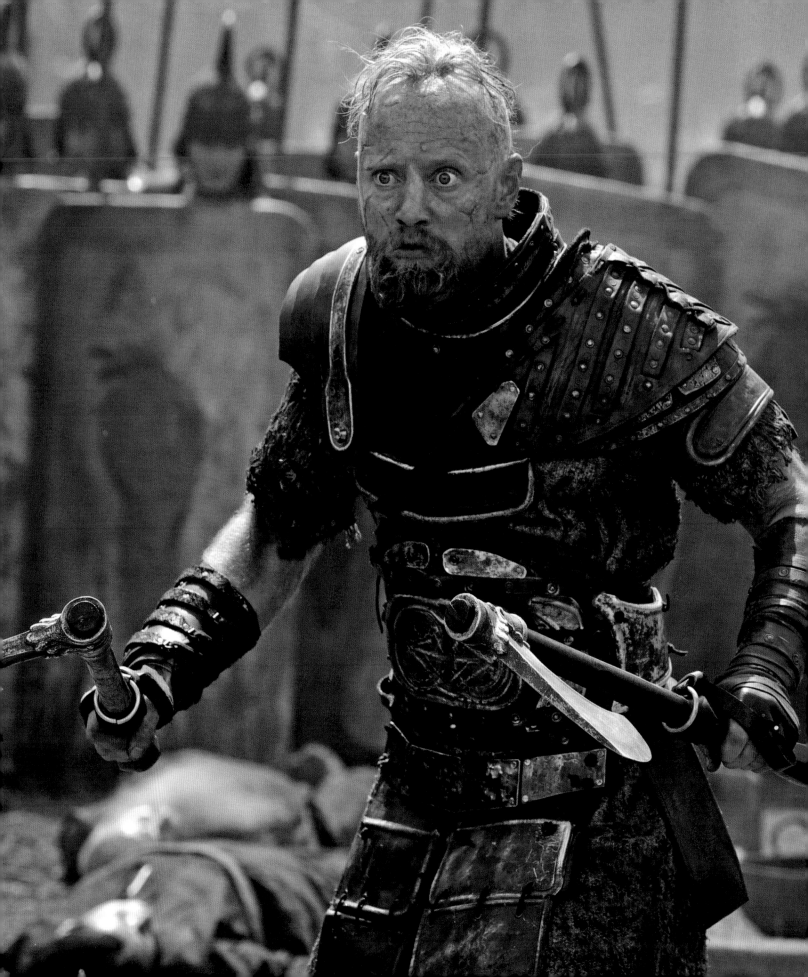

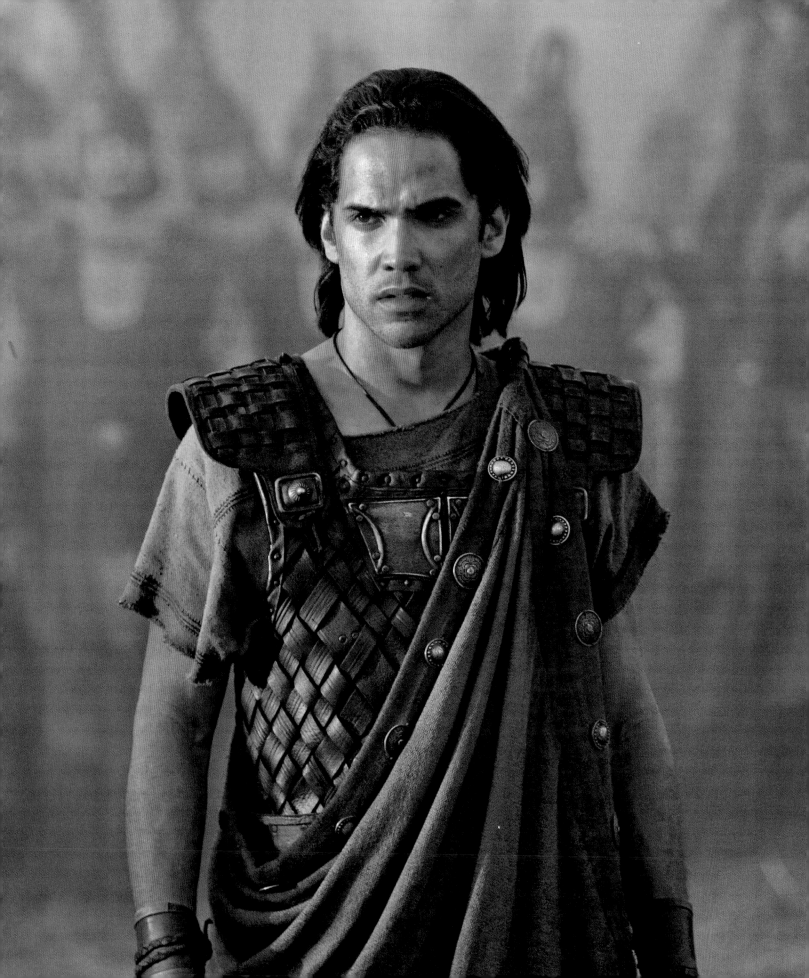

"I am Hercules' nephew. And a valued companion. I tell of our journeys."

—Iolaus (from the screenplay)

Reece Ritchie
Iolaus of Athens

Iolaus is the son of Hercules' half-brother who, unlike Hercules, never went to war. Instead, Iolaus' father became a worker for the booming Athenian theater scene and Iolaus grew up amongst actors, writers, and directors. As a child, he began appearing in productions and eventually became one of Athens' finest actors and storytellers.

Throughout his life, Iolaus admired his uncle's achievements. To him, Hercules was a true hero, whereas he only playacted the role of hero. So Iolaus decides to join Hercules on his adventures. His job is to spread the legend of Hercules by telling stories to terrify the enemy. "Iolaus is full of wonder," explains actor Reece Ritchie, "but he also has this kind of subtext that it's not quite enough for him to be an orator. He wants to prove himself as a worthy warrior." Hercules however, is extremely protective of his nephew and always keeps him as far from danger as possible. While Iolaus will hone his storytelling talents during his time with Hercules, he will also have the chance to fulfill his lifelong ambition of becoming a warrior.

OPPOSITE: Reece Ritchie as Iolaus. ABOVE: Early costume design.

For a weapon, Iolaus carries a single dagger that has a lot of relevance for the character. "Everyone else has these incredible weapons. Hercules has the big club, Atalanta has her bow and arrows, Tydeus has two massive axes," explains Ritchie. "And all Iolaus gets is this one little dagger—like a toothpick—which, for me, represents his inadequacy as a warrior in the beginning of the movie. But do not underestimate the dagger; it winds up serving quite a relevant function in the story. It may be small but it can do great things. Beware the dagger of Iolaus!"

Ingrid Bolsø Berdal
Atalanta of Scythia, the Amazon kingdom

Atalanta was known in Greek mythology as the virgin huntress who refused to marry. For the sin of being born a female, she was abandoned on the mountainside by her father to make her tough. Raised by a she-bear, she became a fierce hunter and a master of the bow and arrow.

Here, though, Atalanta's backstory was changed for the purposes of the story. This Atalanta is from Scythia, the Amazon kingdom, and is the daughter of an Amazon queen who was murdered, along with Atalanta's sisters. Fleeing into the woods, Atalanta barely survived the slaughter and was on her own until she met Hercules.

"Hercules helped me avenge their murders," Atalanta explains in the film. "He became my brother in arms." She joined his group of mercenaries. The only female in Hercules' inner circle, Atalanta proves that she can more than hold her own in a very masculine world. "Being an Amazon, she's obviously very well trained in archery and combat," explains Ingrid Bolsø Berdal. "As an Amazon, she is the icon of a strong woman."

The stunning Norwegian actress had to train long and hard, for more than six months, to get her body in shape and to learn how to use a bow and arrow and drive a chariot. "The pre-production phase is very crucial," Berdal says. "You have to do the exercises so many times that it becomes automatic and you can rely on muscle memory when the pressure is on and the cameras are rolling."

The hard work paid off. "As the only female mercenary in the group, you really need to believe Atalanta is tough, trained, and strong," says Brett Ratner. "Ingrid pulled that off; she is in incredible shape, probably more so than any of the guys in the group."

"Look around, Hercules. We are more than friends. We are family. All we have is each other." —Atalanta (from the screenplay)

RIGHT: Ingrid Bolsø Berdal as Atalanta.
ABOVE: Early costume design.

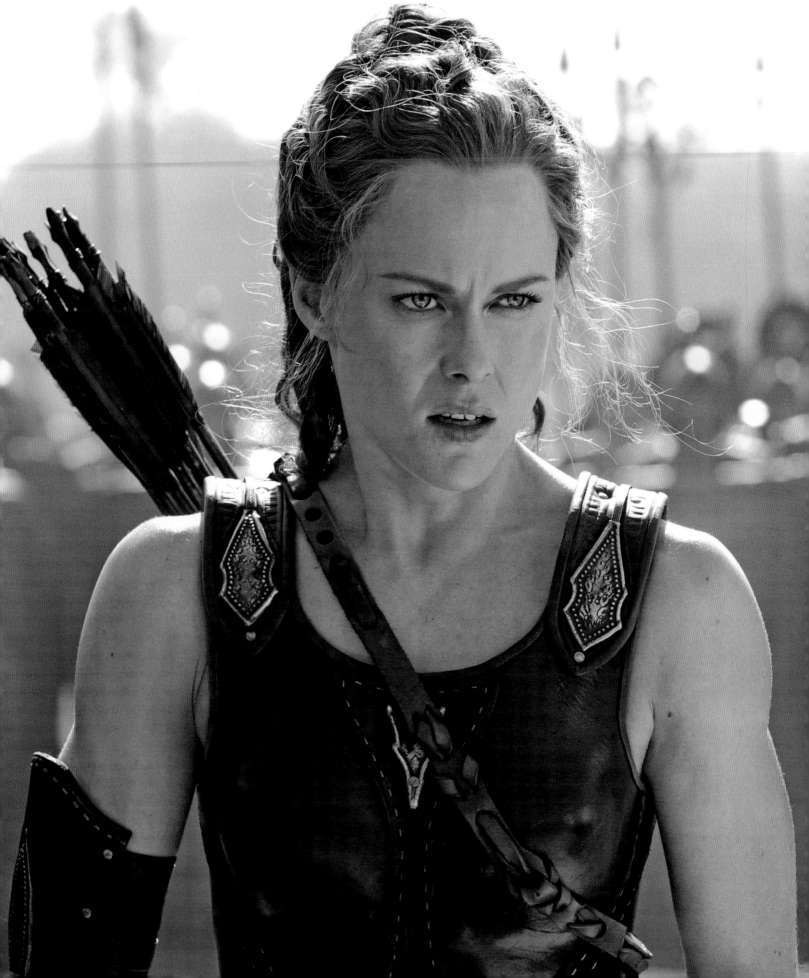

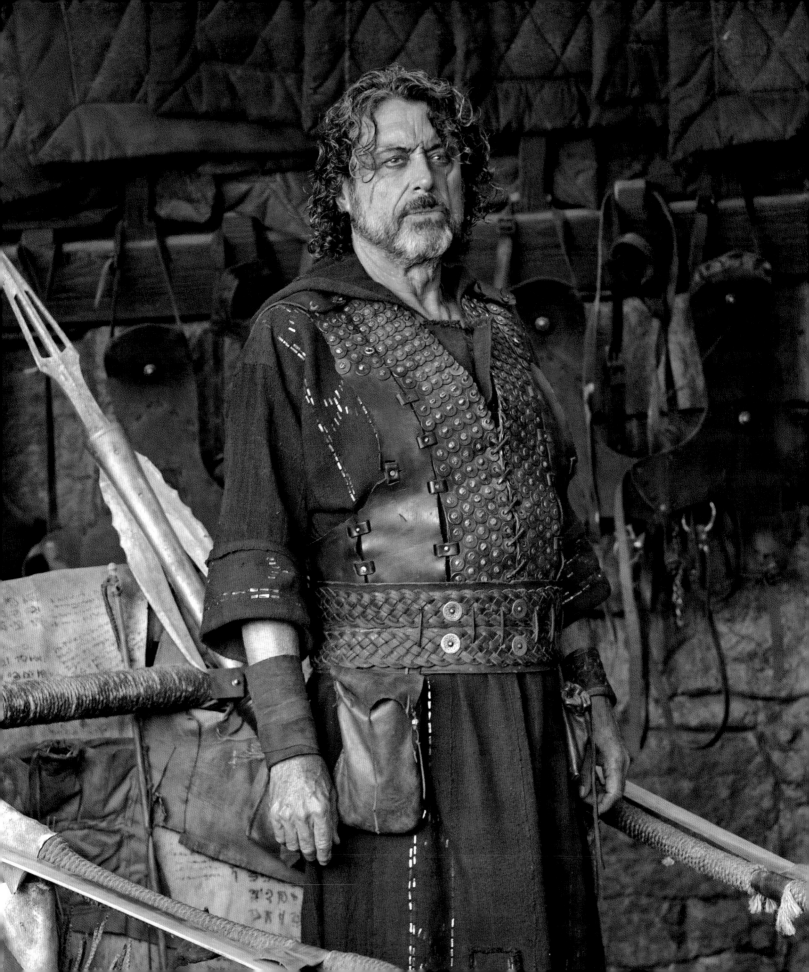

"I am ready for what's next." —Amphiaraus [from the screenplay]

Ian McShane
Amphiaraus
the famed seer of Argos

He is the elder statesman of the group and his story is more complex than his companions can even imagine. "Amphiaraus, in his youth, was quite an unsavory character," explains actor Ian McShane. Once a man driven by greed, in his quest for wealth and power he made many enemies who eventually wiped out his family. Hungering for vengeance Amphiaraus went after them but before he could slaughter them, the gods blessed (or cursed) him with the gift of vision.

So Amphiaraus became a priest at the temple of Zeus in Olympia and found peace. Years later, while away on a mission of bringing aid to the poor, Amphiaraus had a vision that the temple was attacked and sacked by a warlord. Hurrying back, he found the temple burned, the priests slain, and the statue of Zeus gone.

The priest set off to recover the statue and was helped by Hercules. Once their mission was complete, Amphiaraus had a vision from the gods to follow Hercules and serve as his companion-in-arms. Thus, he became Hercules' spiritual advisor of sorts. "He is older than the other warriors but, as he says, 'you like to have me around because I speak the truth and because I have faith,'" says McShane. He also fights like a demon because, having seen the moment of his own death, he knows it is not yet his time to die.

"Can Amphiaraus, the soothsayer, see the future? Is he in contact with the gods?" asks fellow actor Rufus Sewell. "We don't know. But there's something slightly spooky and ethereal about it. He's a little older, and he has a vicious fighting style which involves carrying a long stick with pointy bits on it so he can dispatch several assailants at the same time without breaking a sweat."

During the course of his adventures, Amphiaraus learns that although one must heed the gods, man is ultimately the master of his own fate.

OPPOSITE: Ian McShane as Amphiaraus. ABOVE: Early costume design.

37

Rebecca Ferguson
Ergenia

Born the daughter of Cotys, Ergenia grew up in a family of schemers and connivers who only sought power. As a teenager, she was married off to the young and handsome King of Thrace. Her father's goal was to work his family into the line of succession, but he had not foreseen that his daughter would fall in love with her husband.

Finding herself in the company of a good man introduced Ergenia to a world she had not known existed. She drew away from her father's corruption and embraced the world of her kind and generous husband. When her son Arius was born, Ergenia's life was perfect.

Then Cotys poisoned the king in order to wedge himself on the throne. Since Arius was the legitimate heir, as his grandfather, Cotys became "lord protector" and de facto ruler of Thrace.

Ergenia suspects that it was her father who murdered her husband, though she can't prove it. Now she lives in fear for her son and will do anything Cotys asks to keep Arius safe. She hopes that someday Arius will take his rightful throne and will be a good king to heal Cotys' wrongs.

OPPOSITE: Rebecca Ferguson as Ergenia. ABOVE: Early costume design.

Meanwhile, because of all the savagery in Thrace, Ergenia studied to become a healer and physician to help her people. "It was very important for me to make sure Ergenia is not a princess who walks around in beautiful clothes," says actress Rebecca Ferguson. "Ergenia gets her hands dirty and she is a nurse. She is a mother of the earth."

"I am not just 'anyone.' My name is Ergenia, daughter to Lord Cotys."
—Ergenia (from the screenplay)

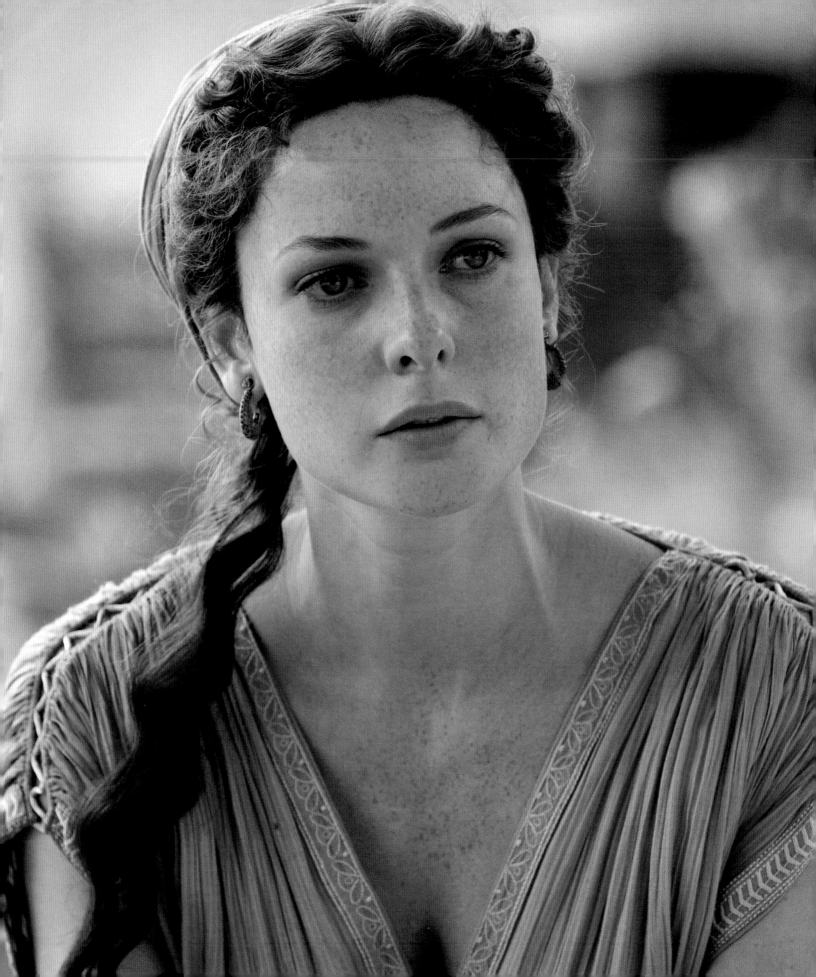

John Hurt
Lord Cotys

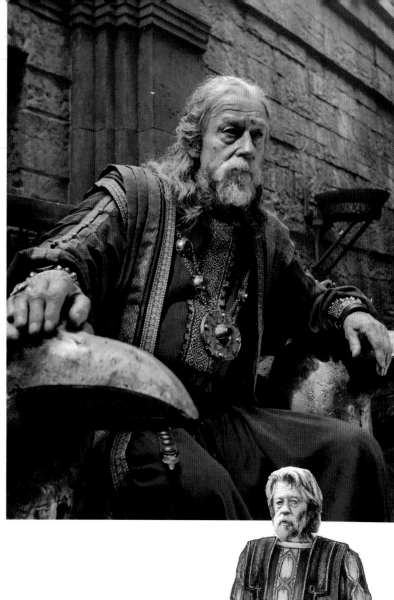

Cotys' father was general to the King of Thrace and a brutal, abusive man who craved power and won it through warfare. Because of his father, Cotys grew up wanting wealth and power. In truth, he is not unlike most kings and conquerors of his time. Those that won, history has remembered as great rulers; those that failed, history recalls as tyrants.

Cotys is cerebral, intelligent, and fiercely clever. His ultimate goal is not to consolidate power in Thrace but to take over Greece and build his own empire. To achieve that end, he is willing to sacrifice everything—his people, his daughter, even his own grandson.

Ironically, although his methods are reprehensible, Cotys' ultimate goal has merit. Greece is a weak collection of city-states and tiny kingdoms. If the entire chaos was placed into order under a strong ruler, who knows what it might achieve?

In playing the character, John Hurt wore a tunic. "It's rather singular for him," says the actor. "He wears a long tunic nearly all the time whereas most of the Greeks wore the short tunic and shin guards. So, Lord Cotys looks a little more regal and a bit more unusual than the others." For a weapon, he carries a beautiful dagger with a jeweled scabbard.

ABOVE: John Hurt as Lord Cotys and Joseph Fiennes as King Eurystheus. RIGHT and OPPOSITE: Early costume designs for the characters.

"I now crave an empire."
—Cotys [from the screenplay]

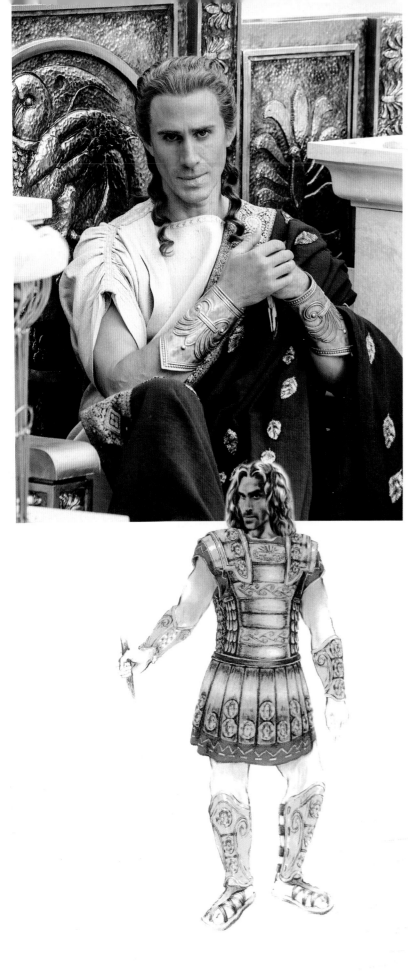

Joseph Fiennes
King Eurystheus

The king of Athens inherited his throne from his father and grew up in absolute luxury in an age when most people lived in poverty. Eurystheus never knew discomfort or hunger and, from a young age, grew accustomed to wielding power.

Appreciative of the finer things, Eurystheus has a refined taste in art and music; in his reign all the arts flourished and Athens grew more wealthy, powerful, and intellectual. He enjoys collecting rare birds from around the world to complement the beauty of his palace.

Eurystheus understands the value of appearances to convey power and intimidate opponents. He is sensitive to potential rivals; even if, like Hercules, they do not know they are rivals.

Eurystheus is willing to do anything to cling to power —mostly because he does not wish to lose the life of luxury he is accustomed to. This leads him to alliances with ruthless men like Lord Cotys.

The character is entirely original to the screenplay and was not in the graphic novel. "He lingers in the background," explains Brett Ratner, "to remind Hercules of the great crime he committed by killing his family."

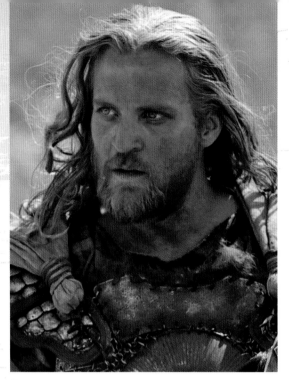 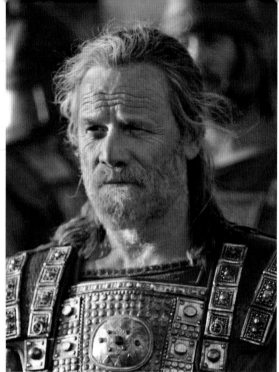

Tobias Santelmann
Rhesus

Peter Mullan
Sitacles

Rhesus, the best friend of Ergenia's murdered husband, was among the first to suspect that the young King was murdered by Cotys, his father-in-law. To avenge his friend, Rhesus began a guerilla campaign against Cotys in the mountains around Thrace.

A charismatic leader and adept general, Rhesus and his troops are slowly overtaking the army of Thrace when our movie opens. If Cotys is going to succeed in his plan to rule Thrace, he must crush Rhesus so he sends his daughter in search of Hercules.

Rhesus' weapon of choice is a long sword designed to be carried in one hand while riding on a horse.

Sitacles joined the Thracian army at a young age and became known for his brutality. He rose quickly through the ranks and soon became Cotys' main enforcer. Like Hercules, he fights for pay and is the ultimate mercenary. He sports an elaborate sword, which was based on an ancient Greek design.

Sitacles lives for gold, food, wine, and women. He takes whatever he wants.

Heartless and cold blooded, Sitacles may well represent what Hercules could have become if he'd continued on his path of grief and violence.

"Men who deal in violence attract violence."
—Ergenia (from the screenplay)

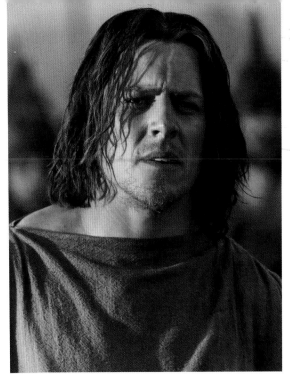

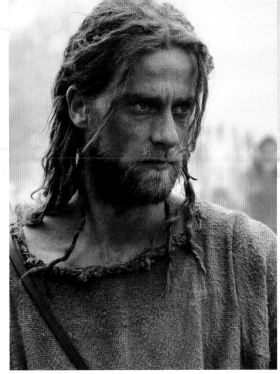

Steven Peacocke
Stephanos

Joe Anderson
Phineus

Stephanos was created by the screenwriters for the movie and was not in the original graphic novel. He is one of the farmers conscripted into the army for Lord Cotys to fight Rhesus. "You feel for these farmers who have been dragged from their homes and into the conflict," says screenwriter Evan Spiliotuopoulos. "Their fate brings into focus the repercussions of war."

Steven Peacocke, the Australian actor, played Stephanos. "Stephanos probably doesn't even know why he is fighting or what he is supposed to achieve, like most soldiers I suppose," says Peacocke. "We're just blokes who've never before picked up a sword so the battle is pretty shocking for us."

As a soldier, Peacocke's costume consisted of a long tunic with an armored breastplate. "I've never worn a skirt before," admits Peacocke, "but the weather was so hot that having a bit of a draft was a good thing."

Phineus, played by Joe Anderson, spends a great deal of movie time on a horse, befitting his role as a scout. The part required actor Joe Anderson to do extensive training because he had very little experience on horseback.

"I didn't really know how to ride. I once sat on a horse on a beach," admits Anderson. "We trained for about three months, which was terrific because you really go through the gambit. First, you are terrified and very sore, then after a while you figure out that you have to be the boss. You have to man up to the situation."

The training was difficult but rewarding. "We galloped over the Hungarian hillsides, which was awesome," continues Anderson. "We also did a lot of chasing after footballs with polo sticks to get dexterous. The hardest part was riding the horses when they're wearing the armor. You have to do a lot more, and you get blisters everywhere."

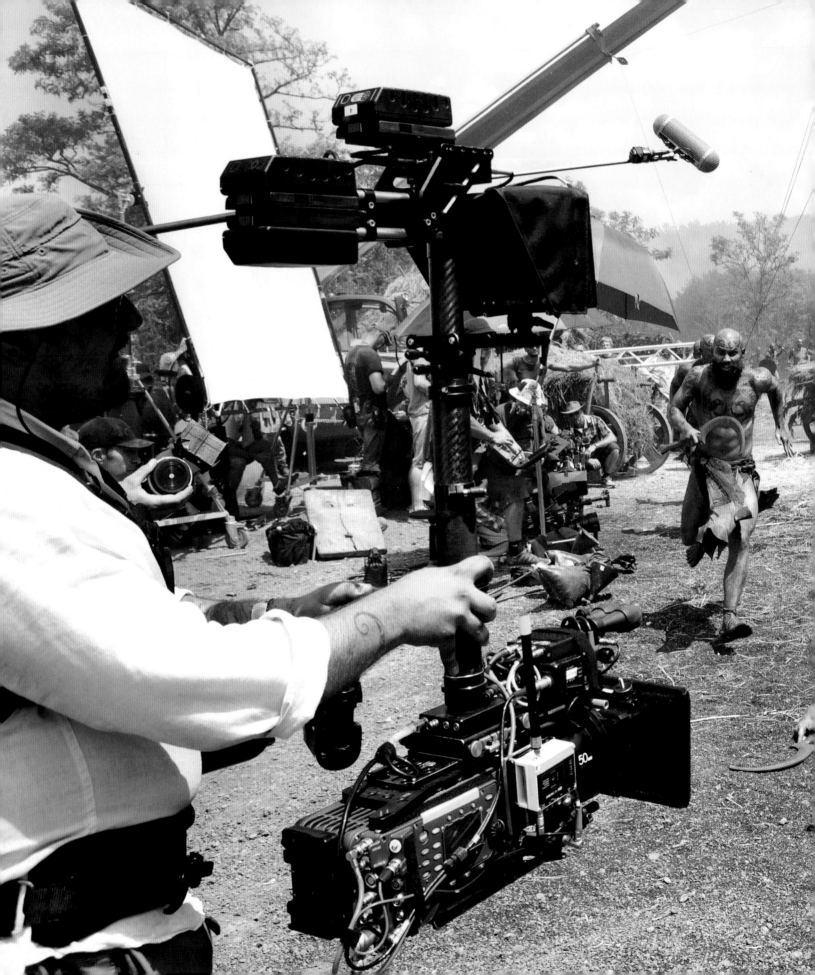

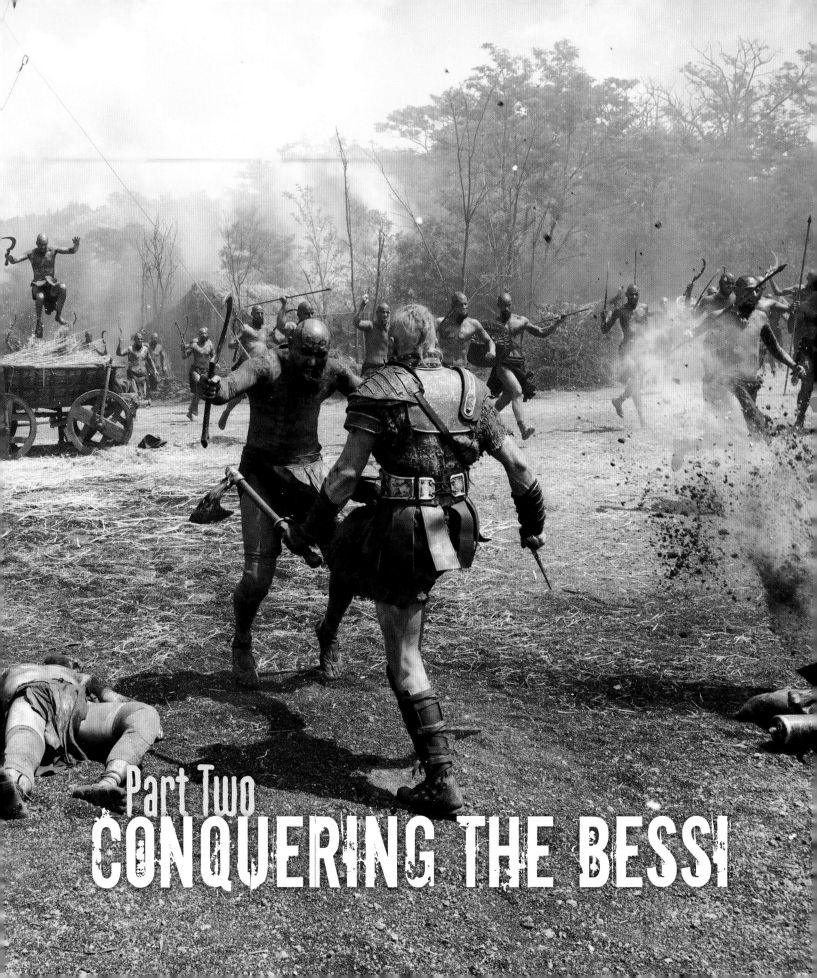

Part Two
CONQUERING THE BESSI

irth
rcules... Weta Workshop

Artists at the Weta Workshop created many of the early concept character drawings featured throughout this book. Working with special effects supervisor John Bruno (who also supervised the creature design,) Weta created visualizations of some of the sequences where Hercules battles the Cerberus, the Boar and the Hydra in flashbacks of his Twelve Labors.

The Weta Workshop, founded by Peter Jackson, Richard Taylor, and Jamie Selkirk in 1993, is best known for the company's work on such award-winning film projects as the *Lord of the Rings* trilogy, *King Kong*, *The Hobbit*, *District 9*, and James Cameron's *Avatar*, as well as many other blockbuster movies and gaming properties. Housed in a 65,000 foot facility in Wellington, New Zealand, the company creates everything from handmade weapons, costuming or creature suits to large scale tank and vehicle construction, all under the supervision of five-time Oscar®-winning design and effects supervi-

The company is named for the New Zealand Weta, which is said to be one of the largest cricket-like insects in the world.

Pre-production concept art from Weta to help visualize three of Hercules' Twelve Labors as featured in the opening sequence of the film. These included killing the seven-headed Hydra (top);

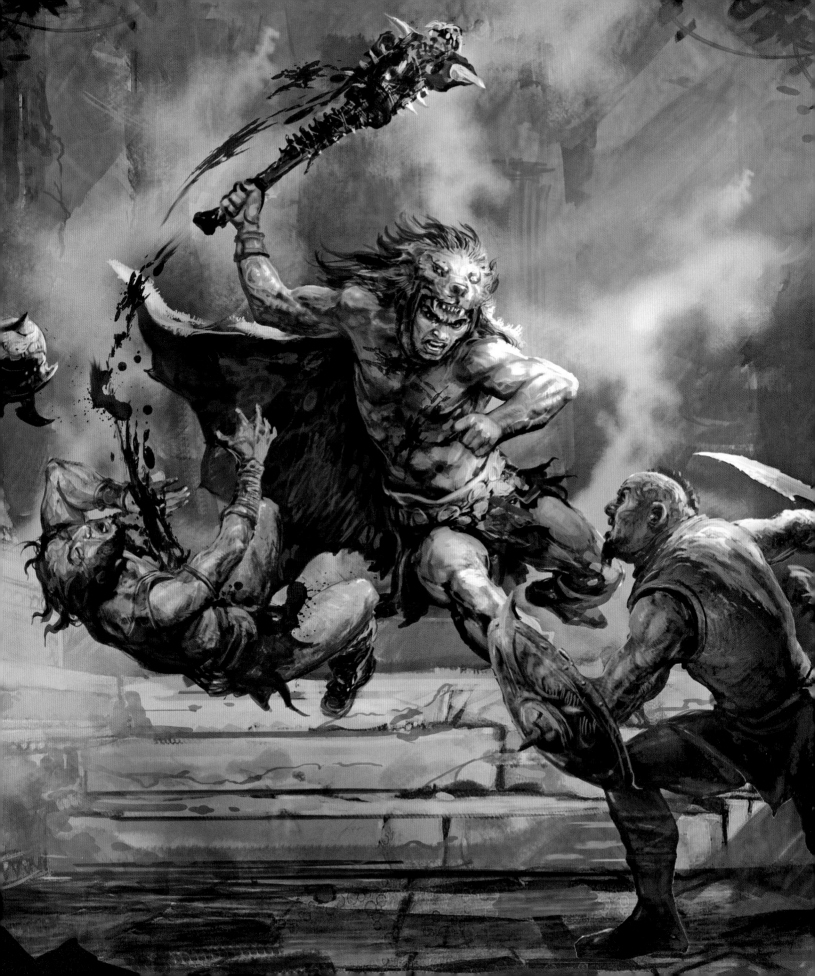

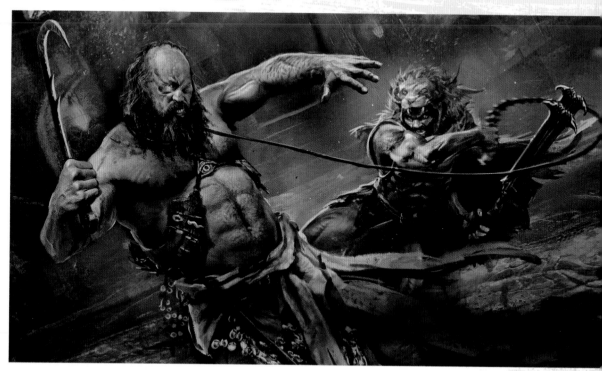

Weta Workshop concept art. LEFT and ABOVE: Hercules
in battle by Gus Hunter. BELOW: Mood concept entitled
"Glory" by Eduardo Peña.

Shooting in Hungary

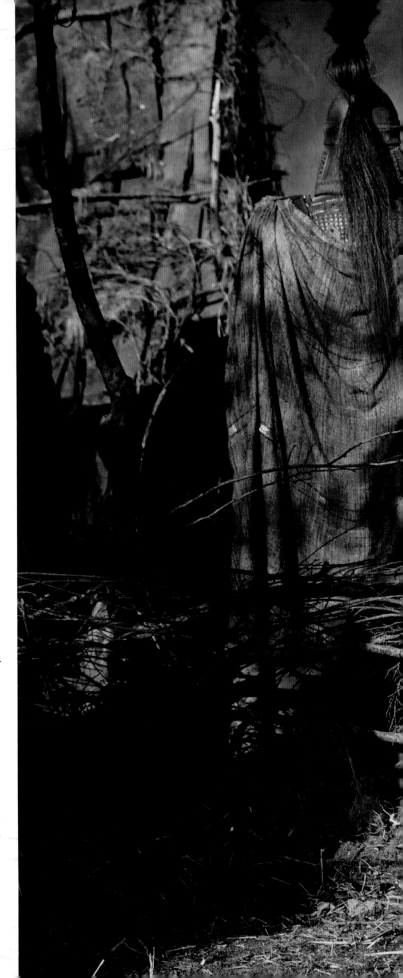

Hercules was shot on location in Hungary, one of the few places in the world where an enormous amount of space was available for both the outdoor locations and the studio work. A giant back lot was created on a farm near Páty, about thirty minutes outside of Budapest. In addition, the production used all seven sound stages and the back lot at the Origio Film Studio in Budapest.

"Brett Ratner was adamant from the beginning that he wanted incredible, epic, memorable sets," explains producer Beau Flynn. "He didn't want this movie to be a green screen film. There are a lot of visual effects in it, but they only augment the in-camera action. We didn't want the audience to feel as if they were seeing just a glossy, slick, visual effects swords and sandals movie. That's been done a lot. We wanted to do something very different, and Hungary had an enormous amount of space for us. I don't know many countries where we could take over that much acreage and completely do whatever we wanted."

The scope of the sets was very important to the director. "We're using practical locations, and constructing enormous sets, which is very different from the way most movies are made these days," says Ratner. "You would have to go back to *Gladiator* or *Braveheart* to see sets as large as these. The Coliseum in *Gladiator* was huge and that's the kind of scope in this film."

RIGHT: Reece Ritchie as Iolaus on the battlefield.

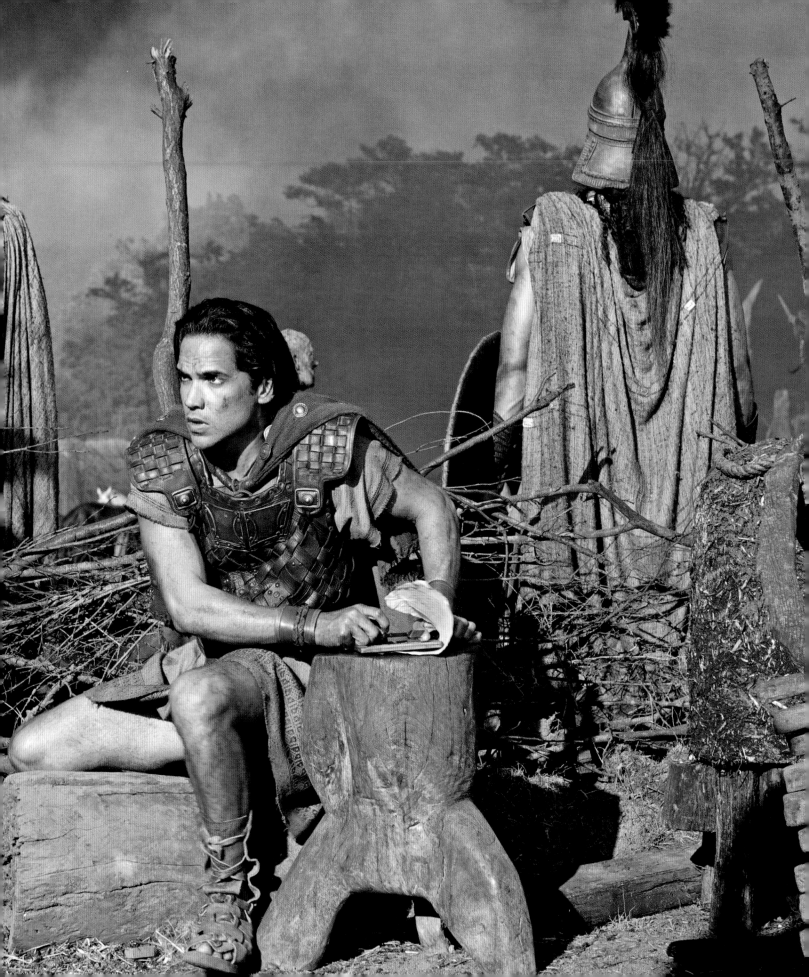

JEAN-VINCENT PUZOS
Production Designer

Though the task of creating the widely varying and generally enormous sets was extremely challenging, the filmmakers were confident that production designer Jean-Vincent Puzos had the extraordinary imagination, exciting ideas, and solid background for such a tremendous undertaking.

"Jean-Vincent and I had been talking about this movie for over a year before I started working on it," explains Ratner. "He came up with the most amazing designs that were based on historical reference, but had a new and fascinating slant. It was his idea to get away from the classic white marble look for most of the sets. The dark, aged, textured look worked so well for our story."

Puzos' work defied the clichéd look used in most movies to replicate ancient Greece. "Our image of Greece is that it was very white, with marble statues and flowery architecture, but in reality that was only one aspect of it," says producer Beau Flynn. "We used a lot of Croatian style rustic backgrounds for the mountains, badlands, and marsh lands."

Puzos was interested in the concept that the movie would be realistic and gritty and that, in this retelling of his story, Hercules was a real man and not a fantasy figure. "It was very exciting to do a period movie where you can try to fit in with the period, but you had the freedom to develop many different ideas," Puzos said. "I felt that it was almost like a Sam Peckinpah western or a David Lean extravaganza."

Prior to becoming involved in motion pictures, Puzos had worked as an architect and landscaper and he used that combination of talents to create a unique style on his sets.

ABOVE: Production designer Jean-Vincent Puzos on the Citadel set.

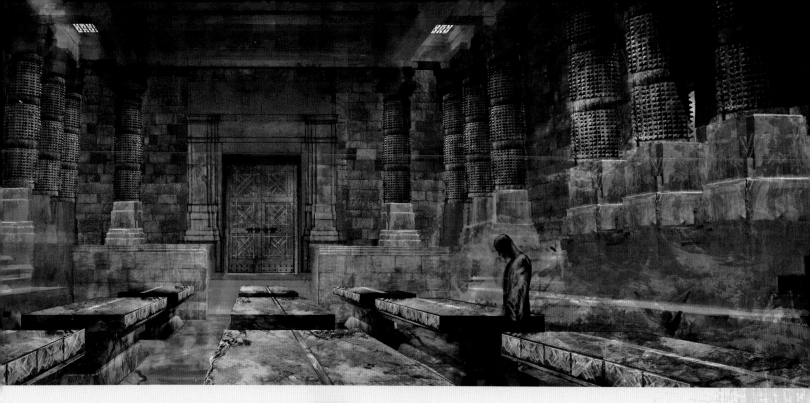

ABOVE: Concept drawing of the feasting hall in the Citadel by Mathilde Abraham. RIGHT: Cotys' Citadel courtyard by Mathilde Abraham. BELOW RIGHT: Concept art, Bessi Barn, by Mathilde Abraham. BELOW: Concept art, Palace of King Eurystheus in Athens, by Marton Voros.

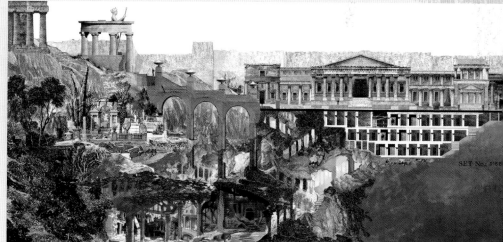

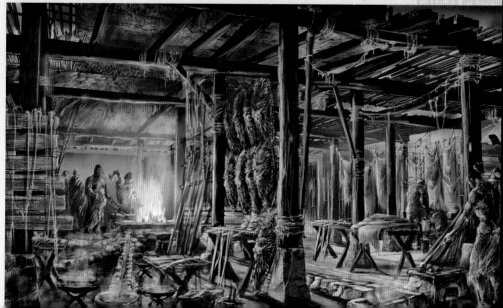

Sets... SHIPYARD

One of the first scenes in the movie takes place in the shipyard where the Corsairs, a band of pirates, have taken Iolaus captive. He is, in fact, hanging from a rope, perilously dangling over a sharp spike.

"The worlds that Jean-Vincent Puzos created—like the shipping yard scene—were entirely unique, but somehow felt authentic for the period. It is a place where ships have gone to die which has become the lair of the Corsairs," states screenwriter Evan Spiliotuopoulos. "Jean-Vincent created these bleached bones of ships that are jutting out of the sand, so it all looks like these giant monsters have literally died, and their skeletons are all that's left. It is a very stark and startling image that opens the movie."

While the weather during the shoot was problematic for the cast and crew, it was ironically beneficial to the design department. "The shipyard was like an organic sculpture that was naturally weathered by the heat and torrential rains on location in Hungary," explains set decorator Tina Jones. "The wood became bleached and the sand settled in around the ribs of the wrecks so they looked as though they had been there for a hundred years."

The ominous atmosphere in the shipyard set the scene for the entire movie and provided a brilliant background for the action in this opening moment when Hercules rescues Iolaus.

BACKGROUND: Concept drawing of the shipyard set by Mathilde Abraham. OPPOSITE: Storyboards by John Mann.

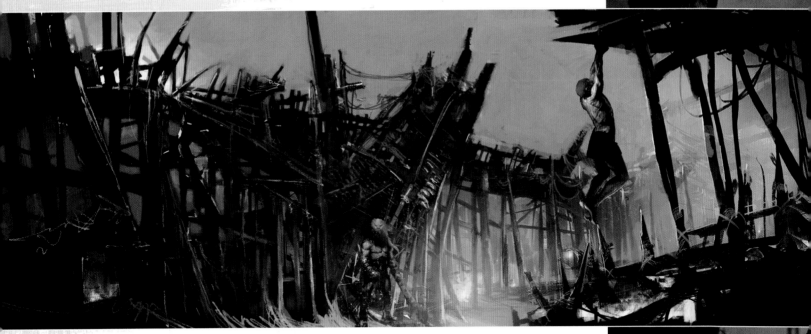

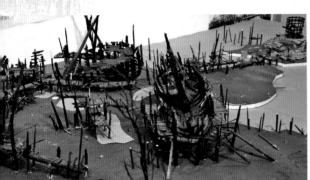

ABOVE: Early concept drawings of the shipyard set by Mathilde Abraham (left) and Renátó Cseh (right). LEFT: Miniature layout model of the set. BELOW: Cinematographer Dante Spinotti, first assistant director J.J. Authors, production designer Jean-Vincent Puzos, and location manager Terry Blyther on the shipyard set location. RIGHT: Corsair pirates Mark Phelan (left) and Christopher Fairbank taunt Reece Ritchie dangling above a spike on the shipyard set.

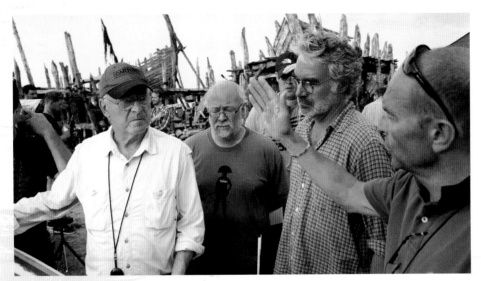

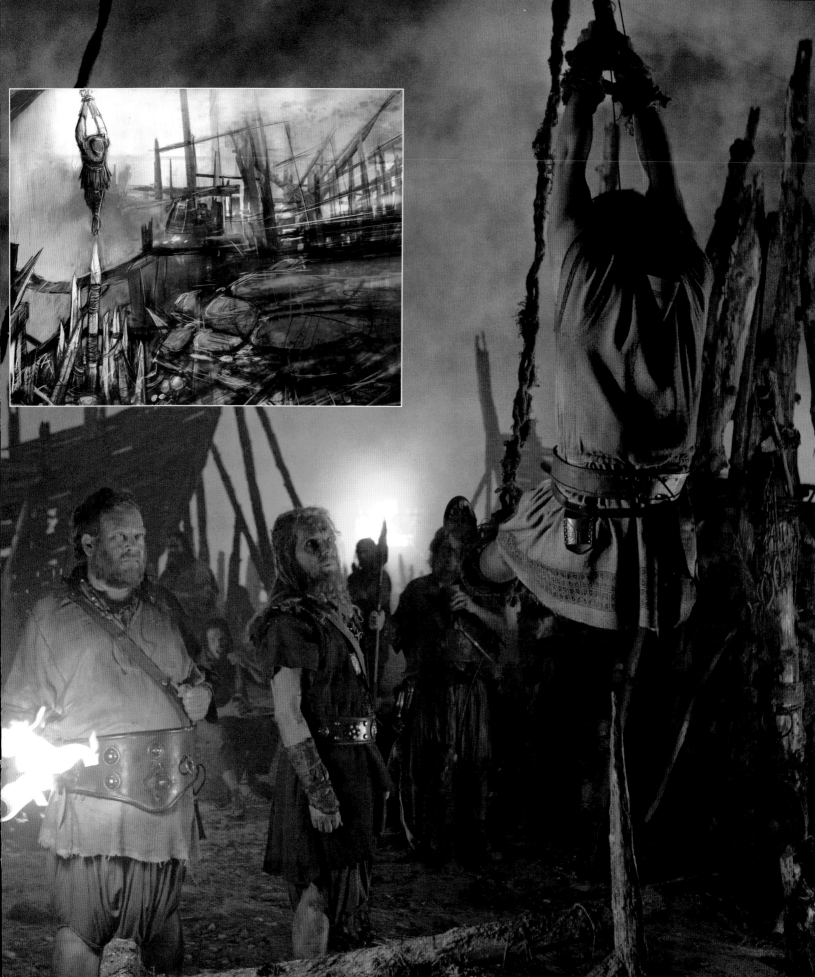

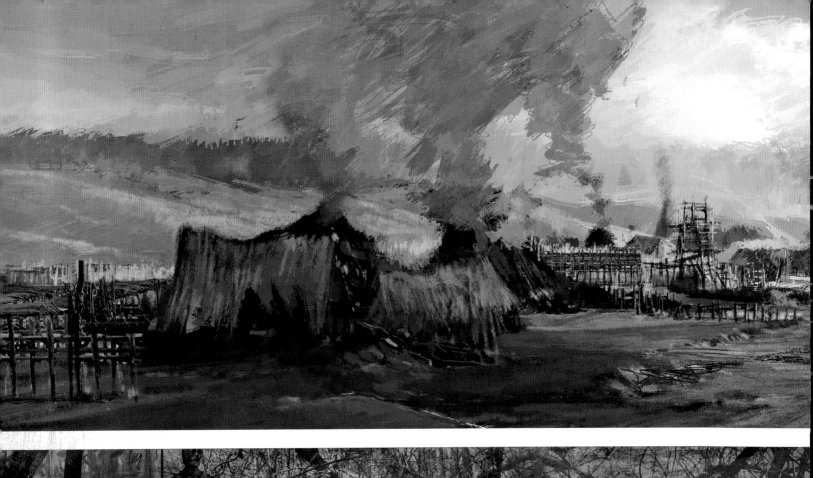

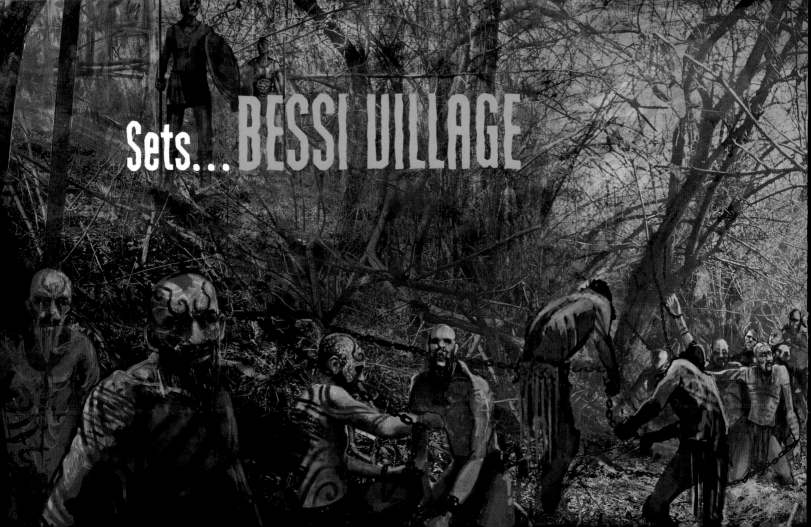

Sets... BESSI VILLAGE

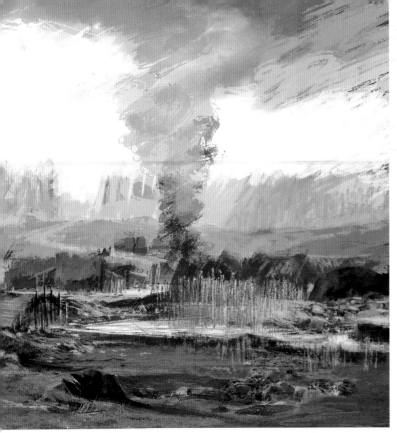

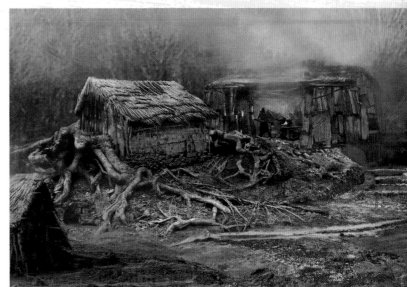

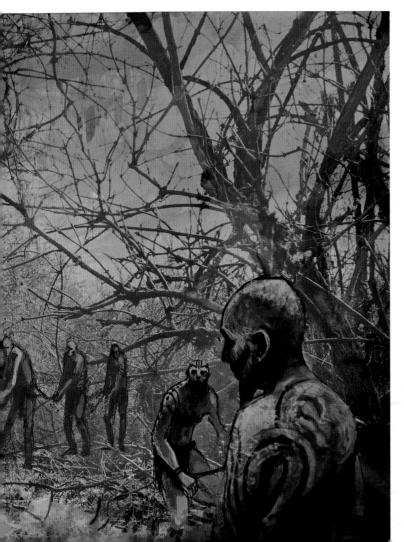

The desolate and brutally desecrated Bessi village was one of Jean-Vincent Puzos' most complex sets. "The mission for me was to take the landscape and blend the design of the village into it so that everything looked real, as though it had been there for decades," explains Jean-Vincent Puzos. "I wanted the first impression to be that you had arrived in a real settlement. I refused to use the normal techniques of set construction."

This meant using nothing but real materials—no painted plywood exteriors, as is done on most film sets. "We built the houses with wood, stone, and mud," explains set decorator Tina Jones. "We never used anything fake. It was very exciting because Jean-Vincent wanted it to be real, gritty, and dirty. He wanted you to be able to almost smell how awful it was." In the end, the sets had the authenticity of an ancient Greek village.

To heighten the reality of the village, Puzos insisted on dressing both the interior and exterior of the sets,

Early concept drawings from Jean-Vincent Puzos' production department depicting the Bessi village set. Art by Mathilde Abraham.

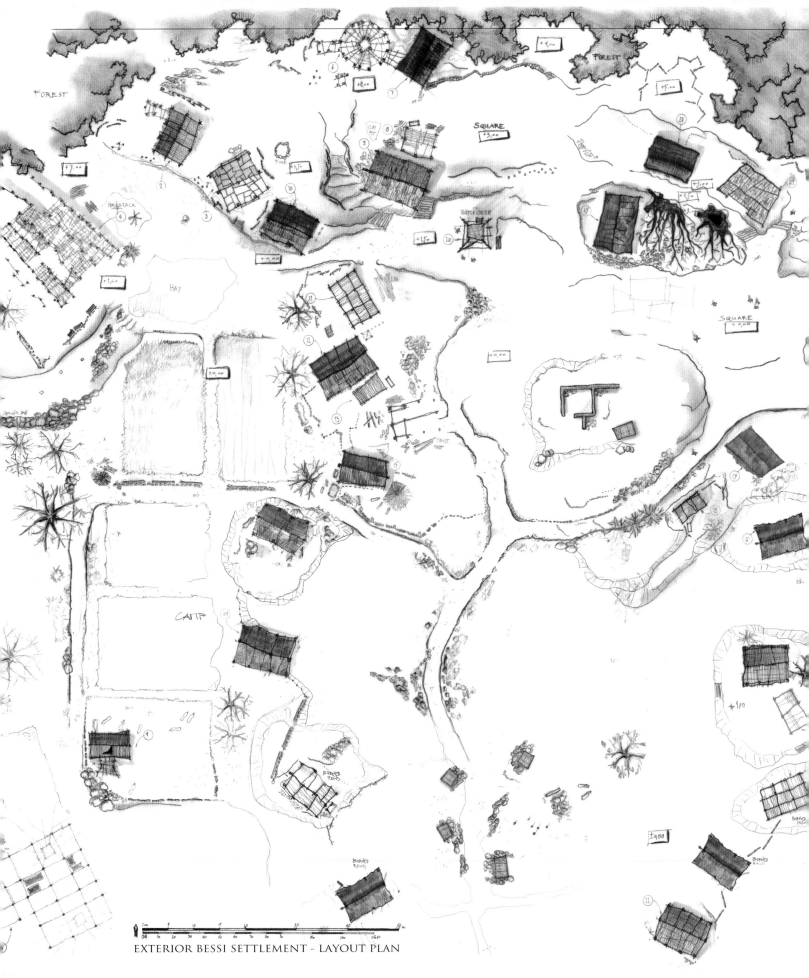

EXTERIOR BESSI SETTLEMENT - LAYOUT PLAN

"To prepare for the movie, I spent many weeks in
Paris at the Louvre. I looked at many different
books and engravings from the 19th century.
I examined the primitive architectural styles in
stone and wood. The Bessi village is based on
really historically accurate farming villages."

—JEAN-VINCENT PUZOS, PRODUCTION DESIGNER

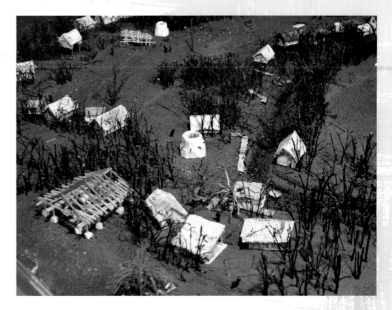

even though a lot of the work would never be seen on camera. "You could go into any of the buildings and shoot—even though that was never part of the brief," Jones emphasizes. "We had to manufacture many of the props and the rest we got mostly from India where we could get very basic cooking implements such as metal and stone cooking pots."

The design was based on a historically accurate farming village that housed a warrior people. "It's a little primitive," explains Puzos, "but nonetheless there are forges where they worked with bronze and other metals. The influence of the warrior's appearance helped develop the look of the village. The warriors were wild, and fierce, covered in green paint and tattooed, so I used that organic look to create their habitat."

As luck would have it, the harsh weather conditions were perfect for aging the sets, even if they made shooting more difficult. "No matter how much you plan and design," states Puzos, "you also need to have luck and for me that meant getting the right weather conditions. In order for the set to look realistic, it needed natural aging. Just prior to shooting we had an incredible rainstorm that flooded the sets and caused an incredible movement of the soil so the buildings settled in as if they'd been there for many years. The rain was followed by a heat wave and

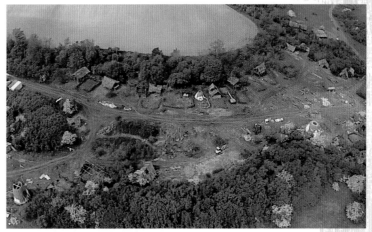

LEFT: Exterior set plan of the entire Bessi settlement.
ABOVE: Scale model of the Bessi set. MIDDLE: Aerial shots
taken by Neil Corbould of the Bessi village set construction in
Hungary. RIGHT: Detail of the finished Bessi village set.

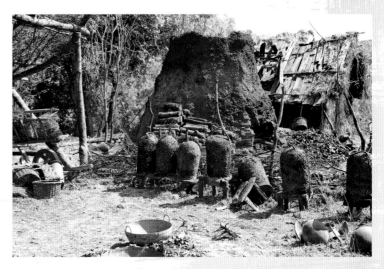

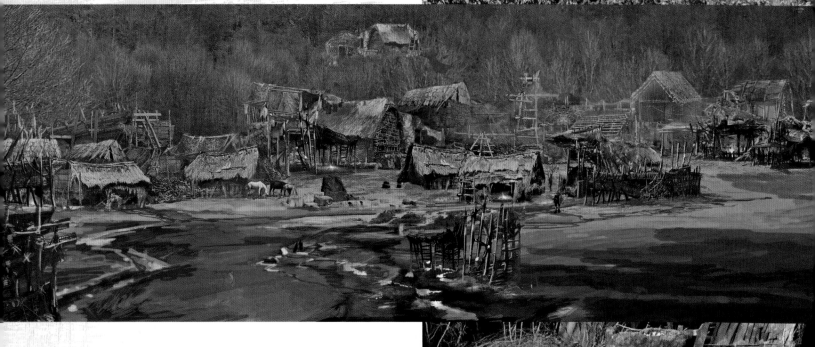

the sun beat down, bleaching everything tens times faster than would normally be possible."

So instead of artificially aging with paint, Puzos used nature's patina and just threw on more mud and leaves. "The effect was amazing," he says. "The rain also spurred the growth of the natural vegetation so it grew up and around the timbers and the buildings became one with their surroundings."

For Puzos, this first location was important because it set the tone for the rest of the production. "When the cast and crew arrived I wanted them to believe that this was a real village," he explains. "Look inside the huts and you see you can sleep inside them. There was a well to provide water. Wheat fields and trees surrounded the settlement. Everyone immediately understood that we were making a gritty movie where nothing was fake. When they picked up their props, they were real, which I think was enormously helpful for the actors."

ABOVE: Early concept drawing of the Bessi village by Mathilde Abraham. RIGHT: The actual set in Hungary.

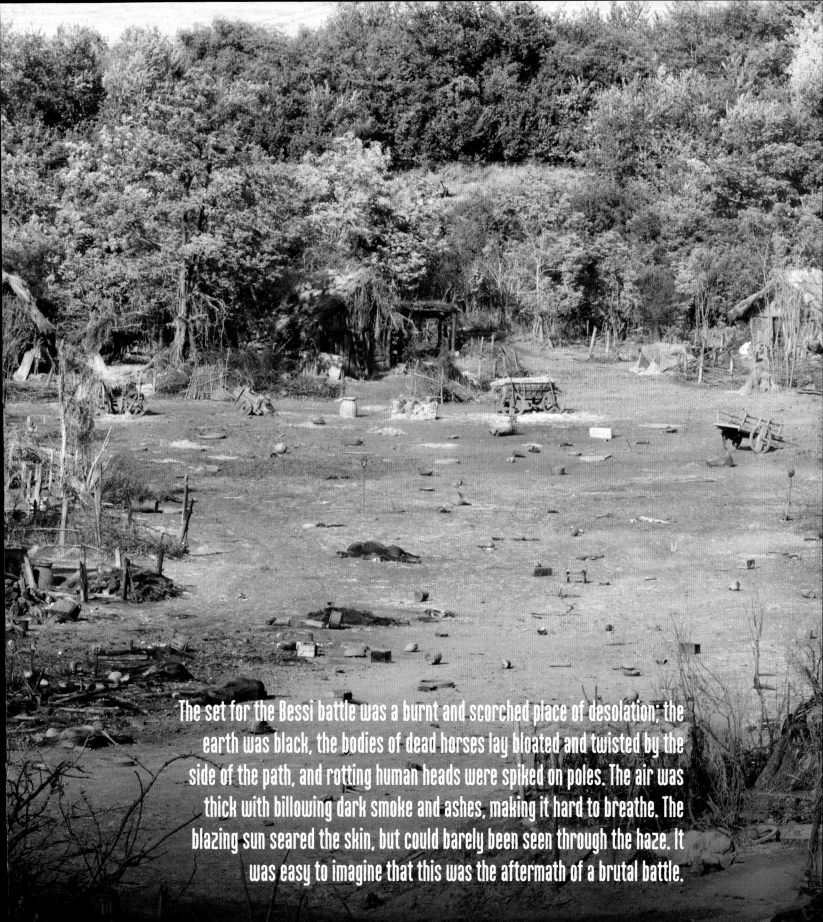

The set for the Bessi battle was a burnt and scorched place of desolation; the earth was black, the bodies of dead horses lay bloated and twisted by the side of the path, and rotting human heads were spiked on poles. The air was thick with billowing dark smoke and ashes, making it hard to breathe. The blazing sun seared the skin, but could barely been seen through the haze. It was easy to imagine that this was the aftermath of a brutal battle.

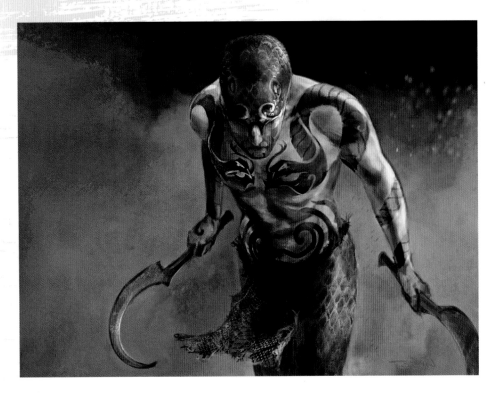

TATTOOED WARRIORS

"The scriptwriter came up with the idea of the tattoos on the warriors. We wanted to make sure that the design of the tattoos was connected to nature and be in some form of an animal. The simplest idea was the snake. We played with many different colors. At first we settled on blue but then went with green. The people are painted and tattooed; they're covered in color for this very primitive look."

—JEAN-VINCENT PUZOS, PRODUCTION DESIGNER

ABOVE and RIGHT: Concept paintings for the Bessi tattoos by Weta Workshop artist Paul Tobin. BELOW: Various ideas for the look of the Bessi warriors exploring different tattoos and skin coloring created by Weta Workshop artist Ben Mauro. The final makeup can be seen on page 66.

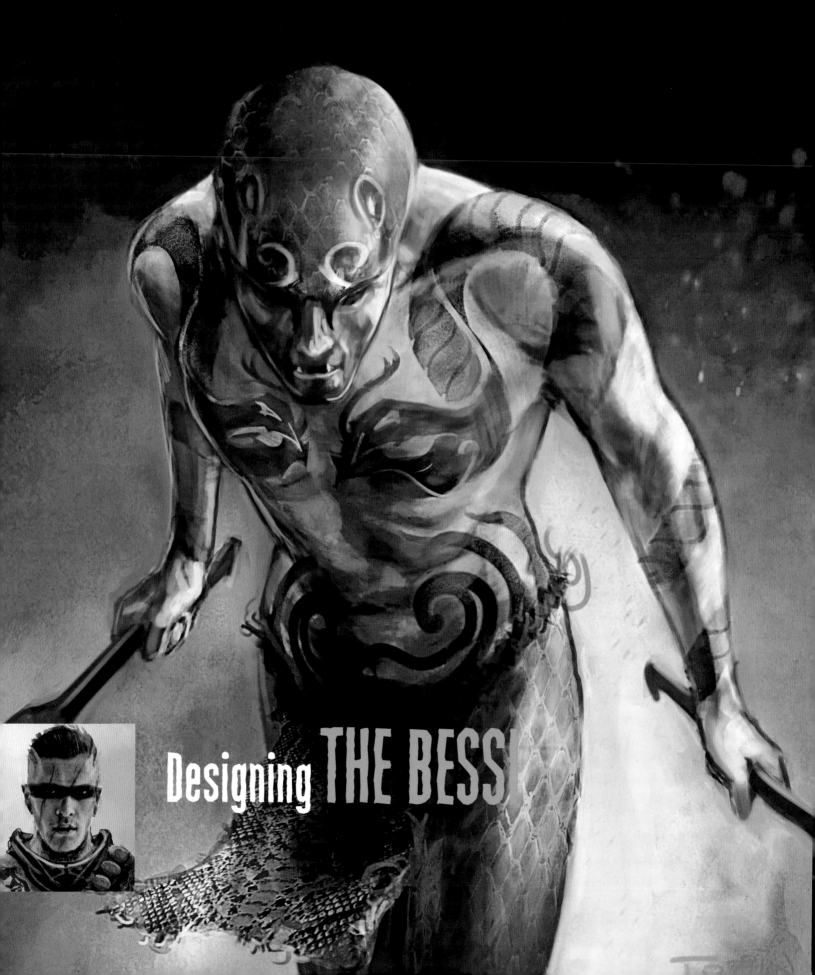

Designing THE BESS

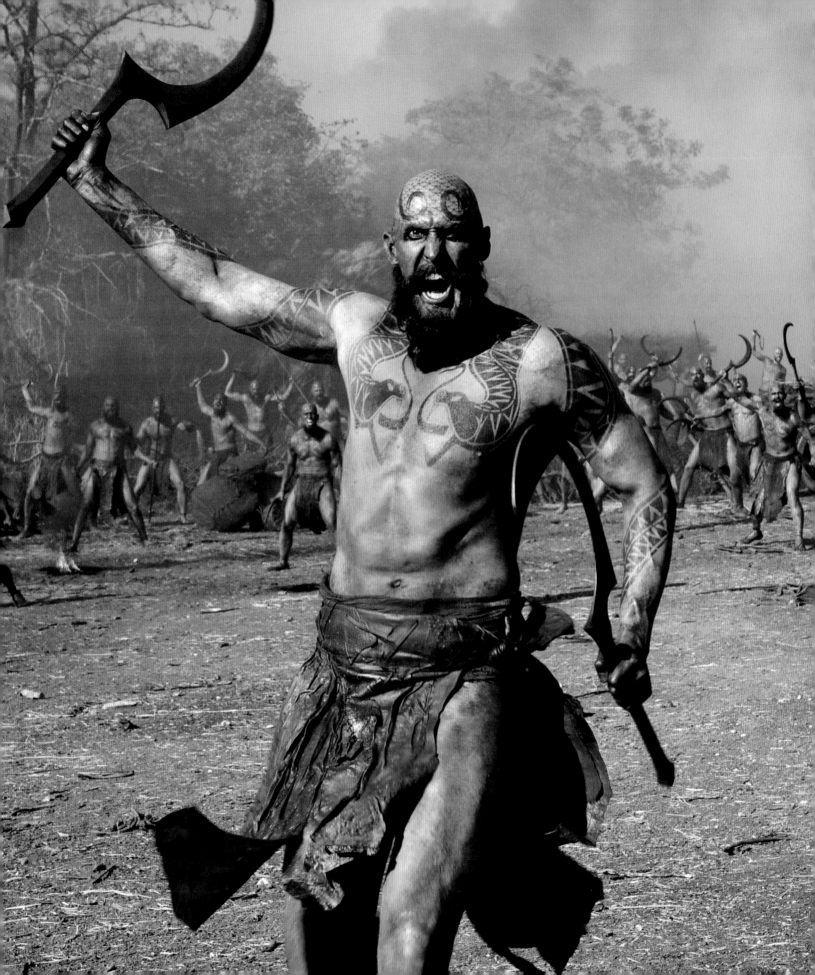

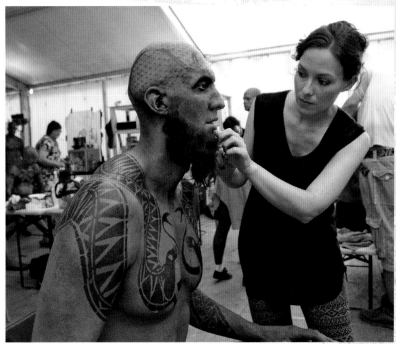

THE EXTRAS

In order to accommodate the 500-600 extras a day, the production built what was basically studio facilities under canvas to house the makeup, hair, and wardrobe departments. Enormous tents linked by wooden walkways were filled with rack upon rack of army uniforms, helmets, and shields. From the early morning hours these tents echoed with chatter as droves of hair, makeup, and wardrobe people worked on long lines of extras going through the works. Huge parking lots were set up for both the crew and the extras. Moving onto base camp, another giant tent with floorboards served to feed up to a thousand people a day.

In the Bessi tent, the extras had their heads shaved and then were spray painted green. They sat patiently as tattoos were meticulously applied one piece at a time. The final touches were the facial hair that had to be glued on piece by piece and then it was off to collect their loin cloths.

One of the Bessi extras had a strange experience. He fell asleep hidden behind a tent. When he woke up the entire cast and crew had long gone. The location was in the middle of the countryside with no public transportation. Unfortunately, he decided not to get out of his makeup and wardrobe before attempting to walk home. A ferocious looking bald-headed green man covered in tattoos wearing only a loincloth caused quite a stir in the local village.

OPPOSITE: Ian White as a fierce Bessi warrior.
ABOVE LEFT: Makeshift wardrobe room on location in Hungary.
ABOVE RIGHT: Many makeup artists were employed to apply the intricate Bessi makeup.

Hero Weapons

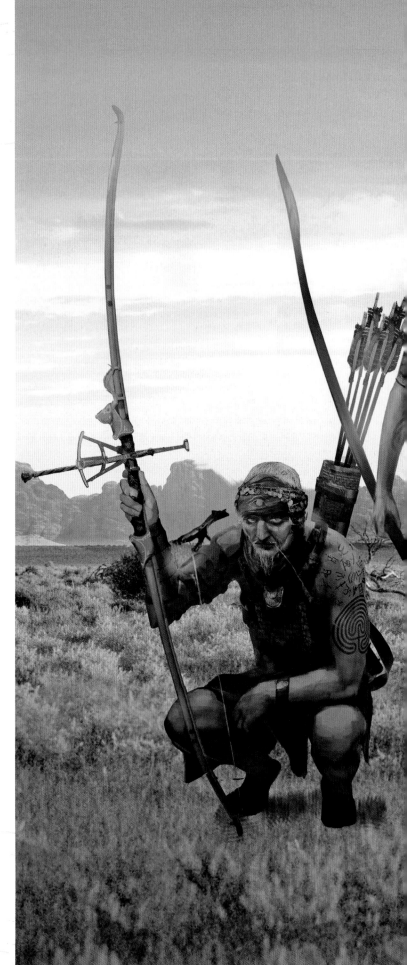

I n addition to the character concepts, many of the original designs for the weapons were created at the Weta Workshop in Wellington, New Zealand.

The Weta drawings for *Hercules* were shown to the filmmakers for approval and concept models were created. Between the active imaginations of Brett Ratner and production designer Jean-Vincent Puzos, the development of the weaponry was a constantly evolving process that took about three months.

Weapons for the principal actors were fabricated at the workshop in England, and weapons for the background artists were made in Hungary. The department included approximately twenty sculptors, model makers, painters, designers, and workshop managers.

Part of their directive was to make a unique weapon for Hercules and each member of his band of mercenaries. Weapons were designed to reflect the individual personalities and styles of each character.

An early concept drawing of the mercenaries and their weapons
from the Weta Workshop. Artist: Aaron Beck.

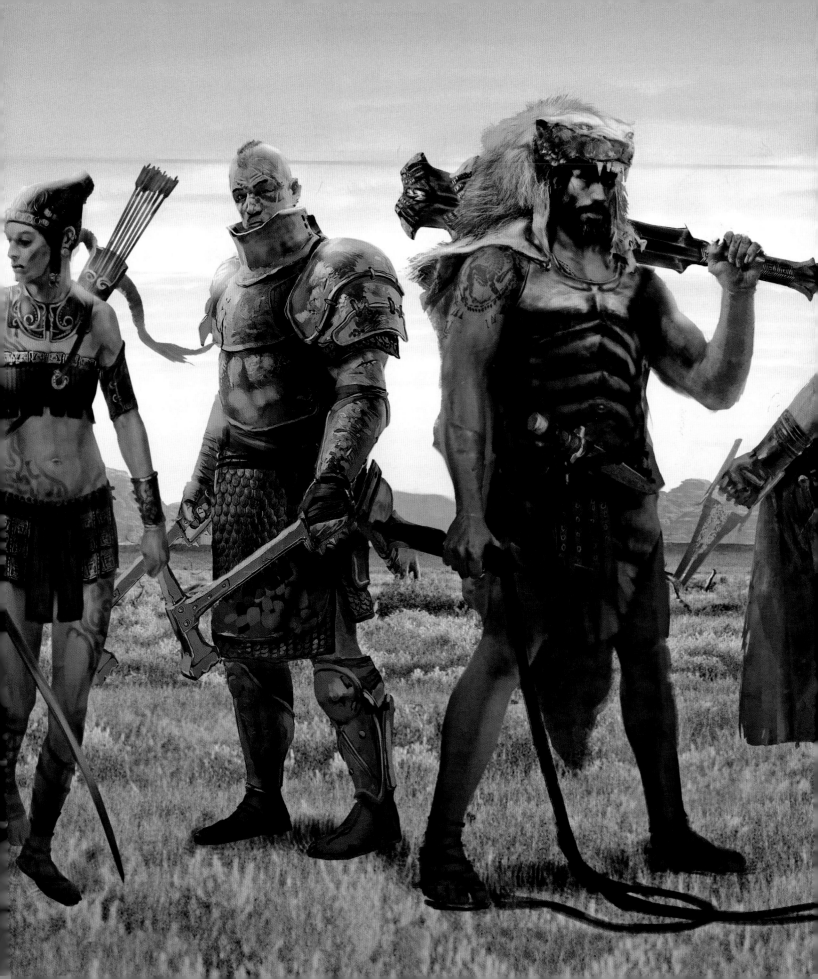

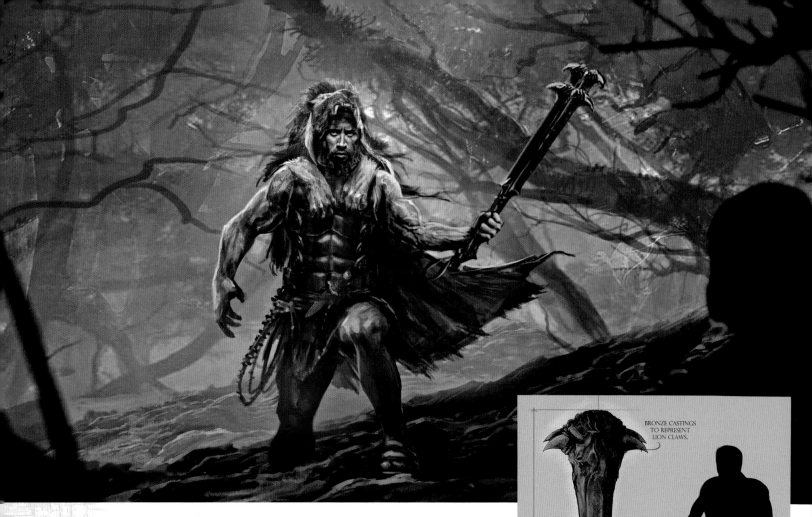

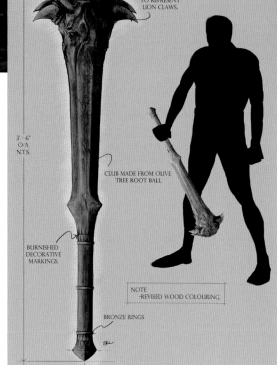

HERCULES: THE CLUB

Hercules carries a club, carved from an olive branch. At the beginning of the film, his club is quite plain, but as he completes his Twelve Labors the style and design of the club changes. After he kills the Nemean lion with his bare hands, for example, he adds the teeth of the lion and takes on the emblem of a lion's head. He also wears a lion's head as part of his outfit.

To kill the Hydra, Hercules uses a massive sword to cut off the three heads.

BRONZE CASTINGS
TO REPRESENT
LION CLAWS.

3'- 6"
O/A
N.T.S.

CLUB MADE FROM OLIVE
TREE ROOT BALL.

BURNISHED
DECORATIVE
MARKINGS.

NOTE
-REVISED WOOD COLOURING

BRONZE RINGS

Much thought was given to designing a club for Hercules. TOP: Concept art by Weta Workshop concept artist Gus Hunter. ABOVE: Concept drawings by Sam Leake from designs by Simon Atherton. LEFT: Movie still of the actual club used by Dwayne Johnson during the battle scene. OPPOSITE: Club concepts drawing from Weta Workshop artist Frank Victoria.

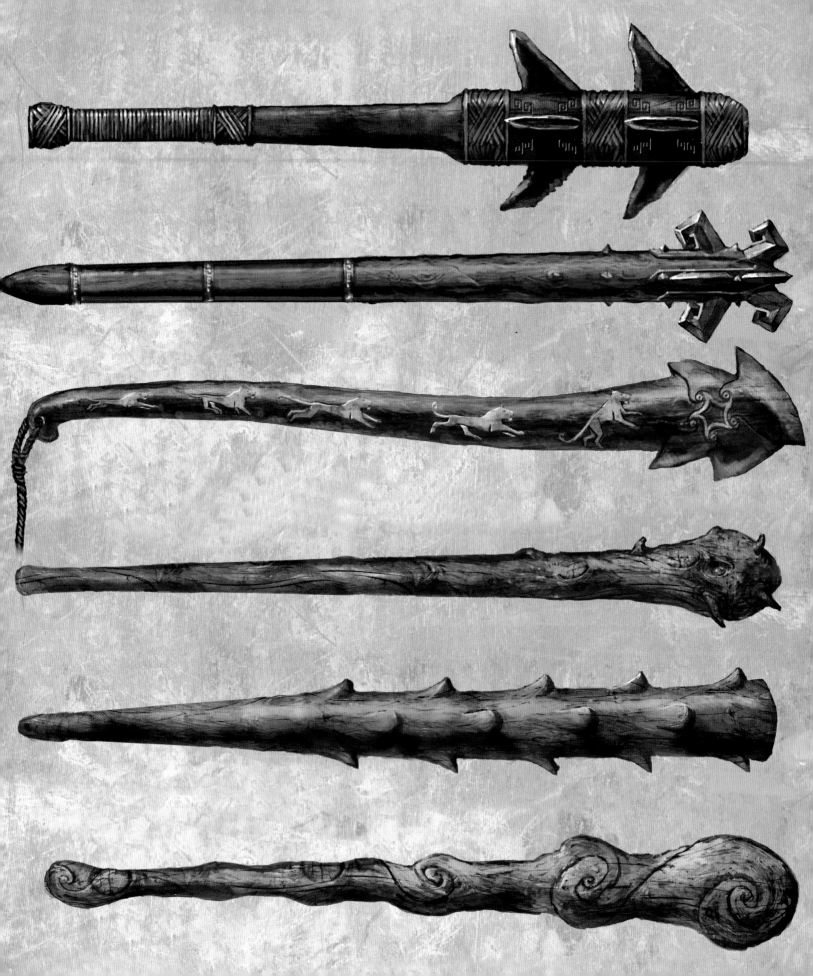

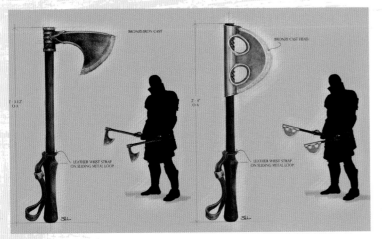

TYDEUS: AXES

Tydeus carries two axes on his belt. "We came up with a way that the axes could be attached to his belt so he could pull them off easily and attack," explains fight coordinator Allan Poppleton. "His character is meant to be a kind of 'beserker' so he uses the axes in a chopping and thrashing motion."

Aksel Hennie, who plays Tydeus, insisted on wearing the axes almost constantly when he was on set, even when he was not being filmed. Although he was given a rubber set of axes, he only wanted to use the actual weapons. "We tried to get Aksel to at least use the rubber axes during the fight," says supervising armorer Tim Wildgoose, "but he loved the metal ones." The metal axes also proved hazardous. "In the heat we were experiencing, they become so hot they would burn you if they touched your skin," adds Wildgoose.

ABOVE LEFT: Concept drawings by Sam Leake from designs by Simon Atherton. ABOVE RIGHT and RIGHT: Concept drawings of Tydeus and the axes he uses in battle from Weta Workshop, art by Christian Pearce. Of all the mercenaries, Tydeus changed the most from concept to casting. Originally conceived as a brute giant, almost as large as Hercules, he was eventually cast as small and almost feral. LEFT: Askel Hennie. FOLLOWING PAGES: Askel Hennie and Ingrid Bolsø Berdal in the battle scene.

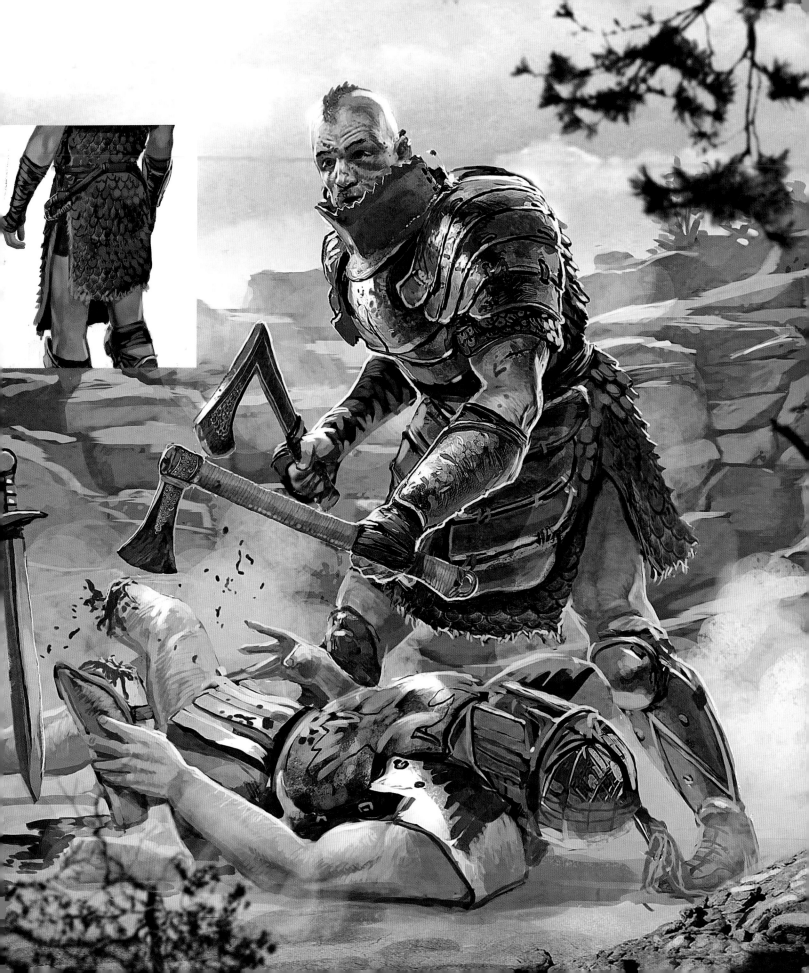

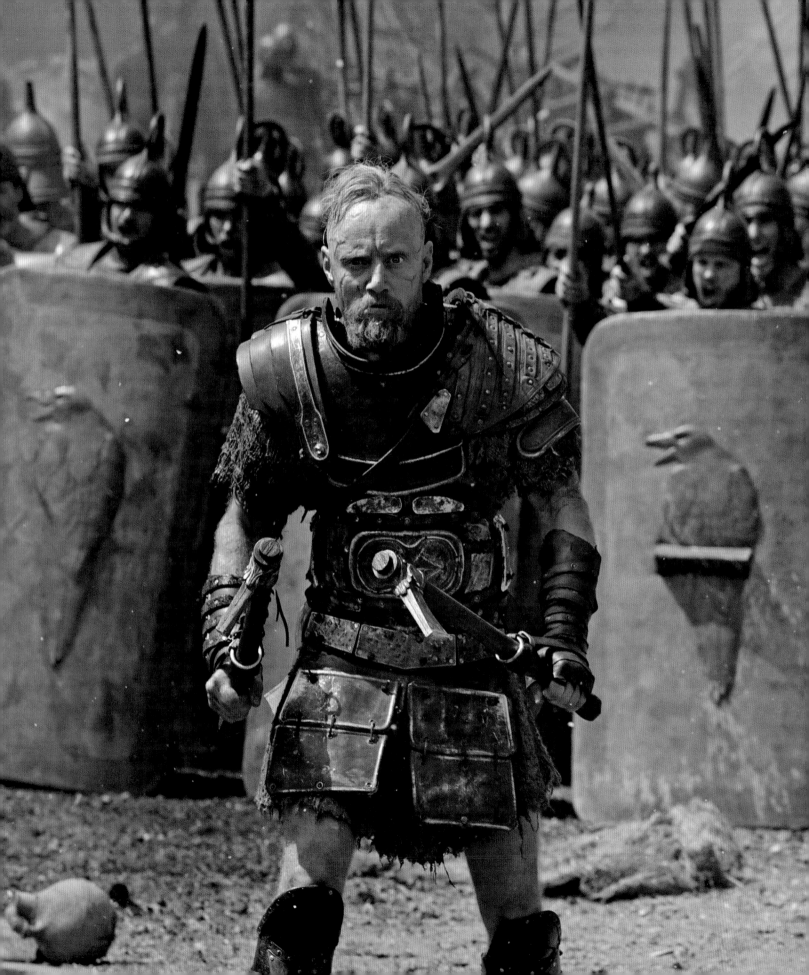

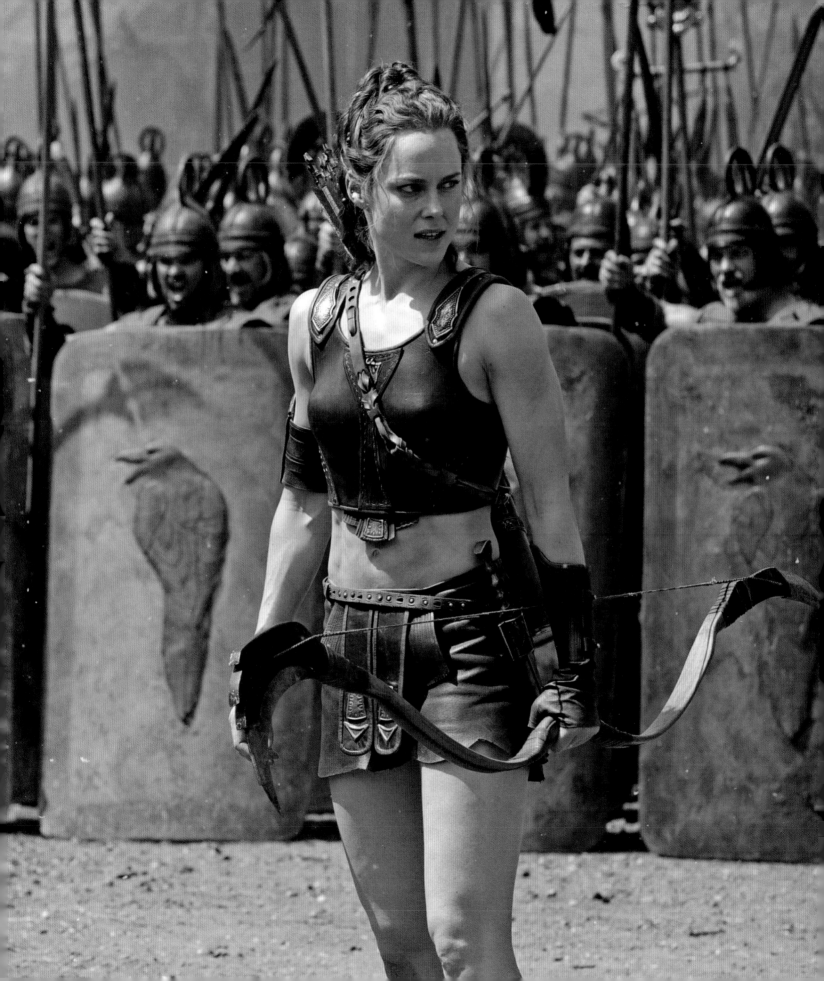

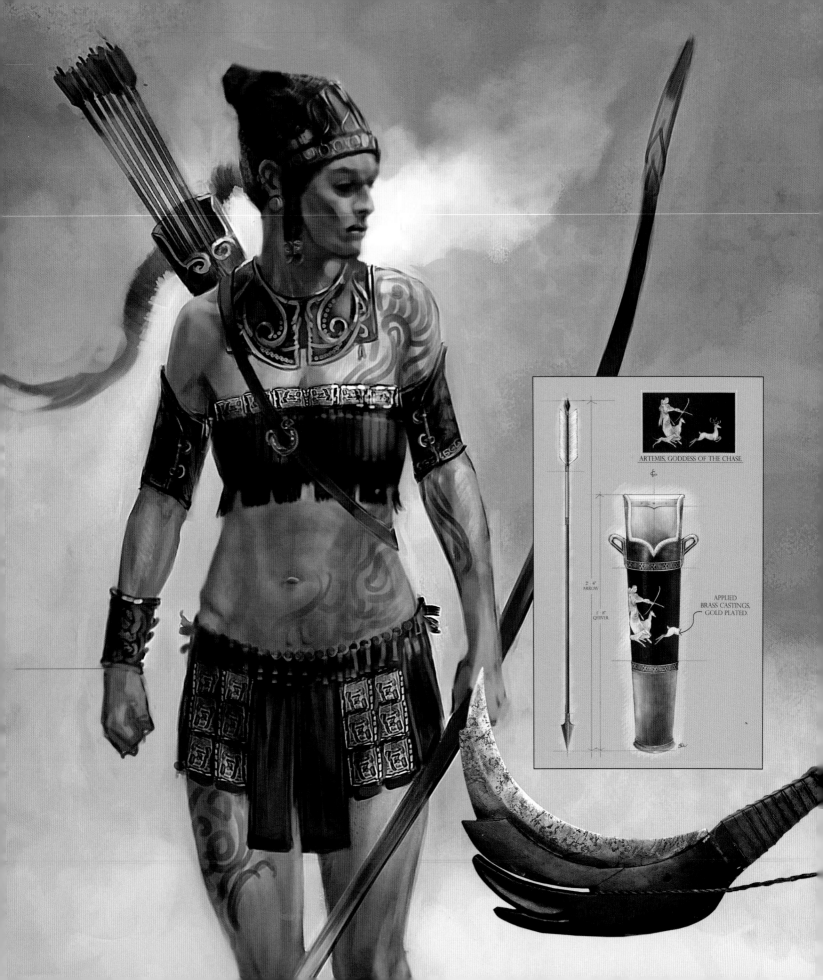

ARTEMIS, GODDESS OF THE CHASE.

2"- 4"
ARROW

1'- 8"
QUIVER.

APPLIED
BRASS CASTINGS,
GOLD PLATED.

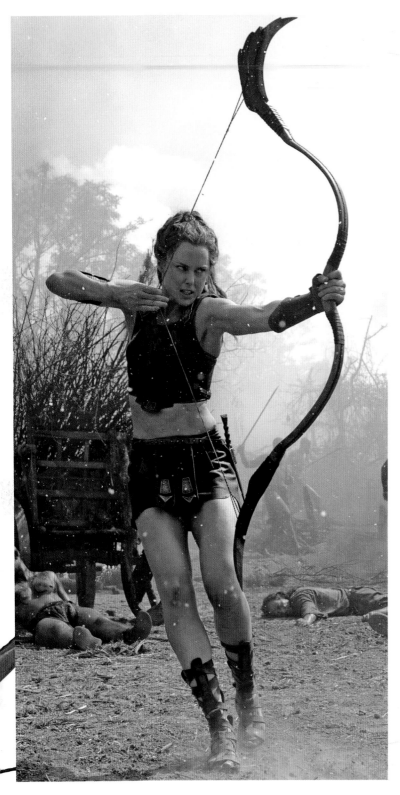

ATALANTA: BOW

Atalanta's weapon of choice is the bow and arrow and she has mastered the art of the weapon better than anyone else. The director wanted her bow to have blades on each end so she could do some acrobatic fighting and take out opponents with blades instead of just firing arrows.

"We had a metal version of her arrows, but that barely came out of the bag," says Tim Wildgoose. "It would be very dangerous to use on set. Whenever she fought we used the arrows with the soft ends. We did the same thing for the quiver." To protect the actress while she was performing her acrobatic stunts, the weaponry department created soft foam quivers so that she could safely roll on the ground. She also had foam arrows that wouldn't hit her in the head when she was doing somersaults.

"Atalanta's chariot was also equipped with various arrows, and she had two mini-crossbows," says Wildgoose. "These were based on the huge crossbow that the Greeks used to use. We created a miniaturized version."

Ingrid Bolsø Berdal spent months training with archery expert Steve Ralphs, better known as "the bow and arrow man." He taught her all the different stances and ways of firing an arrow, giving Ingrid a really good understanding of how a trained archer would use a bow.

OPPOSITE: Concept drawing of Atalanta by Weta Workshop artist Paul Tobin. Insets: Concept drawing by Sam Leake from designs by Simon Atherton of Atalanta's arrow and quiver. Detail of the final bow prop. LEFT: Berdal became an expert archer for the role of Atalanta. ABOVE: Atalanta's mini-crossbow prop.

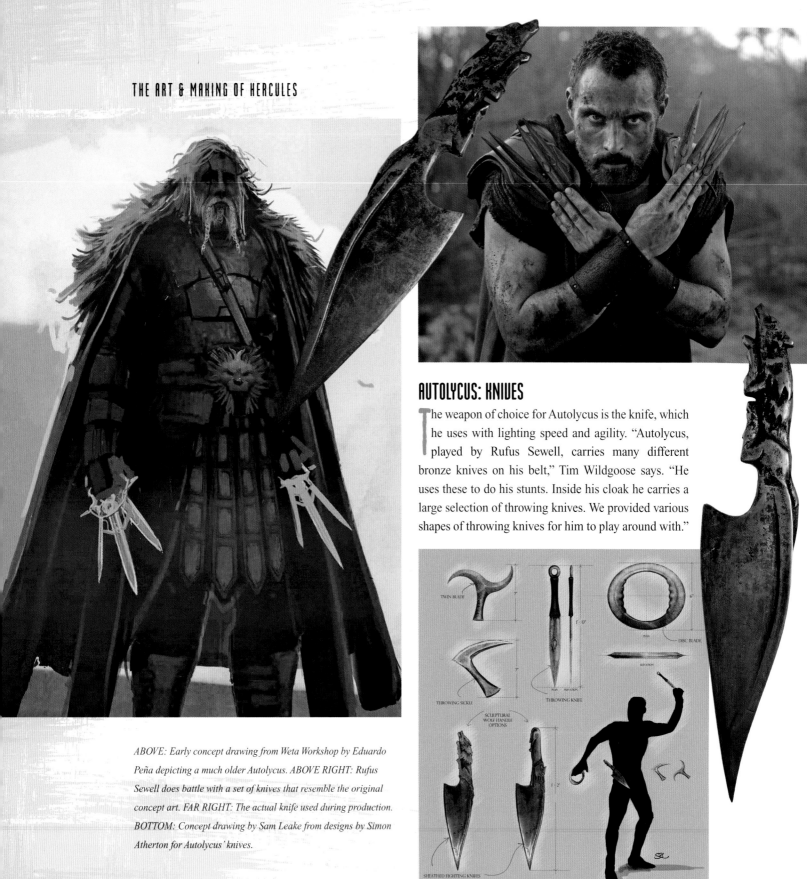

AUTOLYCUS: KNIVES

The weapon of choice for Autolycus is the knife, which he uses with lighting speed and agility. "Autolycus, played by Rufus Sewell, carries many different bronze knives on his belt," Tim Wildgoose says. "He uses these to do his stunts. Inside his cloak he carries a large selection of throwing knives. We provided various shapes of throwing knives for him to play around with."

ABOVE: Early concept drawing from Weta Workshop by Eduardo Peña depicting a much older Autolycus. ABOVE RIGHT: Rufus Sewell does battle with a set of knives that resemble the original concept art. FAR RIGHT: The actual knife used during production. BOTTOM: Concept drawing by Sam Leake from designs by Simon Atherton for Autolycus' knives.

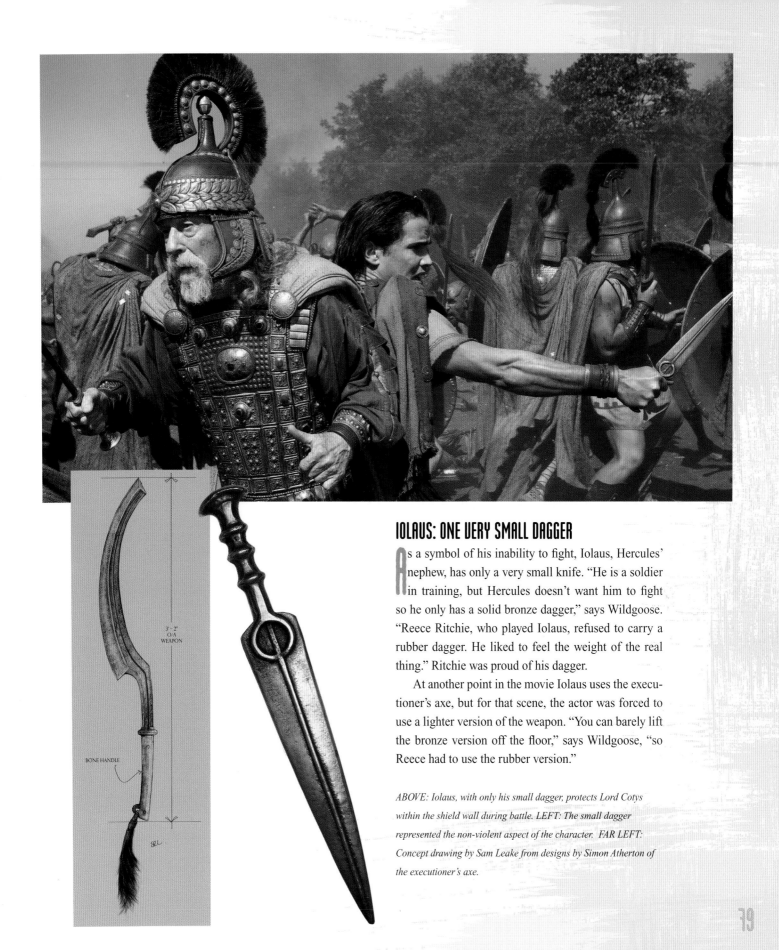

IOLAUS: ONE VERY SMALL DAGGER

As a symbol of his inability to fight, Iolaus, Hercules' nephew, has only a very small knife. "He is a soldier in training, but Hercules doesn't want him to fight so he only has a solid bronze dagger," says Wildgoose. "Reece Ritchie, who played Iolaus, refused to carry a rubber dagger. He liked to feel the weight of the real thing." Ritchie was proud of his dagger.

At another point in the movie Iolaus uses the executioner's axe, but for that scene, the actor was forced to use a lighter version of the weapon. "You can barely lift the bronze version off the floor," says Wildgoose, "so Reece had to use the rubber version."

ABOVE: Iolaus, with only his small dagger, protects Lord Cotys within the shield wall during battle. LEFT: The small dagger represented the non-violent aspect of the character. FAR LEFT: Concept drawing by Sam Leake from designs by Simon Atherton of the executioner's axe.

3' - 2"
O/A
WEAPON

BONE HANDLE

AMPHIARIUS' WHIP

HERCULES' WHIP

ATALANTA'S WHIP

AUTOLYCUS' WHIP

COTYS' WHIP

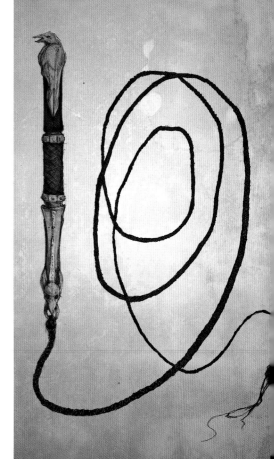

WHIPS

Whips are used throughout the movie and many different styles were created. The most distinctive has to be the one used by Sitacles, the heartless and brutal enforcer for Lord Cotys. The story behind this whip is that at the end of each battle, Sitacles collects a single vertebrae from the backbone of those he slaughtered. He then strings the bones together into this vicious and diabolical whip that he uses freely and frequently.

THIS PAGE: Concept art for the various styles of whips used by different warriors in the battle scenes by Renátó Cseh. OPPOSITE PAGE: The terrifying vertebrae whip belonging to Sitacles symbolized his sadistic nature.
TOP: Using the whip during battle. BELOW: Prop maker Tamas Fuchs attends to the bone whip, which had to be repaired quite often.

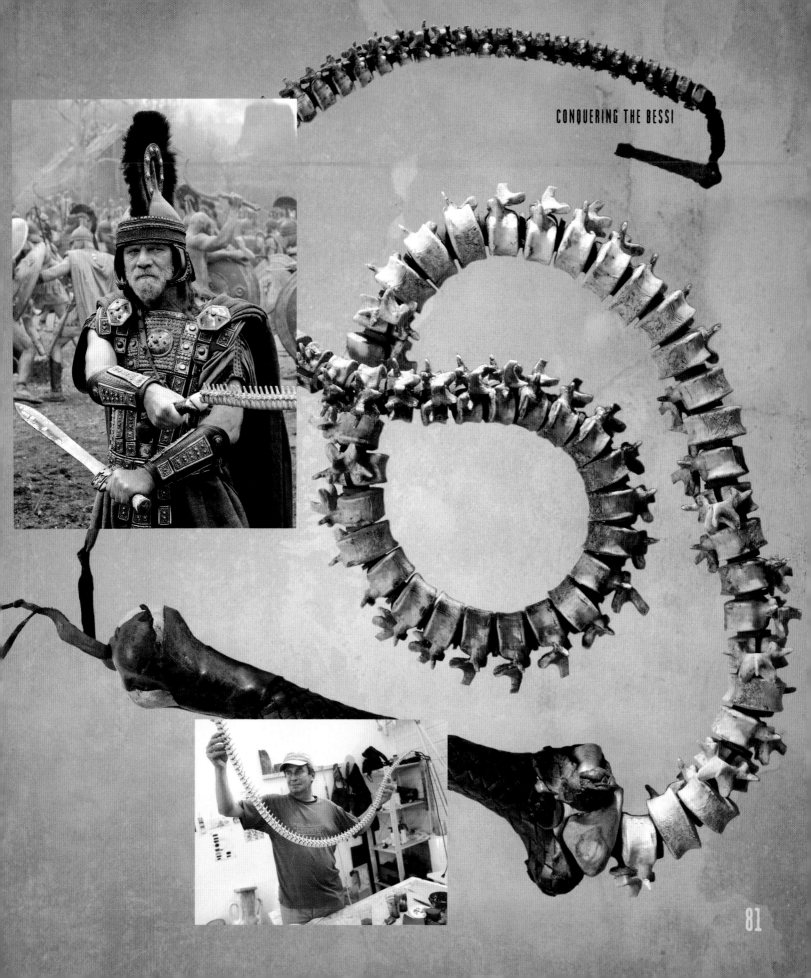

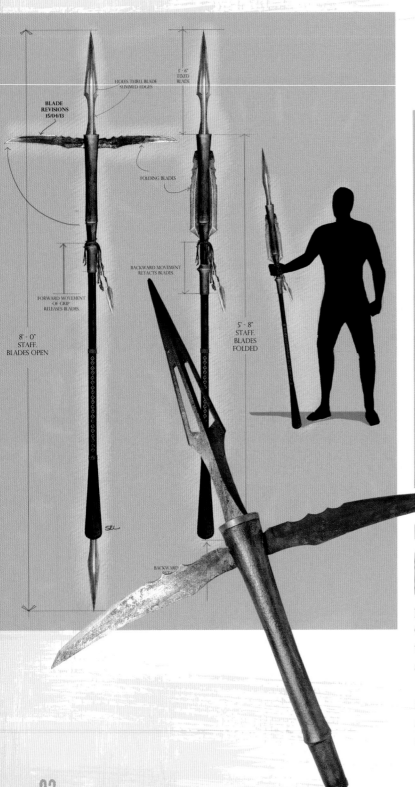

BLADE
REVISIONS
15/04/13

HOLES THRU BLADE
SLIMMED EDGES

1'-6"
FIXED
BLADE

FOLDING BLADES

BACKWARD MOVEMENT
RETRACTS BLADES

FORWARD MOVEMENT
OF GRIP
RELEASES BLADES.

8'-0"
STAFF,
BLADES OPEN

5'-8"
STAFF,
BLADES
FOLDED

BACKWARD

SITACLES: SWORD

Sitacles (Peter Mullan) carries an elaborate sword which was based on an ancient Greek design.

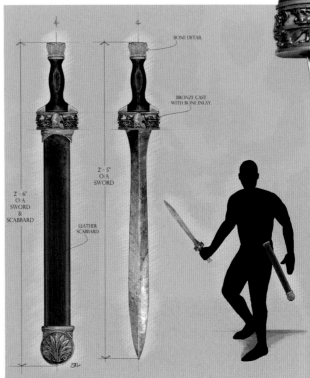

BONE DETAIL

BRONZE CAST
WITH BONE INLAY.

2'-5"
O/A
SWORD

2'-6"
O/A
SWORD
& SCABBARD

LEATHER
SCABBARD

AMPHIARAUS: THE STAFF

Amphiaraus, the seer, carries a staff, which at first appears like a tall walking stick but can also be deadly. "We had a version where the blades open out as a surprise," reveals Tim Wildgoose. "The blades on the side open and when he twists it, a blade shoots out of the bottom. We have a metal version that is used for close-up and a soft bendy fighting version for the fight sequences."

THIS PAGE: Concept drawings by Sam Leake from designs by Simon Atherton of the swords used by Sitacles and the staff carried by Amphiaraus, compared with the final prop.

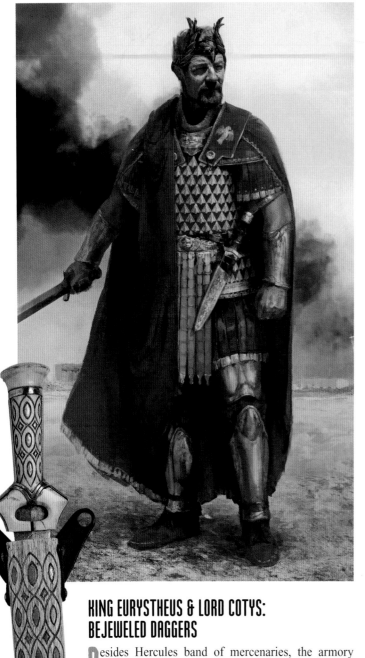

RHESUS & PHINEUS: LONG SWORDS

The two leaders of the Bessi tribes both carry long swords. They were designed to be used on horseback so that the warriors can hold their horse with one hand and attack the enemy with the sword in the other hand.

RIGHT: Final long sword props from the film.

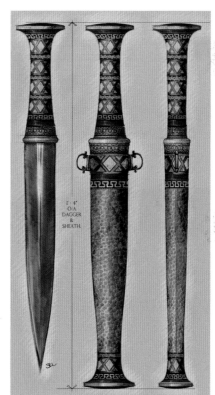

KING EURYSTHEUS & LORD COTYS: BEJEWELED DAGGERS

Besides Hercules band of mercenaries, the armory department had to design and manufacture weapons for other principal cast members. King Eurystheus (Joseph Fiennes) had an elegant dagger suitable for his station as King that was designed to match the rest of his costume. Lord Cotys (John Hurt) had a beautiful dagger with a jeweled scabbard.

ABOVE LEFT: Concept drawing of Cotys by Weta Workshop artist Long Ouyang.
ABOVE: Concept drawings by Sam Leake from designs by Simon Atherton for Cotys' dagger.
LEFT: King Eurystheus' dagger prop.

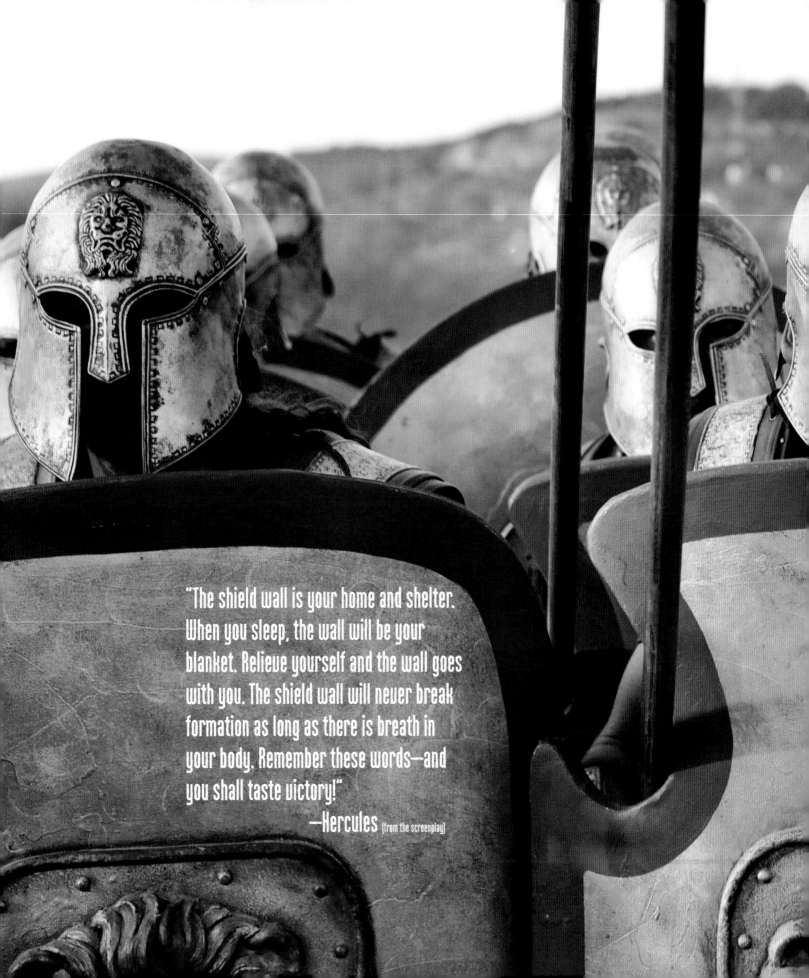

"The shield wall is your home and shelter. When you sleep, the wall will be your blanket. Relieve yourself and the wall goes with you. The shield wall will never break formation as long as there is breath in your body. Remember these words—and you shall taste victory!"

—Hercules (from the screenplay)

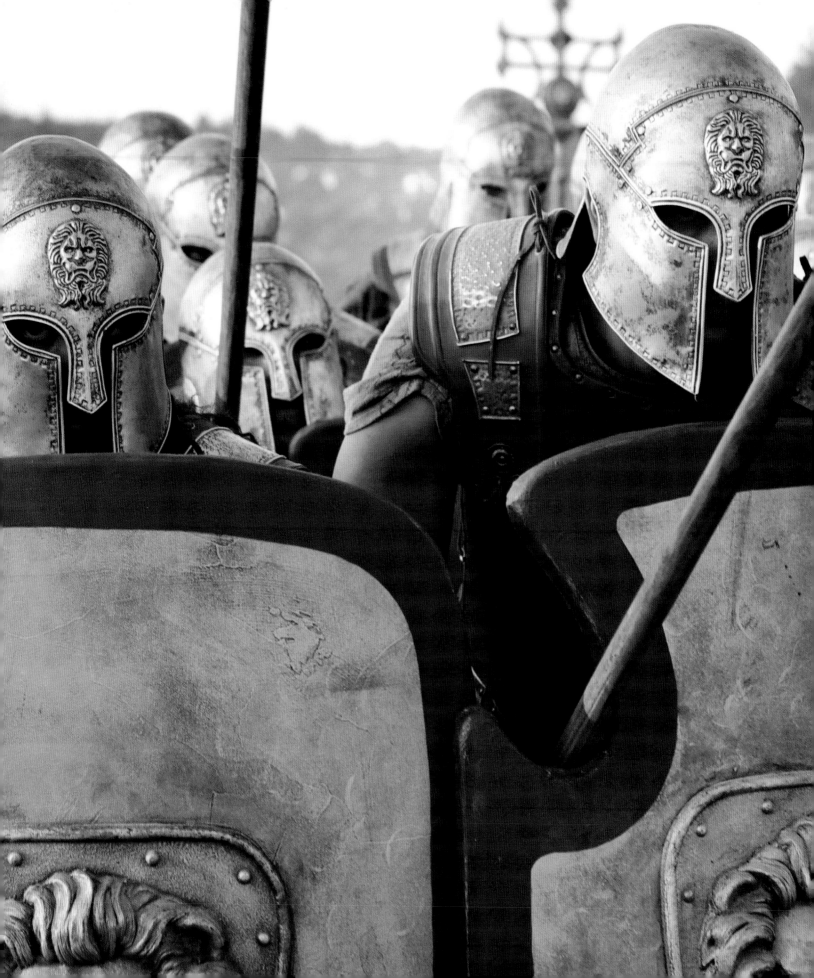

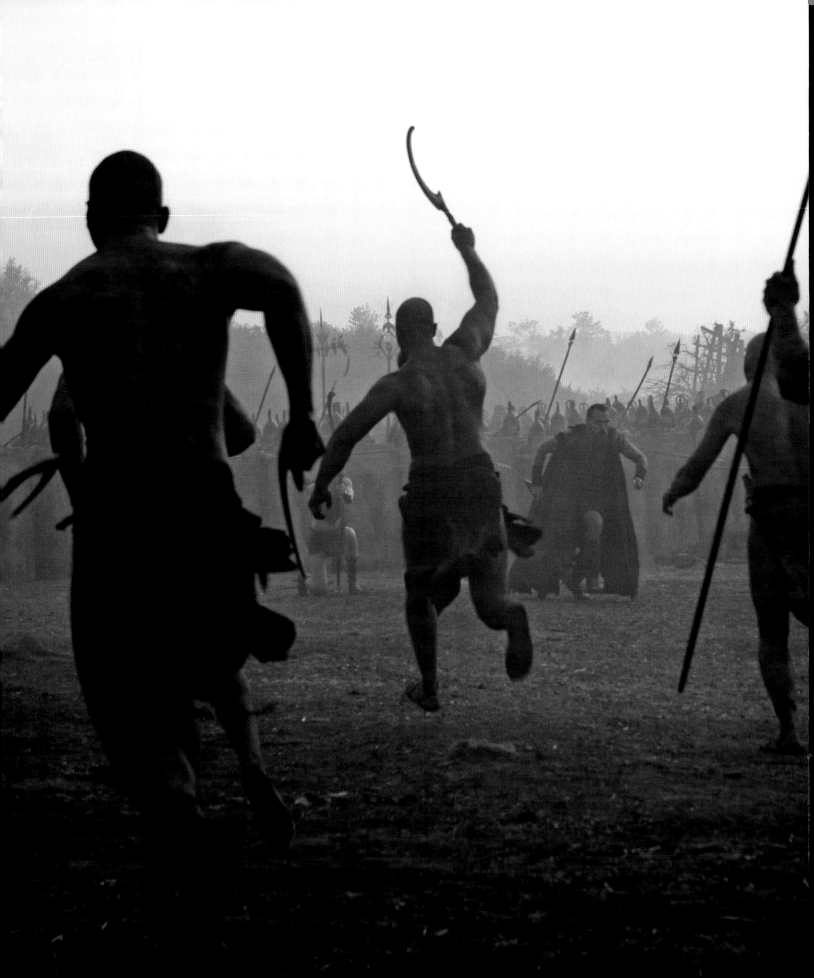

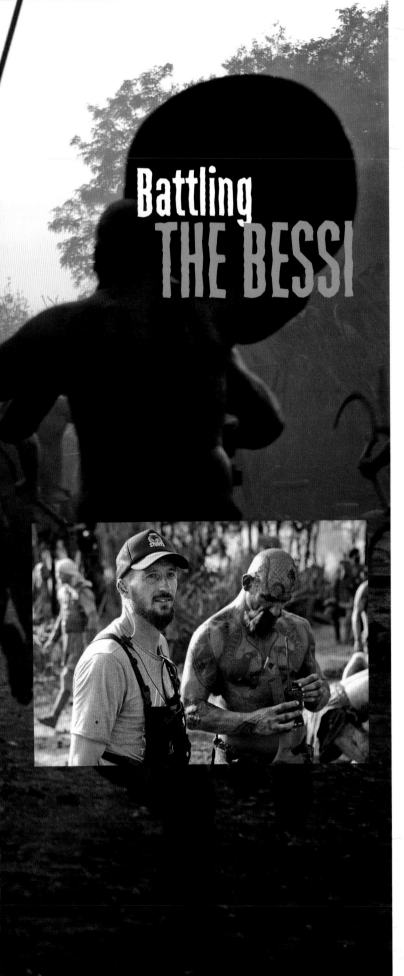

Battling
THE BESSI

The largest and most complicated sequence for stunt coordinator Greg Powell and fight coordinator Allan Poppleton was the battle between Hercules, his mercenary band, the ragtag Cotys army, and the Bessi warriors led by Rhesus.

"For that particular battle, Brett wanted the Cotys army to be ill-trained," says Poppleton. "He wanted the Bessi warriors to be crazy, berserk, almost animalistic organic kinds of creatures. After the battle Hercules realizes that he needs to whip them into shape."

The stunt work for the Bessie battle was extremely intense. Hoards of screaming, green, bald-headed, tattooed warriors threw themselves at the Cotys Army. "They dived up and over the shield wall. They got quite a way in, and then they started strangling, punching, and kicking anyone in sight," says Powell with a big grin.

Most of the fight sequences entailed the use of many different weapons. Poppleton took the list of weapons designated for each character and started working out what the practical style of using them would be. "We then adapted the style to fit the character and the genre of the film. We then did a 'show and tell' for Brett to make sure he was happy with everything before starting to choreograph each of the fight sequences."

The sequence is one of the highlights of the movie and the production spent weeks filming the complicated action as the Cotys army took on the ferocious Bessi warriors.

PREVIOUS PAGE: Production still from the Bessi battle scene. For the final movie, the background will be deleted so no one can see the houses and modern structures. OPPOSITE: The Bessi warriors attack the army of Lord Cotys. INSET: Fight coordinator Allan Poppleton working with Bessi warrior.

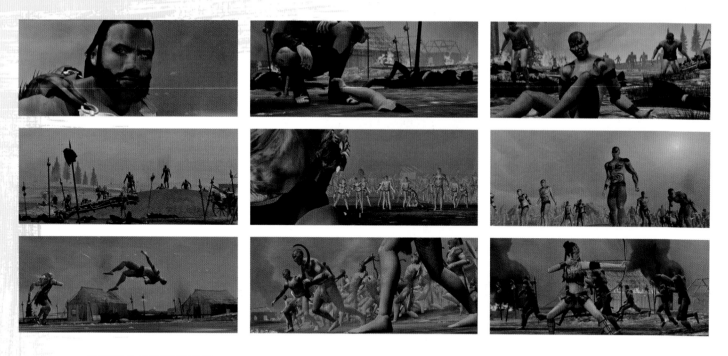

PREVIS & STORYBOARDS

Historically, filmmakers have relied on storyboards, concept artwork, and physical models to help plan the shooting of their movie. Today, pre-visualization teams like The Third Floor complement this process by adding computer animation to the storyboards and story ideas. The resulting "previs" allows shots and scenes, as well as camera angles and other technical aspects, to be effectively mapped out before filming actually begins, saving time, money, and ensuring the director's vision.

Joshua Wassung and artists from The Third Floor in Los Angeles worked with Brett Ratner to pre-visualize eight sequences, about thirty minutes of material, for *Hercules*. Previs for such scenes as the dungeon Cerberus attack, the Rhesus battle, the Bessi ravine, and the fall of Hera's statue, among others, provided an effective way to explore and plan the action prior to filming "on the day." Throughout the process, The Third Floor team collaborated with visual effects supervisor John Bruno, Ryan Cook, and Double Negative, and also worked with editor Mark Helfrich to help fill in the gaps in sequences as he crafted them.

*ABOVE: Pre-visualization stills of the Bessi battle by Third Floor.
LEFT: Brett Ratner shows Gary Barber, chairman and CEO of
MGM, storyboards on the Bessi set. OPPOSITE: Storyboard
panels by Giles Asbury detail how the battle will play out.*

1.

A. THE SOLDIERS ARE SCARED NOW AS THEY BELIEVE THE BESSI ARE AN ARMY OF THE DEAD. CUT

B. SITACLES WALKS BACKWARDS THRU FRAME AS... SAME SHOT

C. HERC STRIDES BACK & CAM PANS WITH HIM AS HE SHOUTS TO "FORM A SHIELD WALL..." SAME SHOT

D. ...TO C.T.S. HERC AS SITACLES RELAYS THE ORDER TO FORM A SHIELD WALL. CUT

E. WIDE AS SITACLES ORDERS A SHIELD WALL AS IOLUS RUNS IN TO SHIELD WALL - CAM PANS AS.. SHOT CONTINUES

2.

A. ...THE THRACIANS RUN & RUMBLE FORWARD TO START TO FORM A SHIELD WALL.

B. INT. FORMING SHIELD WALL AS IOLUS RUNS IN NEXT TO COTY'S AND TURNS... CAM TRACKS ROUND. SAME SHOT

C. ...AWAY FROM CAM TO WATCH AS SOLDIERS STRUGGLE TO FORM A SHIELD WALL AROUND THEM. SAME SHOT

D. IOLUS LOOKS ABOUT HIM AS THE SQUARE TRIES TO FORM ABOUT THEM AND SEES...

E. IOLUS' P.O.V.MORE BESSI APPEARING - THEY RISE UP IN MID-GROUND & BACK-GROUND (COVERED) CUT

3.

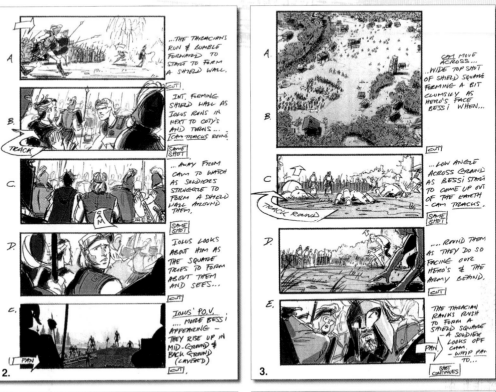
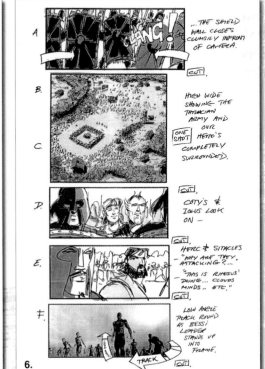

A. CAM MOVE ACROSS... ...WIDE TOP SHOT OF SHIELD SQUARE FORMING A BIT CLUMSILY AS HERO'S FACE BESSI WHEN... CUT

B.

C. ...LOW ANGLE ACROSS GROUND AS BESSI START TO COME UP OUT OF THE EARTH - CAM TRACKS. SAME SHOT

D.ROUND THEM AS THEY DO SO FACING OUR HERO'S & THE ARMY BEHIND. CUT

E. THE THRACIAN RANKS RUSH TO FORM A SHIELD SQUARE - A SOLDIER LOOKS OFF CAM. - WHIP PAN TO... SHOT CONTINUES

4.

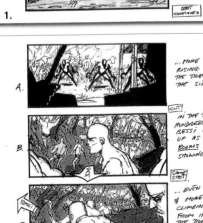

A. ...MORE BESSI RISING FROM THE TRENCH TO THE SIDE. CUT

B. IN THE TRENCH HUNDREDS OF BESSI CLIMB UP AS CAM BOOMS BACK SHOWING.... SAME SHOT

C. ...EVEN MORE & MORE BESSI CLIMBING UP FROM INSIDE THE TRENCH WIPING FRAME. CUT

D. SCORES OF FEET RUN UP THRU' FRAME AS CAM TILT & CRANES UP TO SEE... SAME SHOT

E. ...THE BESSI CLIMBING UP FROM THE TRENCH - CAM CONT' TO CRANE UP TO REVEAL... SHOT CONTINUES

5.

A. ...THE BESSI EMERGE INFRONT OF SHIELD WALL & IN B.G. MORE BESSI EXITING THE.... CUT

B. ...TREE LINE ON THE OTHER SIDE OF THE SHIELD SQUARE. CUT

C. INSIDE THE FORMING SHIELD SQUARE LOOKING OUT AT. HERC' & BESSI - CAM DOLLY'S BACK AS.... SAME SHOT

D. ...THE SHIELD WALL CLOSES - CONT' TO DOLLY BACK PAST COTY'S SHIELD CIRCLE AND.... SAME SHOT

E. ...OUT THE OTHER SIDE OF SHIELD SQUARE WALL WHERE.... SHOT CONTINUES

6.

A. ...THE SHIELD WALL CLOSES CLUMSILY INFRONT OF CAMERA. CLANG! CUT

B.

C. HIGH WIDE SHOWING THE THRACIAN ARMY AND OUR HERO'S COMPLETELY SURROUNDED. ONE SHOT

D. CUT. COTY'S & IOLUS LOOK ON -

E. HERC & SITACLES - "WHY ARE THEY ATTACKING?..." "THIS IS RHESUS' DOING... CLOUDS MINDS... ETC." CUT

F. LOW ANGLE TRACK ROUND AS BESSI LEADER STANDS UP INTO FRAME. TRACK CUT

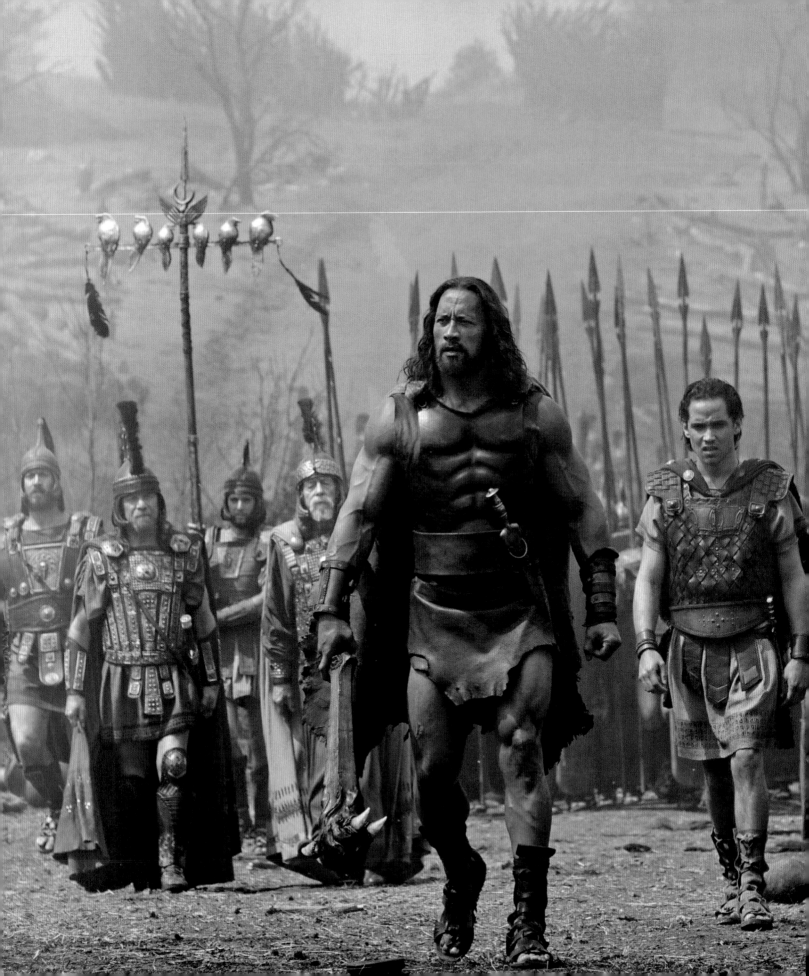

"When they arrive at the Bessi village, there are
dead bodies everywhere, heads on sticks all over the
place. All of a sudden, these bodies start coming
out of the ground and rising up. The Cotys army
puts up their shield wall and the Bessi warriors
charge head first in there. The shields are probably
four feet high but the warriors just break through.
The battle was a skirmish. A hit and run sort
of thing. Grab them, fight, grapple, run, kick,
strangle, punch, and that kind of thing. The
boys did a really good job."

—GREG POWELL, SUPERVISING STUNT COORDINATOR

The mercenaries are appalled by the ruthless devastation when
they arrive at the Bessi camp. They will soon discover this is a trap.
FOLLOWING PAGES: Mass chaos on the battlefield.

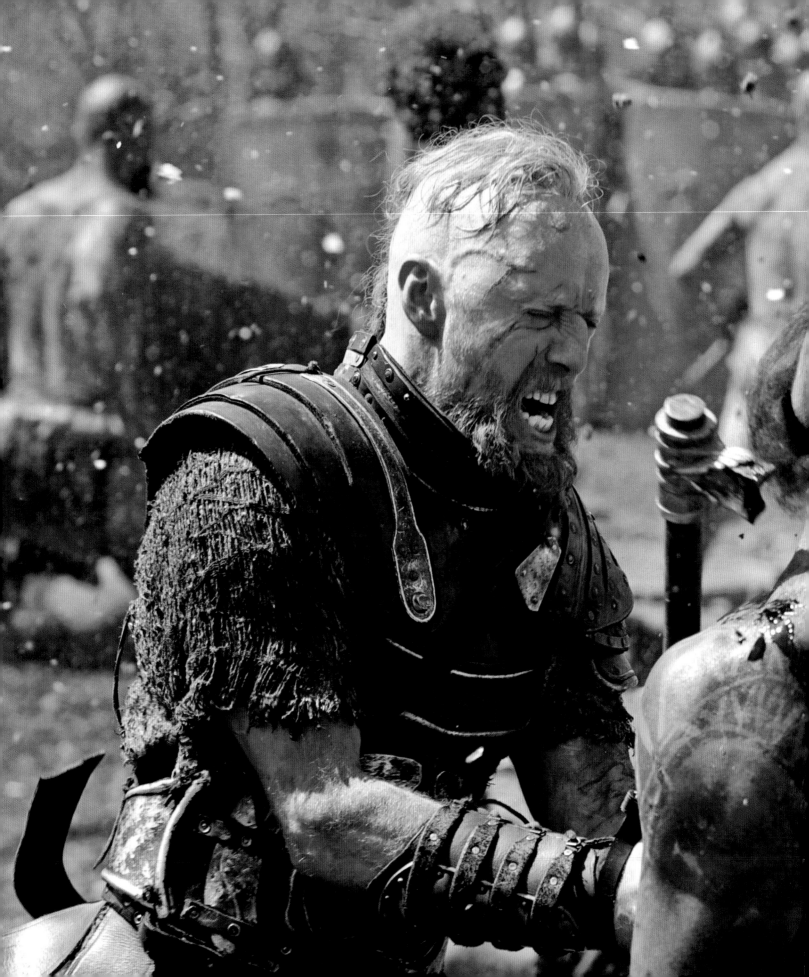

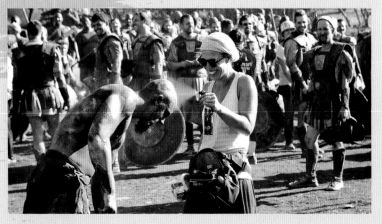

THE WEATHER

Every film production in every corner of the world is dependent on the most unpredictable element of all: the weather. Everything can be perfect in terms of the sets and costumes, the actors can be totally prepared and ready to work but the entire production can be shut down or, at the very least, compromised if the weather doesn't cooperate.

And the weather in Budapest during the summer of 2013 was anything *but* cooperative.

"It was an extremely tough shoot because of the weather," explains Brett Ratner. "I've never shot in 110 degree weather. It was hard enough for the crew, but at least we could wear light clothing. The actors and extras were wearing heavy armor and carrying shields. They had to go in there and do the physical stuff. They fought like demons."

For the crew, it was a full time job keeping the extras hydrated and as cool as possible. PA's handed out truckloads of bottled water and the teams constructed a mister that the cast could walk through.

The fierce sun was also a hazard. Though the Bessi warriors didn't have to wear heavy armor and helmets, their skin was exposed to the rays of the sun so they had to be slathered with sunscreen before being sprayed with the green paint.

"It was unbelievably hot," admits John Hurt. "I was wearing this armor and it just attracted the heat. It was like wearing a grill on your chest. The extras were extraordinary. I don't know where they came from, probably from various weight lifting clubs all over the country because they were extraordinarily built. I never heard anyone complain; they were fantastic."

Nothing was more difficult during the shoot than the heat and humidity. The heavy armor and thick body paint did not help the situation. While some extras never returned after the first day, an amazing amount of them stayed through the end of production.

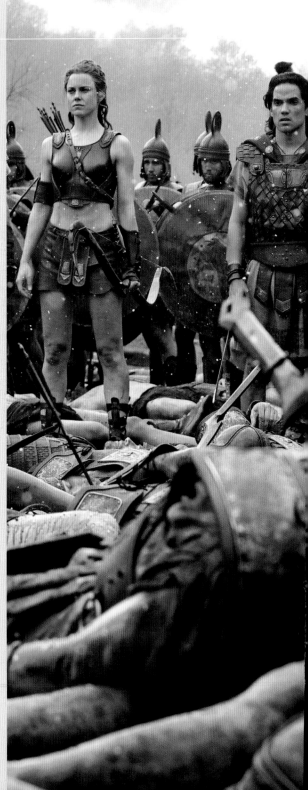

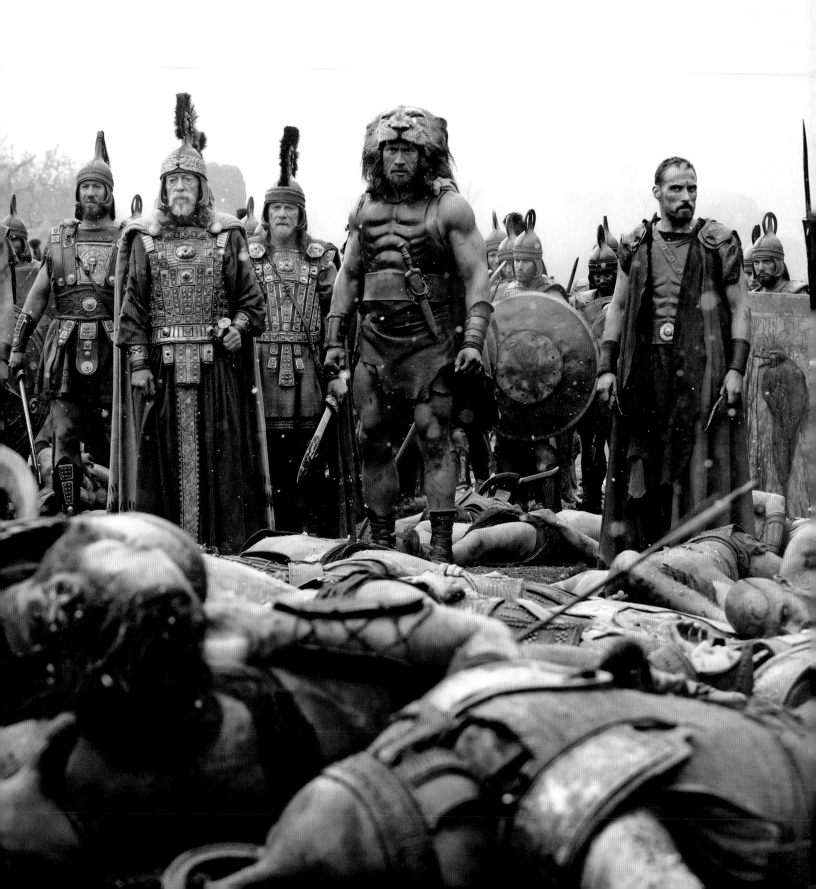

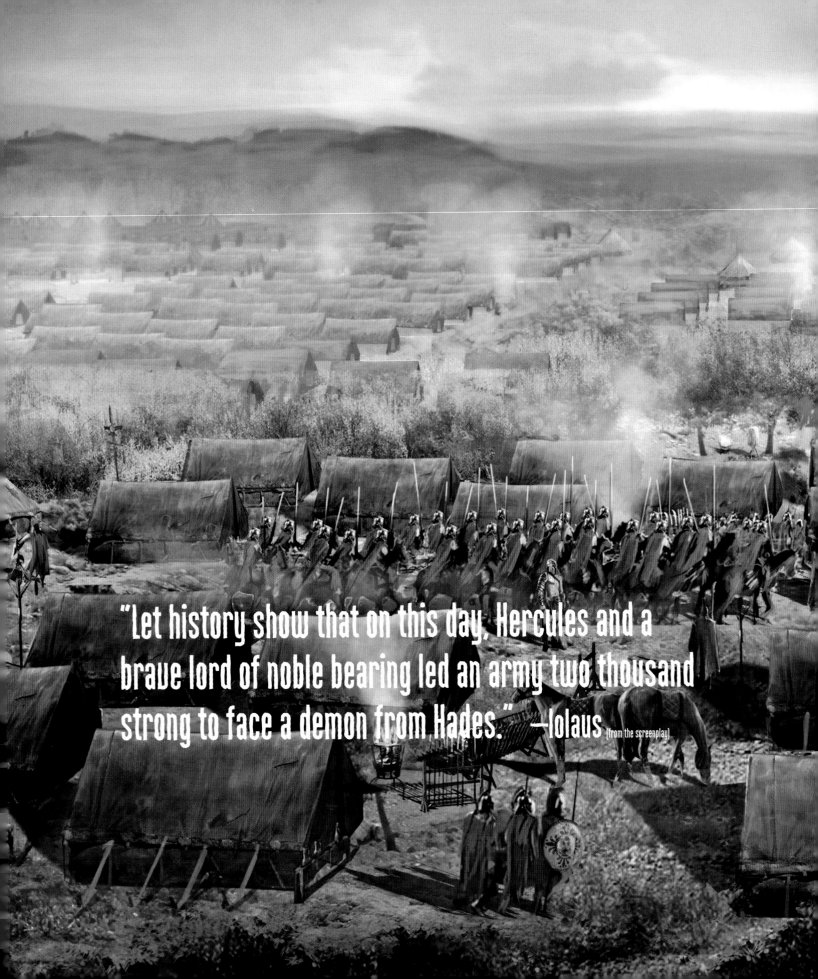

"Let history show that on this day, Hercules and a brave lord of noble bearing led an army two thousand strong to face a demon from Hades." —Iolaus (from the screenplay)

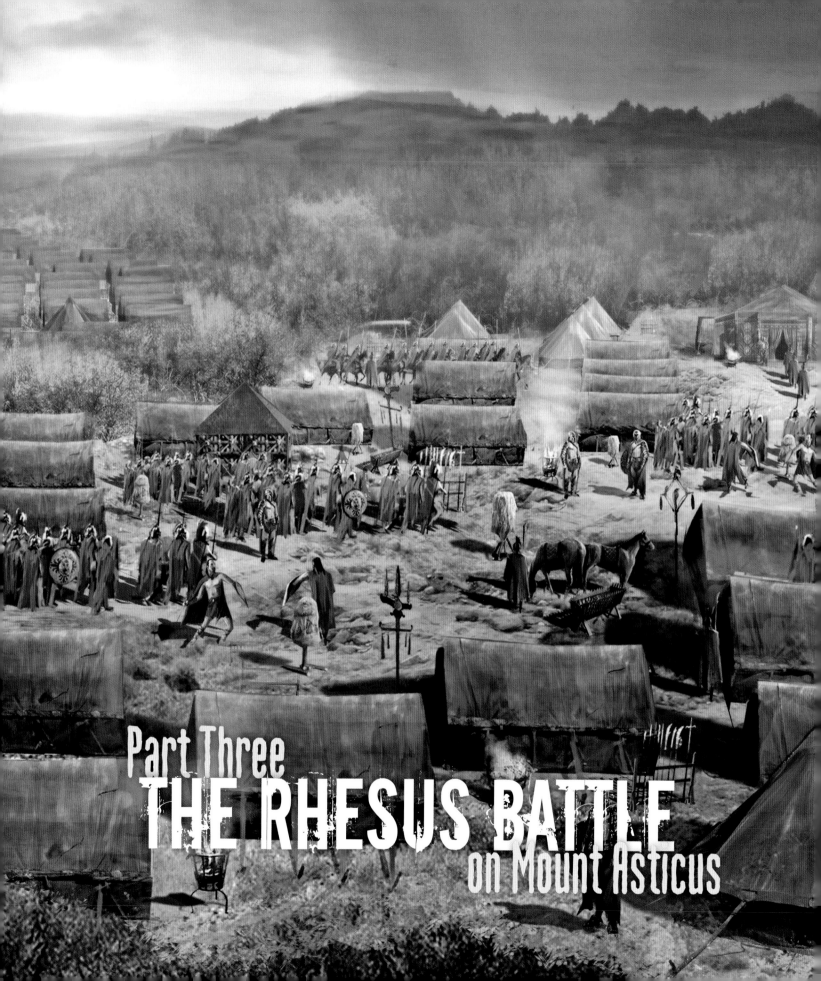

Part Three
THE RHESUS BATTLE
on Mount Asticus

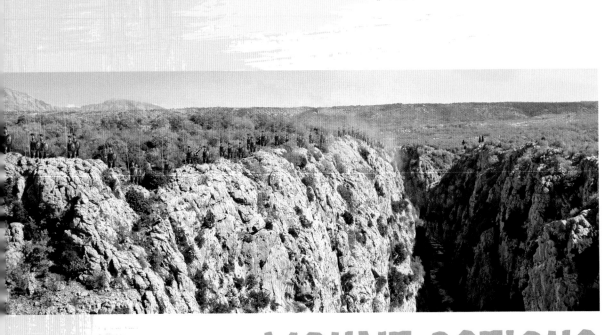

March to MOUNT ASTICUS

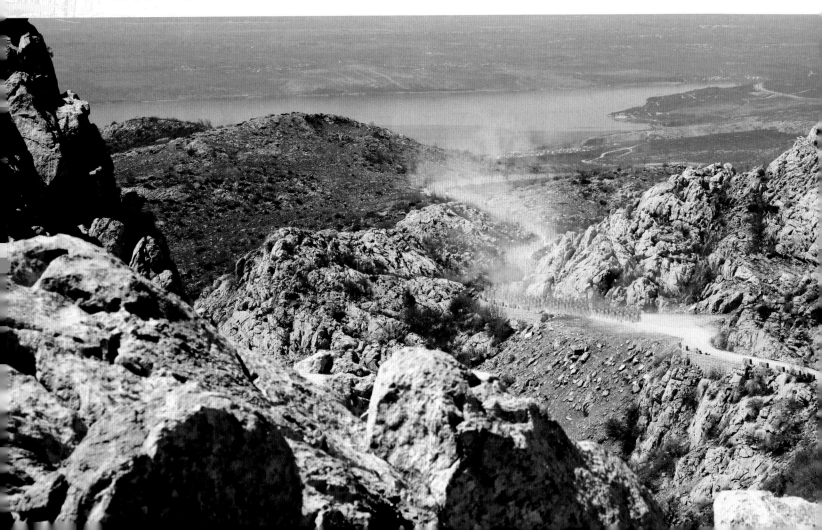

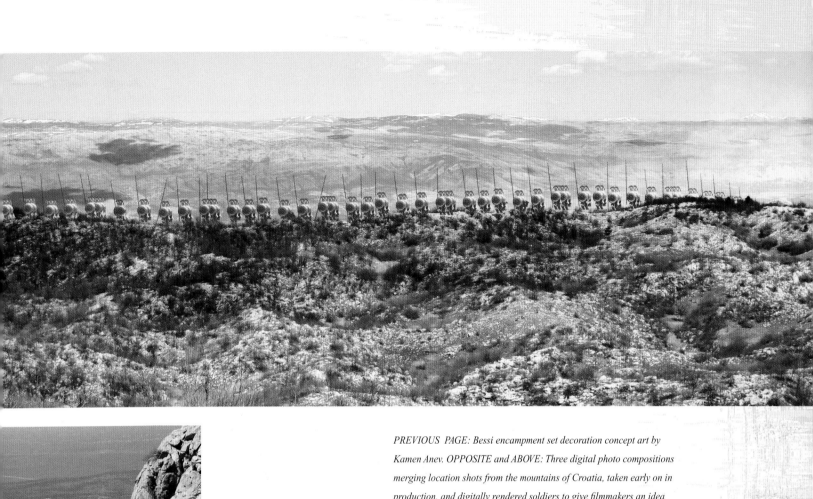

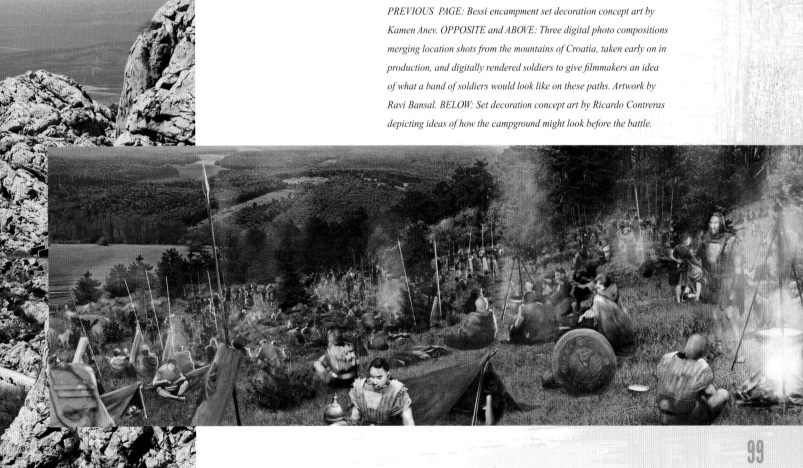

PREVIOUS PAGE: *Bessi encampment set decoration concept art by Kamen Anev.* OPPOSITE and ABOVE: *Three digital photo compositions merging location shots from the mountains of Croatia, taken early on in production, and digitally rendered soldiers to give filmmakers an idea of what a band of soldiers would look like on these paths. Artwork by Ravi Bansal.* BELOW: *Set decoration concept art by Ricardo Contreras depicting ideas of how the campground might look before the battle.*

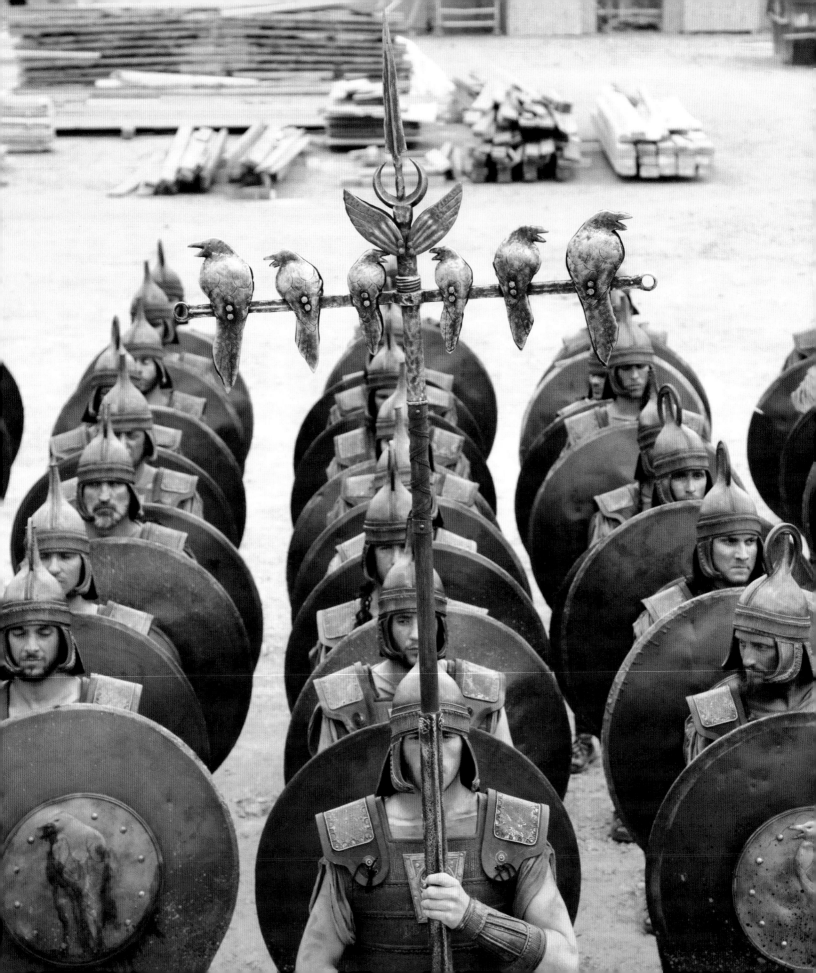

Preparing to be Invincible

know our battle scenes have never been seen before," says producer Beau Flynn. "They're scary, aggressive, and violent, but they drive the story forward. It's very exciting! Our mantra was reality plus 20 per cent."

Choreographing battle scenes is as complicated as creating any ballet or musical and it can be a lot more dangerous. One wrong move can mean severe injury, especially when the field is overrun with chariots and horses. So it is no surprise that months and months were spent working out the intricate choreography, moves, and gags to augment the amazing stunts and unique fight scenes. And this was all done with a minimal amount of green screen or visual effects. For the most part, the fight scenes are live action.

When stunt coordinator Greg Powell first read the script he wanted to know how strong Hercules was supposed to be. This was important in helping to set the tone for the stunts. "Hercules is not supernatural," explains Powell, "but he is a big guy—probably twice

OPPOSITE: The first dress rehearsal for the march from the Citadel to the Bessi battlefield. Wood beams in the background show that the Citadel was still under construction. ABOVE: Concept drawing of training dummies used by Hercules to train Lord Cotys' army. Artwork by Renátó Cseh. RIGHT: Stunt coordinator Greg Powell.

my size—so if I can throw someone six feet, then Hercules can throw them twelve. I used that principal when working out the fight sequences."

Powell and fight coordinator Allan Poppleton worked with the principal cast for at least three weeks prior to shooting. "It was a very busy time for them; we had to train them for the fights as well as for using their weapons correctly," says Powell.

For the rest of the stunts, Powell selected stuntmen from the four corners of the globe that included British, Canadian, New Zealanders, Hungarians, Slovaks, Bulgarians, and a group of sensational stunt horsemen from Spain headed up by Ricardo Cruz Sr.

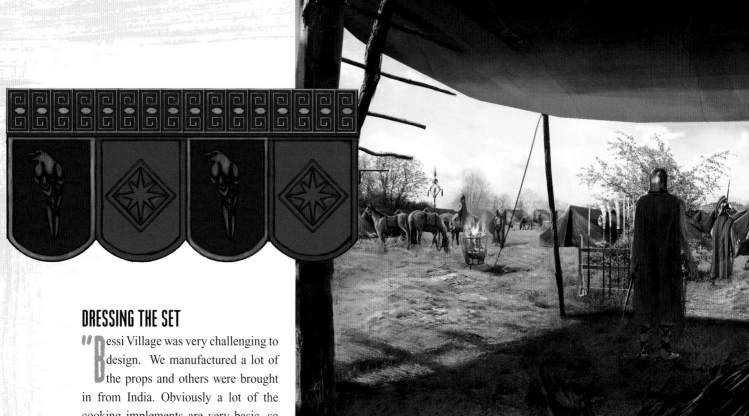

DRESSING THE SET

"Bessi Village was very challenging to design. We manufactured a lot of the props and others were brought in from India. Obviously a lot of the cooking implements are very basic, so we were able to get pestles, mortars, and metal and stone cooking pots.

"Everything was very basic and had to have a reason to be there either because it was particularly beautiful or it had a particular function and was actually used by people in that kind of environment; nothing was superfluous in terms of furniture or dressing the sets. I think everything jelled together just perfectly."

—TINA JONES, SET DECORATOR

Various decorations, instruments, and cloths were added to dress the campsite where the army prepares to fight the Bessi. The symbol of the crow appears everywhere. ABOVE: Tent flags concept drawing by Michael Eaton. ABOVE RIGHT: Set decoration concept art by Kamen Anev. RIGHT and OPPOSITE: Cotys' tent shields and bronze standard concept art by Renató Cseh, and the final dressed set.

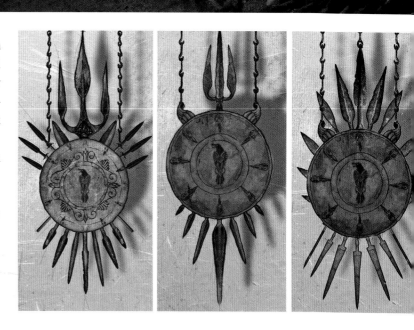

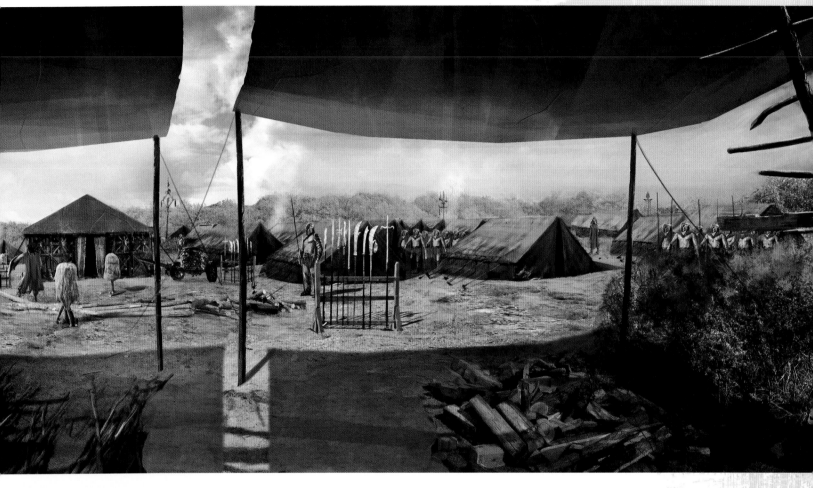

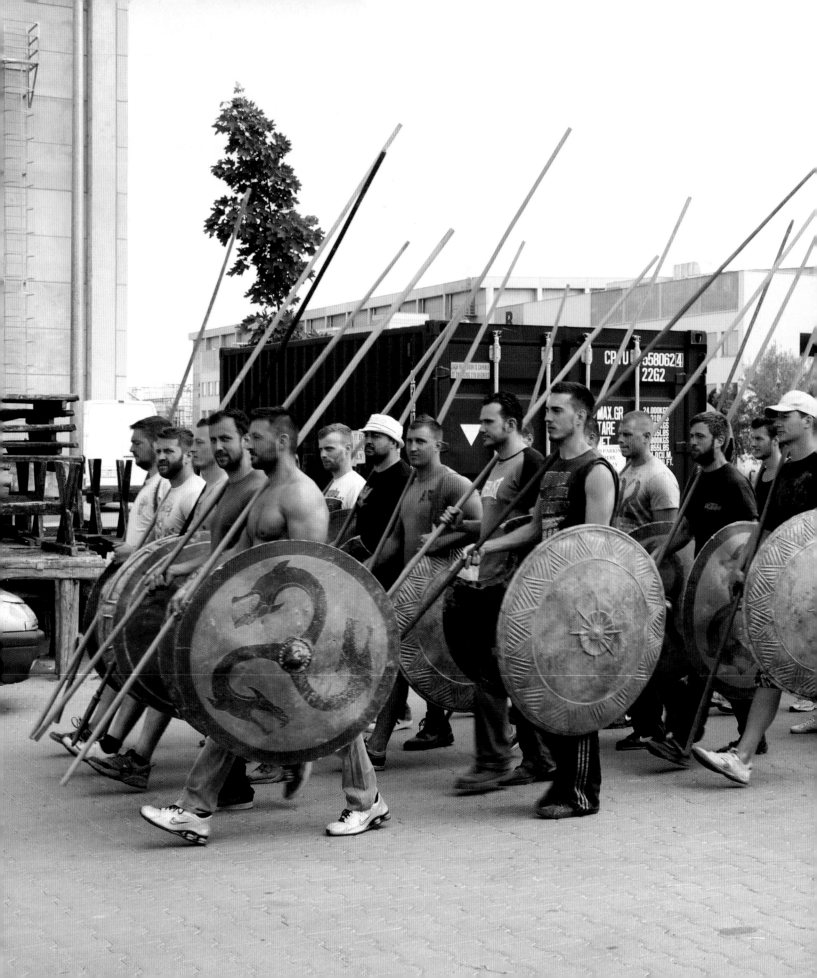

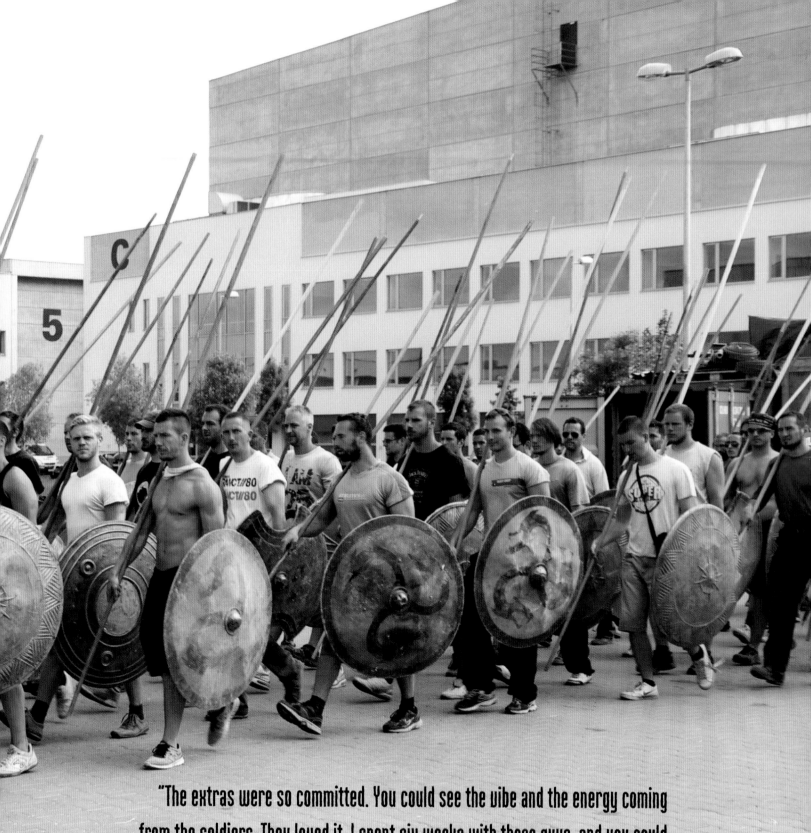

"The extras were so committed. You could see the vibe and the energy coming from the soldiers. They loved it. I spent six weeks with these guys, and you could gradually see them becoming Thracian soldiers. It was amazing." —Brett Ratner

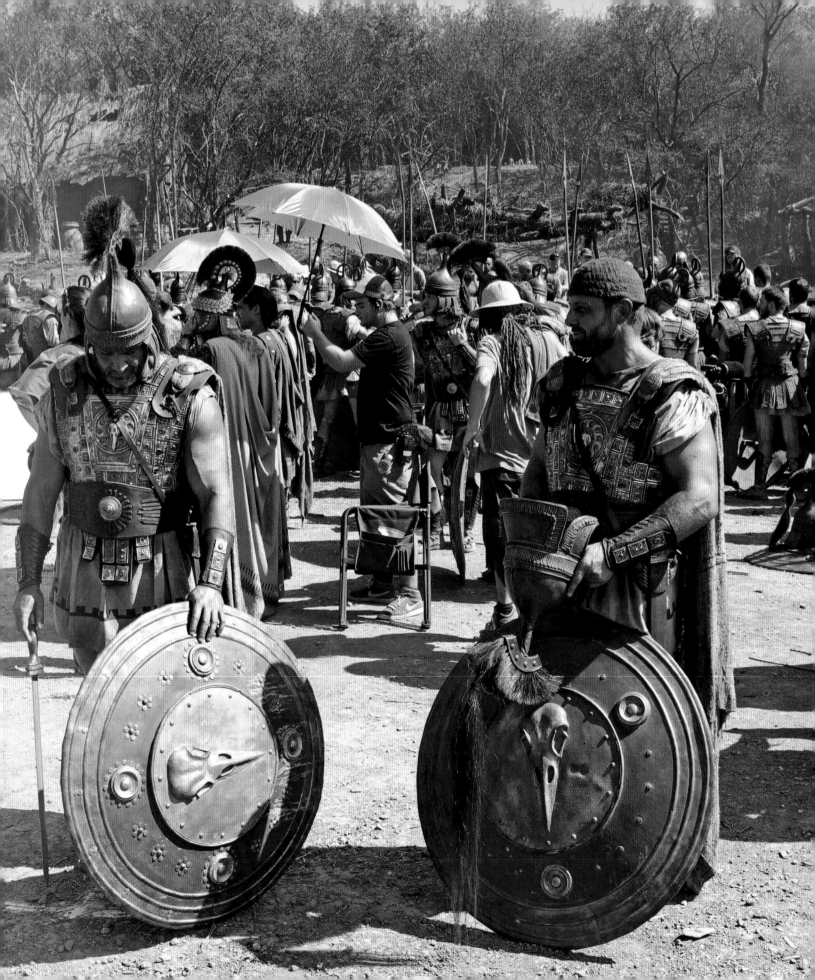

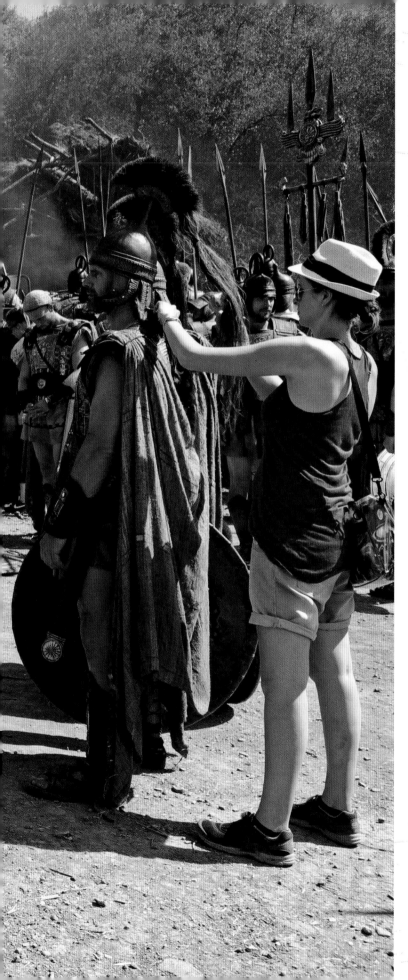

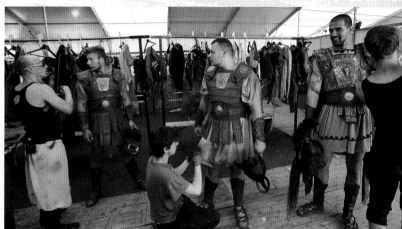

DRESSING THE ARMY

For costume designer Jany Temime, the task of dressing the army of Lord Cotys was complicated by the fact that the army required both a "before" and "after" look. At first, they are a ragtag group of farmers and then, after being trained by Hercules, they had to look more organized and professional. "I needed to make a contrast between the bombast of the first army and the super tight, fast, second army so I used color," explains Temime. "The first army is yellow and brown, and the second army is red and gold—a color combination that looks victorious!"

It addition to the color choices, one of the most important processes in creating period costumes is in the aging of the material. The clothes, especially the military wear, need to look worn, even worn out. To this end, Temime hired an entire department to age the costumes. She brought in two people from London who were masters at the art and hired ten Hungarian art students to be mentored by them. "They were a very talented group of people," says Temime. "To them the

PREVIOUS PAGE: The extras practice their marching orders in the scorching heat outside the film studio. LEFT and ABOVE: The complicated costumes, weaponry, and armor made it difficult to dress the 500 to 600 extras every morning.

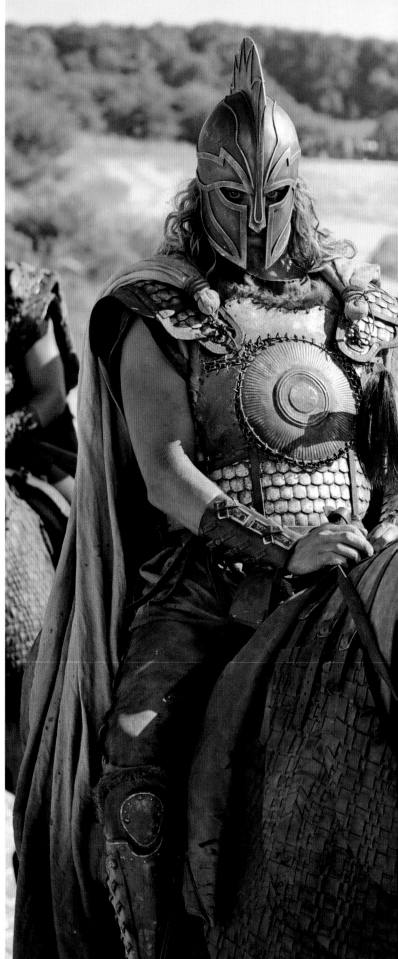

aging process was a creation. They were painters and artists so they brought a freshness and enthusiasm into the job that was delightful."

Finally, it was vital to the success of the costumes that the men wearing them look like soldiers. Prior to filming, the extras were required to train, not only in the art of being a soldier, but also to make sure they were in tiptop shape. "You need the muscles to wear those short sleeves and skirts," says Temime with a grin, "or it looks ridiculous! They needed to know how to march as an army and behave like soldiers and they had to have the right bodies for the job."

Unfortunately, the design of the military costumes was a problem for stunt coordinator Greg Powell. "The costumes are not really stuntman-friendly," explains Powell. "Everything you want to cover up with pads is basically exposed. The arms and legs are showing so you can't use kneepads or shoulder protection. We were really restricted." None of this is evident in the final film however. The 130 stuntmen who stormed onto the battlefield never looked like they were trying to protect any of their body parts.

ABOVE: Costume department working on the armor pieces.
RIGHT: Rhesus and his men prepare to go to war.

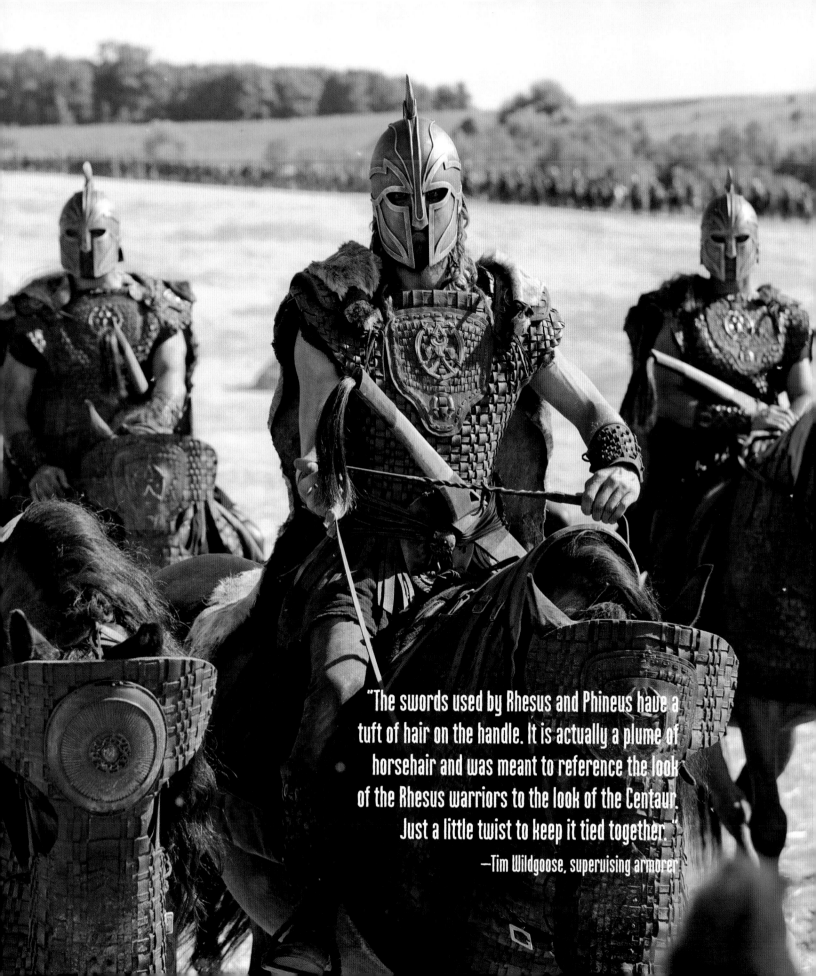

"The swords used by Rhesus and Phineus have a tuft of hair on the handle. It is actually a plume of horsehair and was meant to reference the look of the Rhesus warriors to the look of the Centaur. Just a little twist to keep it tied together."

—Tim Wildgoose, supervising armorer

DWAYNE JOHNSON: MASTER OF THE FIGHT SCENE

The production was blessed with the talents of their lead actor who was no stranger to fight scenes. "Dwayne, of course, is a master," says producer Beau Flynn. "He is so powerful. I've never seen anyone with such an uncanny ability to watch a fight, memorize the moves, and then perform it. Dwayne and Tobias (Santelmann who plays Rhesus) have a very big fight in the movie, and they did the entire thing themselves. Those guys really went for it. We soon discovered that Dwayne Johnson only knows one speed and his commitment to the film was incredible." Johnson insisted on doing all the fights himself, training with the Hercules club and a gigantic sword.

"Dwayne is massive, so we had to take into consideration all the stuff he does," says Allan Poppleton. "His wrestling and the different moves he wanted to put into the role were obviously key to creating his style of fighting. He wanted to use the club in different ways, and he was very hands-on with his ideas."

RIGHT: Fight coordinator Allan Poppleton with Dwayne Johnson.

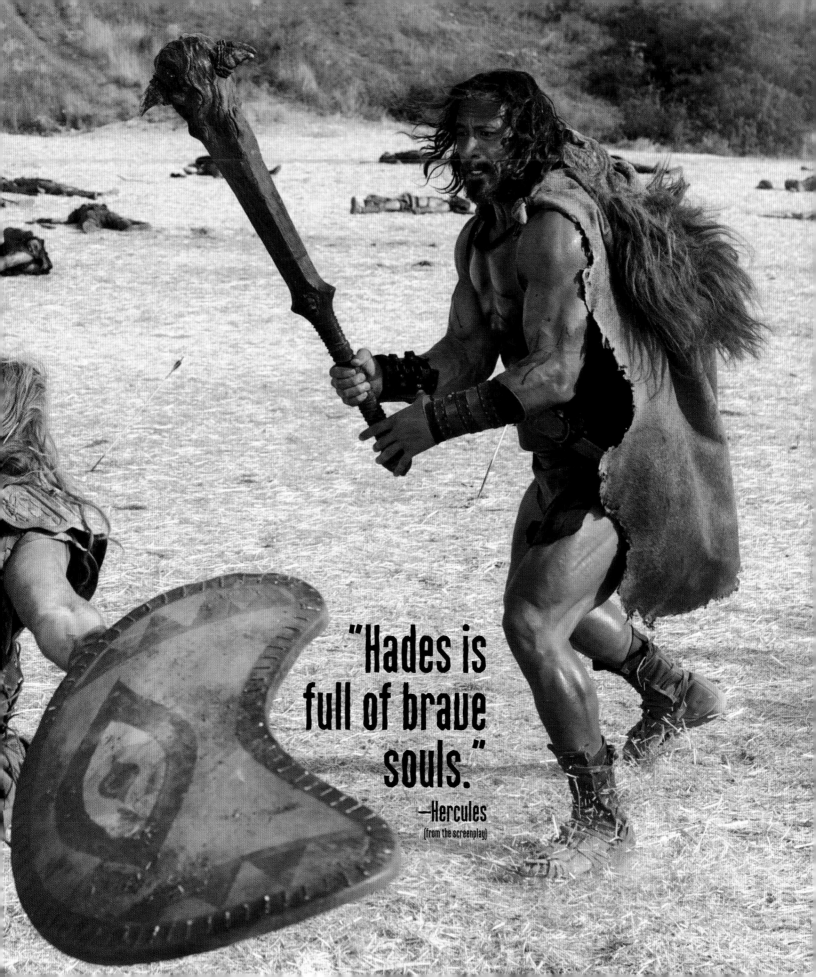

"Hades is full of brave souls."

—Hercules

(from the screenplay)

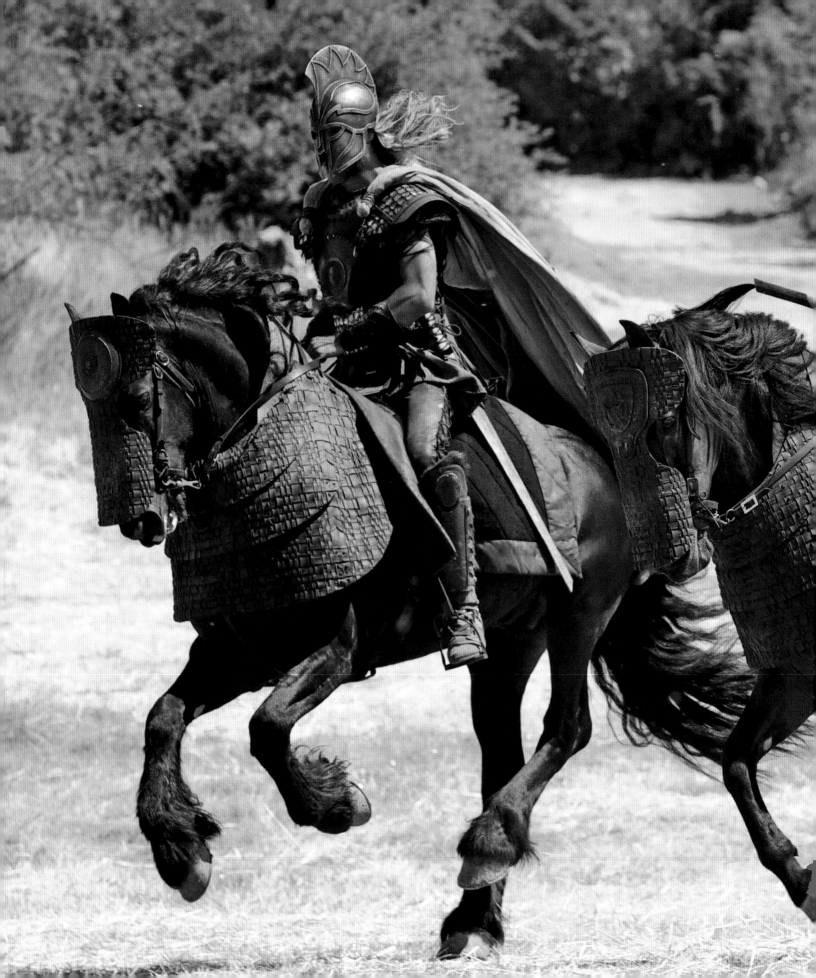

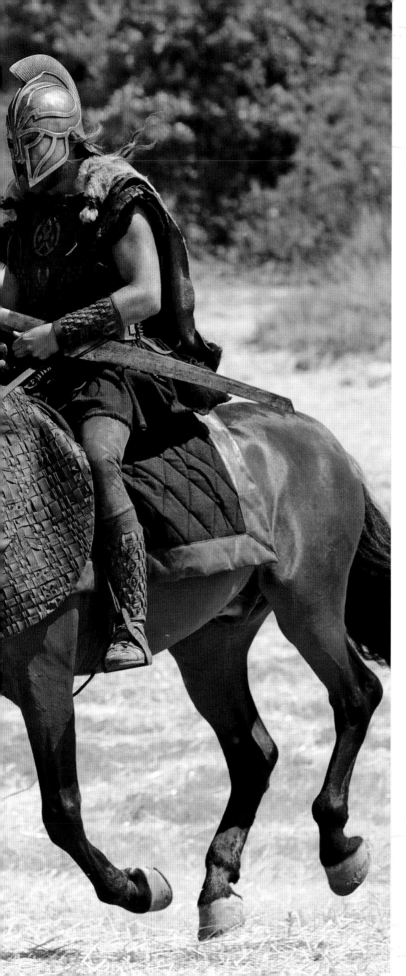

THE HORSE TRAINERS

Horses were instrumental in the making of this film. In general, some of the most amazing stunt work involved horses and that required the work of several specialists. To this end, stunt coordinator Greg Powell assembled a team of some of the top horsemen in the world. Horse master Peter White was hired from the U.K. to work alongside Powell and Ricardo Cruz Sr., a legendary horse master from Spain.

Peter White was thrilled to discover that Powell was familiar with horses and had, in fact, started his career working with the animals. "Greg's background really helped us," explains White. "He devised the stunt sequence and I decided which horse would be the most suitable for it. We worked very well together."

Spanish horses were particularly helpful for the stunt work. "The Spanish have a precision way of riding that is derived from their history of bullfighting," explains Powell. "Their horses have to respond instantly. There are no 'two seconds later' in the bullring. Many pictures went to Spain over the years, and the Spanish riders picked up the art and made it their own."

Of course, the actors all had to ride horses and some were more experienced on horseback than others. Actors Tobias Santelmann (Rhesus) and Joe Anderson (Phineus) had the least amount of riding experience of all the other actors so they had the most amount of work to do. "Tobias and Joe got to a standard where they were safe to work in and around the set," says Peter White. "But we wouldn't necessarily let them go galloping off around the field together."

Rhesus (Tobias Santelmann) and Phineus (Joe Anderson) charging off to battle. Anderson was a total novice when it came to riding and had to be carefully trained and watched.

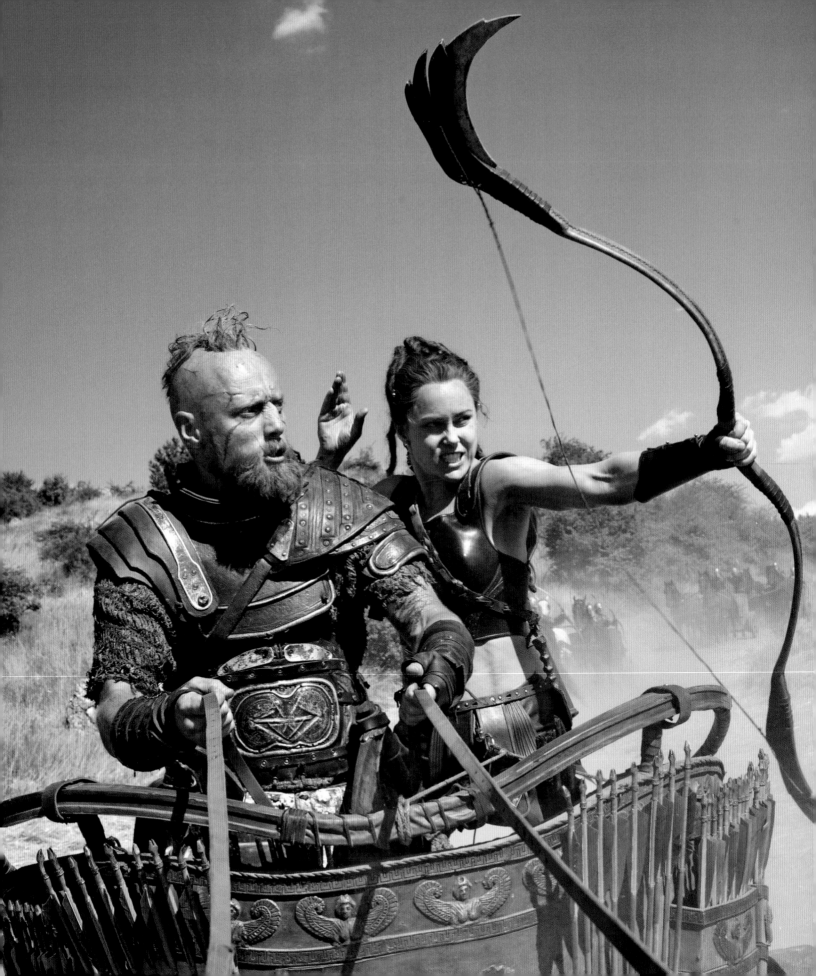

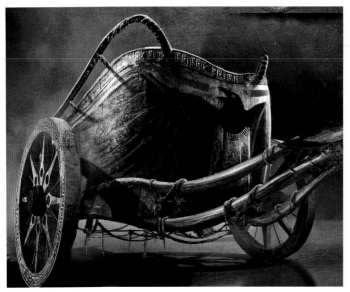

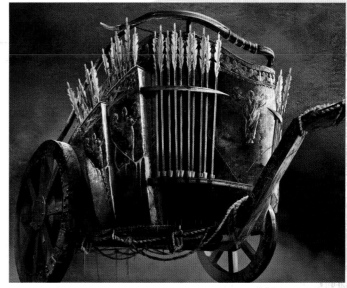

THE CHARIOTS

Many of the actors, including Hercules and his mercenaries, had to learn to drive the chariots. This was no easy task; driving a chariot drawn by horses requires a great deal of focus, balance, and concentration. Accordingly, the actors trained for several hours a day over the course of about six weeks.

"The chariots are quite hard to drive," explains horse master Peter White. "The actors had to think about their balance because there isn't a seat to sit on, and the ground is very undulating. They also had to keep the horses calm and quiet as we couldn't let them gallop around the fields too much."

The smallest person in the group, Ingrid Bolsø Berdal, had perhaps the most difficult challenge, and not because she was the only female in the group of chariot riders. "Ingrid not only had to ride on the chariot; she had to simultaneously and repeatedly fire a bow," explains White. "For some of these shots she was on a chariot going at full gallop."

The actress agreed that it was pretty intense. "They strapped me into the chariot so I couldn't fall off," Berdal admits, with a grin, "but the last thing I heard was the stunt coordinator telling me I was on a quick release just in case the chariot tipped over. I felt completely safe, but it was fun to hear those words."

Each chariot was designed specifically for each character, embellished with artifacts that symbolized

ABOVE: Stunt coordinator Greg Powell drives the power chariot in front of a green screen during filming of the Rhesus battle chariot race. TOP: Details of the chariots designed for Lord Cotys (left) and for Atalanta (right.) Artwork by Kamen Anev.

Many concept designs and models were created to come up with the perfect chariot for Hercules. His chariot had to stand out amongst all the others as the strongest and most intimidating vehicle. ABOVE and BELOW: Concept artwork by Weta Workshop's Christian Pearce. RIGHT: Concept artwork by Kamen Anev. BELOW RIGHT: Construction of Hercules' chariot and detail of the final prop.

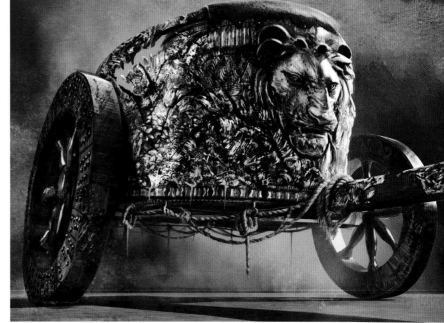

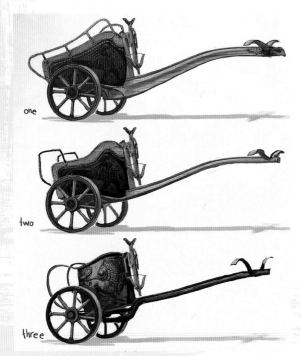

one

two

three

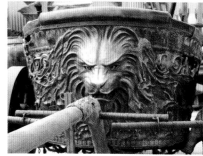

BELOW LEFT: Concept art for Hercules' chariot and (MIDDLE) Autolycus' chariot by Renató Cseh. BELOW RIGHT: Autolycus' final dressed chariot. BOTTOM: Tydeus and Hercules on set in Hercules' chariot.

their owners. It was almost like having a modern car decorated to suit your personality. Hercules' chariot, for example, bore the lion emblem. Even the interiors, which can hardly be seen, were decorated. Atalanta's chariot sported additional quivers full of arrows, and other pieces of weaponry such as miniature crossbows. Amphiaraus' chariot contained the potions and herbs he had collected as a shaman.

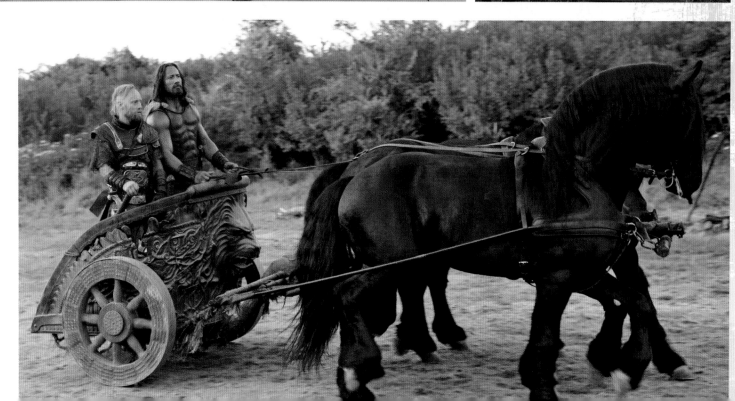

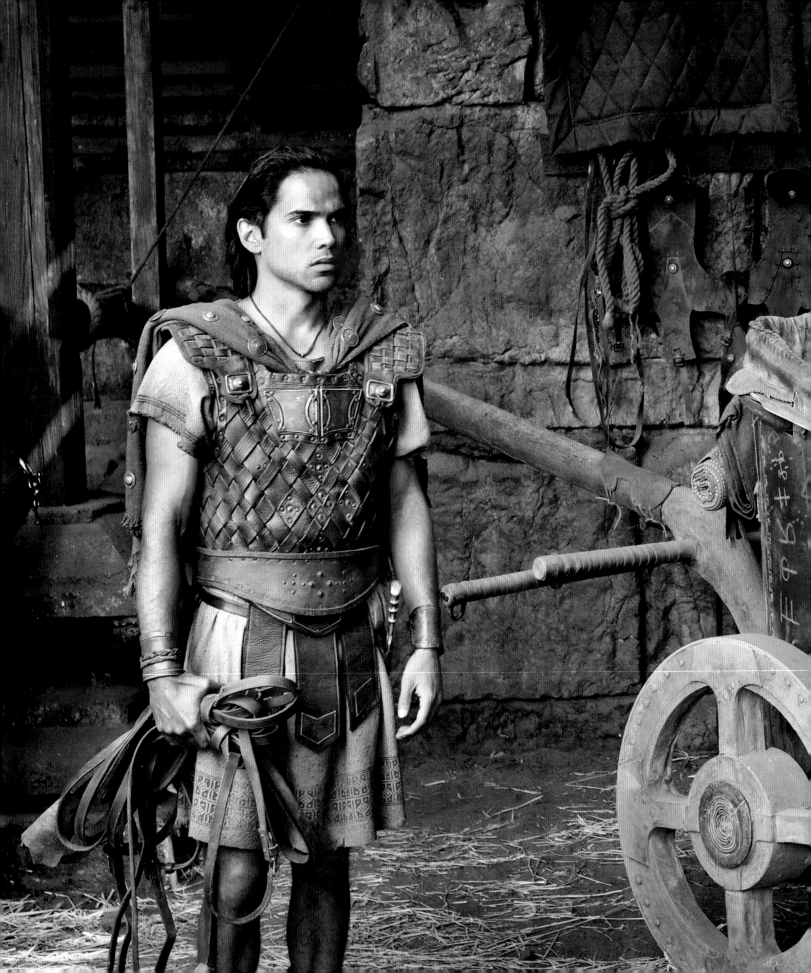

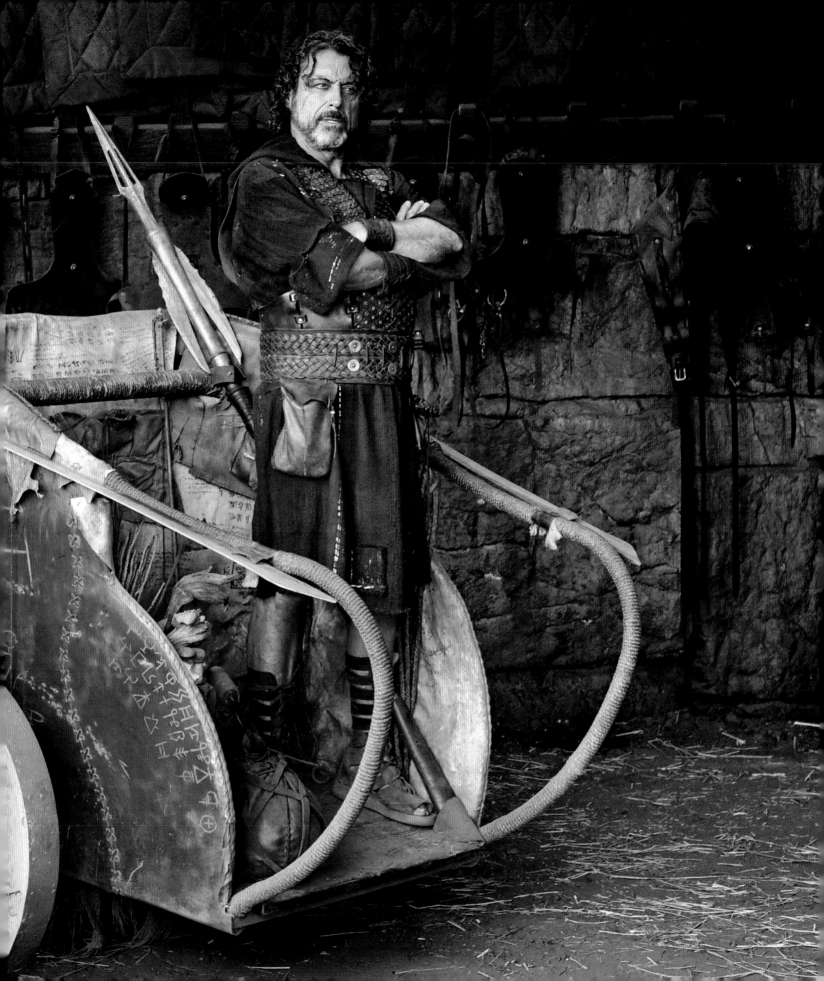

TRAINING THE CHARIOT HORSES

Aside from teaching the cast how to ride and training the stunt horses, Peter White also had to acquire and train several teams of horses to pull the chariots driven by Hercules and his mercenaries. In all, the production used about ninety horses and some had to double for the chariot races. "We were supplying horses for both the main unit and the second unit who were shooting simultaneously," explains White.

Hercules' chariot, pulled by a team of four magnificent black Friesians, was probably the greatest challenge for White. "When you put four horses together it reduces your turning circle, and your stopping ability," says White. "When you're taking that and then adding hundreds of extras, other chariots, and more horses you really have to be on your game." In addition to the actual racing, there were other stunts that had to be performed such as near misses between the chariots, horses knocking soldiers over, and saddle falls which involved using wires to pull a rider off the horse.

The horse teams spent three months rehearsing for the Rhesus battle, slowly building up and becoming more intense. In the last couple of weeks, they intensified the training particularly for the chariot horses. Stunt riders from Spain, the U.K., and Hungary were hired to perform the dangerous work. It was quite a diverse mix of people and languages. "The language barrier could be problematic," admits White, "but we had plenty of time to organize things to get them right."

Hercules' magnificent chariot, with an impressive lion head design, is pulled by four gorgeous black Friesians. Four horses are much harder to control than the two animals on everyone else's chariot but, as always, it is important that Hercules stand out.

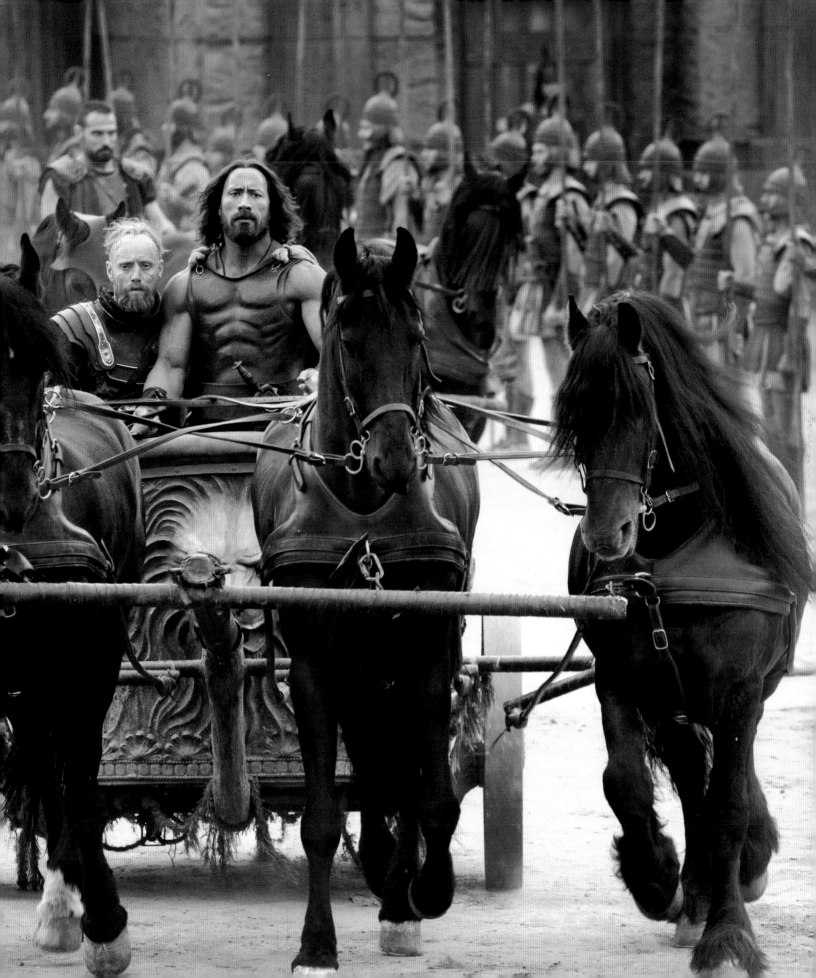

A STAR IS BORN

Among the many horses purchased and/or hired for the production was a rescue horse named Sunny.

"When I first saw Sunny, he was just a bedraggled, worm-coated, shaggy-tailed animal who was blind in one eye and very frightened," says Janice Caputo, a representative for L.A.'s American Humane Association of Film and Television. "Sunny had come from a farm where his job was to pull wagons. He was about fourteen years old but he looked thirty. He was so nervous that he couldn't stand at a station or come out of

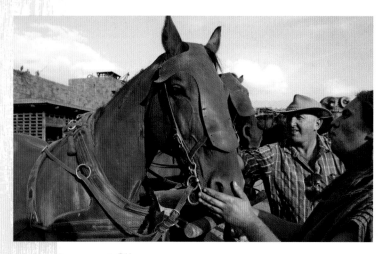

the stall without the companionship of another horse. You couldn't groom him, give him a bath, do his feet or touch his eyes or face. He was such an emotionally tied-up little animal, I was really worried he wouldn't have the stamina to work on the film."

However, Sunny was lucky; he got exquisite vet care from Dora Langer who monitored all of the horses on the set. Horse master Peter White, who was also a horse dentist, was able to fix Sunny's teeth. Even more important, perhaps, was the loving care he received. "I groomed him, talked to him, and gave him the attention

I felt Sunny needed," explains Caputo. "When I'd come by he'd always pick his ears up, always look for me, and always wait to see what I was doing." Soon, the boys from the stable were also talking to Sunny.

"One day I walked in and he literally turned around and looked at me," says Caputo. "He had a little spark in his eye—the first sign that he really had the will to go on. That is when he started getting better. Little by little, Sunny began gaining weight and his health began to improve. It took a long time but it turned out that this skinny, bedraggled little animal was multi-talented. We discovered that he was a trick horse. The farmer who owned Sunny would take him to various fairs and make some money by having him do tricks like lying down and sitting up. Sunny quickly became our leading horse."

Sunny proved to be calm, loving, and gentle, and adept at riding bareback. Eventually, he was used to train the other horses, especially in pulling the chariots. "We actually have not yet discovered all the tricks this animal can do," says Caputo. "We don't know how he went blind in one eye, the accident probably happened about seven years ago. He'll never get his sight back in that eye but that won't stop him from going a long way. Sunny will be coming back to the U.K. with us and will live a life of luxury from now on."

Had it not been for this movie and for the patient care and loving kindness of the people in this production, Sunny would most likely have been put down a long time ago. Instead, he will probably have another fifteen years in the movie business because now Sunny is a star.

LEFT: Sunny the one-eyed wonder rescue horse who became a star on the set, with horse master Peter White. OPPOSITE: Sunny at work with Ingrid Bolsø Berdal.

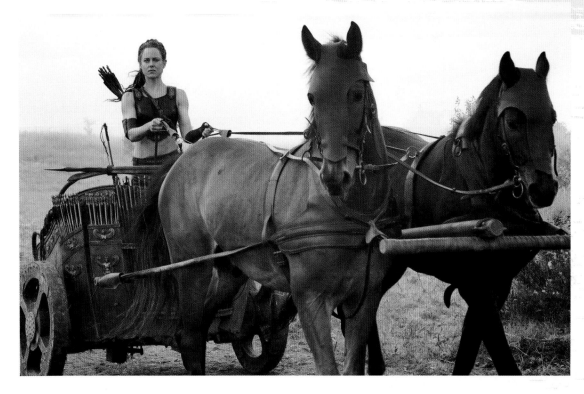

FALLING HORSES

The Rhesus battle sequence required several horses to fall during the action. Though the falling horse stunt is a staple of any western, it has a long and checkered history in Hollywood. In early filmmaking, when a horse was required to fall down, the animal was felled using a barbaric trip wire. That kind of cruel treatment is no longer tolerated on a movie set. These days, horses are trained to fall down on a precise spot that is deeply layered with a straw-like stunt pad to provide a comfortable, safe landing. At a signal from their riders, the horse drops down on his side, lies still for a moment, and then springs back to his feet. The only real danger is to the rider who has to get out of the way before getting kicked in the head or squashed under the animal. The Spanish riders proved to be a tough breed; one stuntman was kicked but had to be forcibly restrained from getting right back on his horse.

Getting a horse to actually fall down by himself, without using a wire, requires a lot of training over a long period of time and simply does not work for every horse. "It takes a certain type of horse to learn how to fall," explains horse trainer Peter White. "They need a very relaxed personality. Training a horse to fall with confidence takes about three to four months. It's a slow process that we start at a standstill, then at a walk, and then build up to a cantor, and finally a gallop. It has to be done by very skilled riders because you can't afford to put the horse under any undue stress or danger."

In this movie, the stunt was made even more complicated because some scenes required more than one horse to fall. "We had up to ten falling horses working at one time," explains White. "It took a lot of preparation and very good stunt riders."

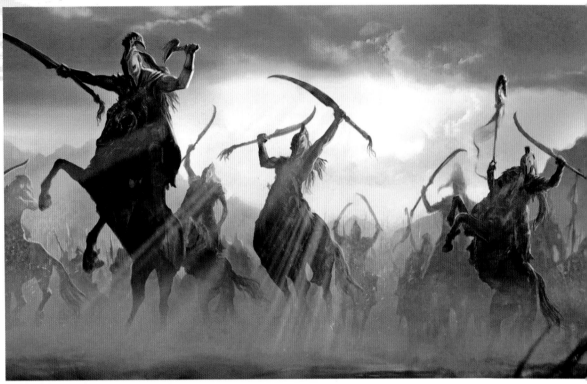

ABOVE LEFT: Study for a Centaur soldier, Weta Workshop, by
Paul Tobin. ABOVE: Painting by Gus Hunter, Weta Workshop, of
the Centaurs attack. LEFT: Weta Workshop, artist Nick Keller.
BELOW: Digital negative painted with riders, artwork by Simon
Gustafsson, Double Negative Special Effects.

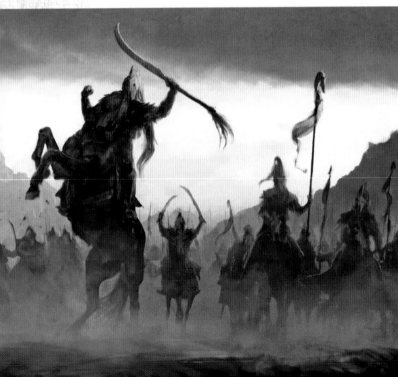

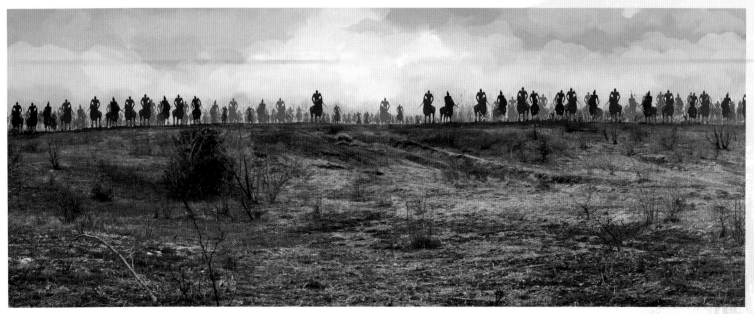

THE CENTAUR

The Centaur is a mythological creature with the head, arms, and torso of a human grafted onto the legs of a horse. This half-human, half-animal was believed to be the embodiment of untamed nature. Centaurs were known for being lusty, uncultured, violent, and overly indulgent drinkers.

Centaurs are first mentioned in the film by Sitacles, who is trying to convince Hercules and his mercenaries to fight for Lord Cotys. "Rhesus is a sorcerer," says Sitacles. "His magic words confuse men, bend them to his will. He leads an army of monsters—half horse, half human."

Later, on the battlefield, eight Centaurs appear in the distant shadows but, up close, we discover that they are not what they seem. Moving into the light, we see they are merely men on horseback whose armor gives them the appearance of being mythological creatures.

ABOVE: This is a digital negative that was taken during a location shoot and then soldiers were painted onto the neg. The location was not used. RIGHT: Rhesus and Centaur concept drawing by Weta Workshop artist Long Ouyang.

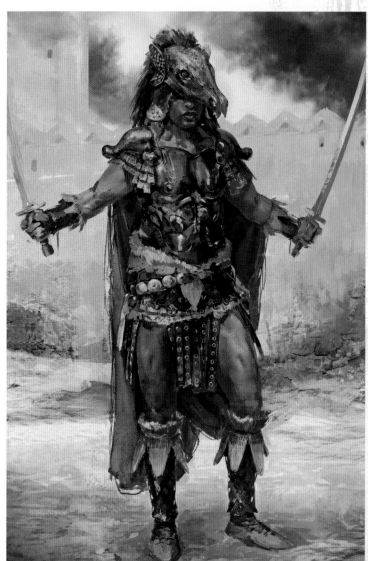

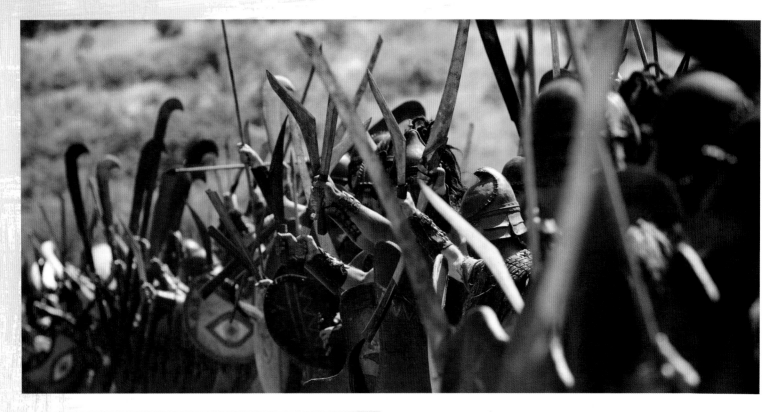

THE RHESUS ARMY: WEAPONS & WARRIORS

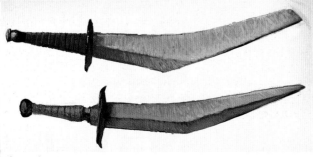

While the weapons for the Bessi warriors were as blunt and primitive as the tribe itself, the generic weapons for the Rhesus battle had to represent a multitude of tribes. In the story, for this battle, Rhesus has gathered together many different tribes to combat the army of Cotys. These were supposed to be warriors from all over Greece. It would only be logical then to assume that all of these tribes had different shields, decorated with symbols that identified where they came from. Though the varying designs might not be obvious to the audience, they nonetheless added authenticity to the battle scenes.

The style of the weapons also had to display a lot of variety. In addition, the weapons had to be aged. The filmmakers wanted the bronze to look as though it had been left out in the rain. "We had two crews working on the weapons," explains Tim Wildgoose, the supervising armorer. "All the hero weapons were made in our studio in West London. Then we had a crew in Hungary that prepped all the generic weapons for the background actors."

The weapons used in the battle scenes went through a constant cycle of repair and reuse, which actually worked in the filmmaker's favor, as this made the weapons look as if they'd been used many times over. As much as everyone wanted the battle scenes to look totally authentic, certain precautions had to be taken to insure the safety of the participants. The shields that the extras carried for protection, for example, were made out of rubber so that the stuntmen would not be injured when they fell or rolled over on the ground.

OPPOSITE: Weapons used for the Rhesus battle. Concept art by Cristian Pearce, Weta Workshop. ABOVE: Designs for various pieces of armor from different tribes. Artwork by Michael Eaton. FAR RIGHT and BELOW: Character concept art by Aaron Beck, Weta Workshop, depicting a Tribali warrior with burning hair. RIGHT: The look was used but without the flaming dreadlocks.

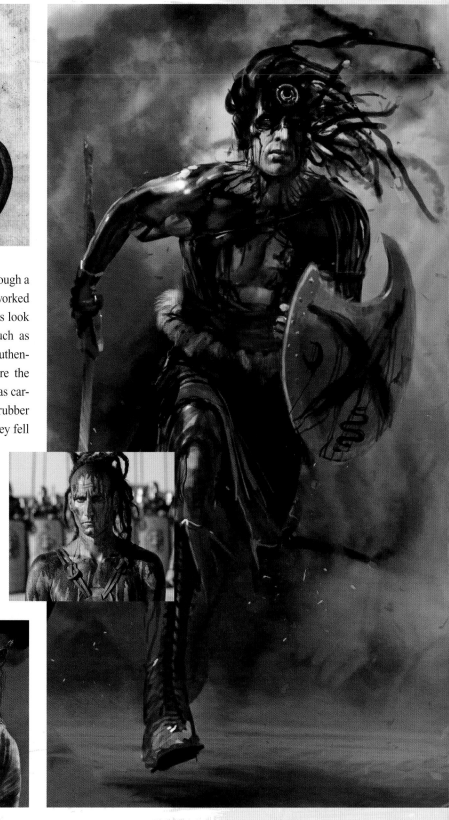

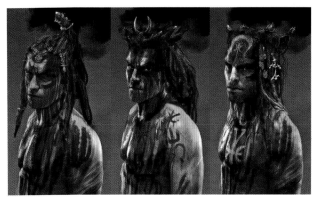

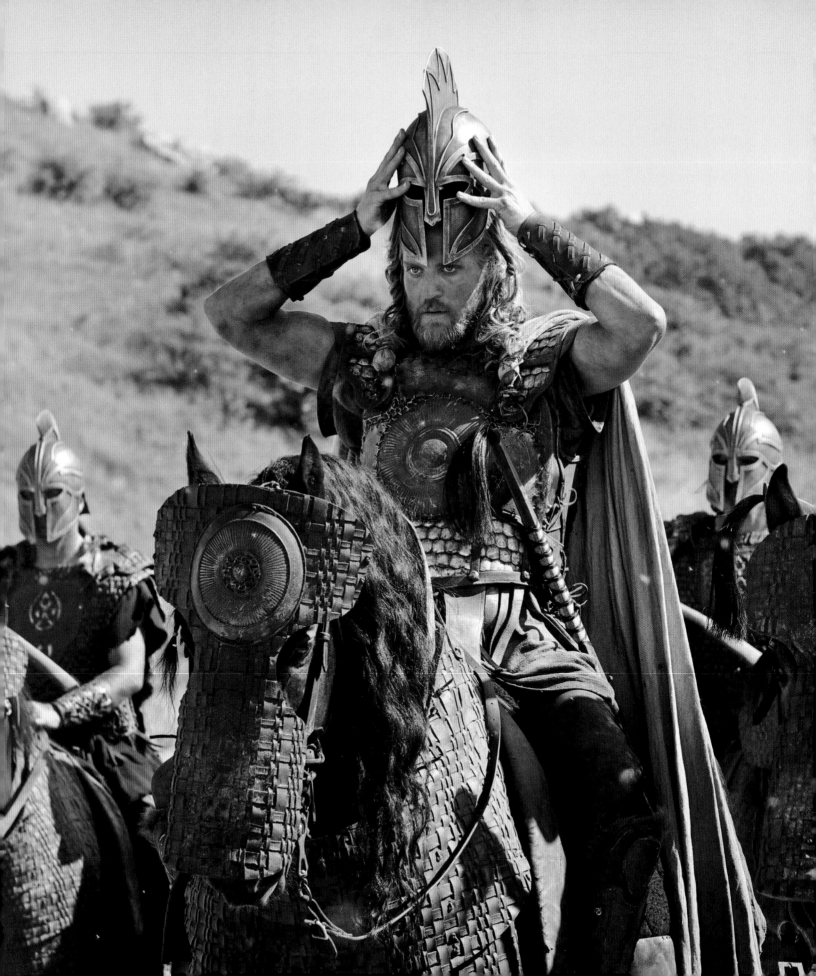

THE RHESUS BATTLE

There are two main battles in the film, which lead up to the climatic ending at the Citadel. The first battle is with the Bessi warriors and it was meant to be very chaotic. Not only are the Bessi warriors a primitive tribe but the army of Lord Cotys, at this point in the story, is mostly composed of farmers with very little training in the art of warfare. Following this battle, the farmers are whipped into shape by Hercules and become a unified group, which alters the tenor of the second battle sequence.

In the first battle the army is using oblong shaped armor that is clumsy and clearly not designed to make fighting easier. "I wanted it to look as if it were from Northern Greece," explains Jany Temime, "and I also wanted to make a strong contrast between that and the new armor." Hercules provides a much different set of armor for the army. "Hercules designed the new armor to be lighter, stronger, and easier to move in," says Temime. "The helmets were a lot smaller." And the new shields now bear the lion emblem, which is the trademark of Hercules.

The training and the new armor altered the fighting in this second battle. "The Rhesus battle was more organized," explains stunt coordinator Greg Powell. "Now the Cotys army, because of Hercules' training, has learned how to use their weapons. They've learned how to use the shield wall properly. They take commands instantly. Everything becomes a tight unit so it's very hard for Rhesus and his men to break through."

Rhesus (Tobias Santelmann) and Phineus (Joe Anderson) prepare for battle.

129

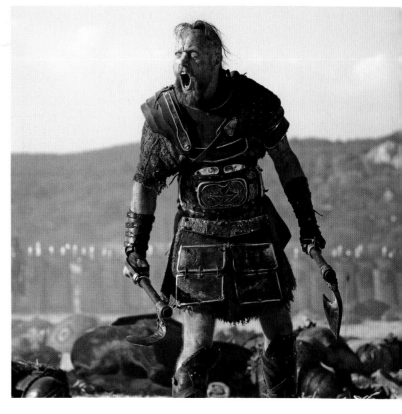

The battle is nonetheless action packed and thrilling. Unlike the Bessi battle, horses and chariots are a major element in this sequence, adding both danger and complication to shooting the scene. "During the Rhesus battle, there was a lot of action going on," says horse trainer Peter White. "We had falling horses, horses knocking people over, saddle falls (guys pulled off their horses with wires), lots of near misses, smoke, and flying debris. We used about twenty-five stunt riders for the sequence. It was pretty intense."

Though the battle scenes appear to be complete chaos, each move for each character is carefully planned, starting with the storyboards (below). Art by Giles Ashbury, adding to previz panels.

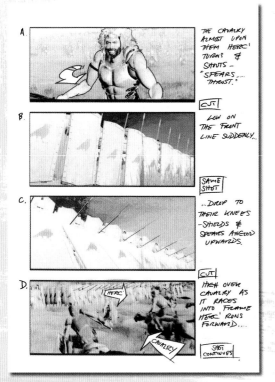

A. THE CAVALRY ALMOST UPON THEM HERC' TURNS & SHOUTS - "SPEARS.... THRUST."
CUT

B. LOW ON THE FRONT LINE SUDDENLY...
SAME SHOT

C. ...DROP TO THEIR KNEES - SHIELDS & SPEARS ANGLED UPWARDS.
CUT

D. HIGH OVER CAVALRY AS IT RACES INTO FRAME HERC' RUNS FORWARD.... HERC CAVALRY
SHOT CONTINUES

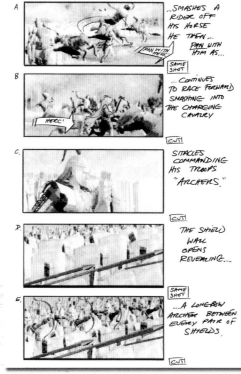

A. ...SMASHES A RIDER OFF HIS HORSE HE THEN... PAN WITH HIM AS...
PAN WITH HERC
SAME SHOT

B. ...CONTINUES TO RACE FORWARD SMASHING INTO THE CHARGING CAVALRY HERC'
CUT

C. SITACLES COMMANDING HIS TROOPS "ARCHERS."
CUT

D. THE SHIELD WALL OPENS REVEALING....
SAME SHOT

E. ...A LONGBOW ARCHER BETWEEN EVERY PAIR OF SHIELDS.
CUT

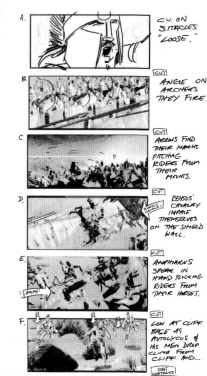

A. CU ON SITACLES "LOOSE."
CUT

B. ANGLE ON ARCHERS THEY FIRE.
CUT

C. ARROWS FIND THEIR MARKS PITCHING RIDERS FROM THEIR MOUNTS.
CUT

D. RHESUS' CAVALRY IMPALE THEMSELVES ON THE SHIELD WALL.
CUT

E. AMPHIARUS SPEAR IN HAND PLUCKING RIDERS FROM THEIR HORSES. AMPH'
CUT

F. LOW AT CLIFF BASE AS AUTOLYCUS & HIS MEN DROP CLIMB FROM CLIFF AND....
SHOT CONTINUES

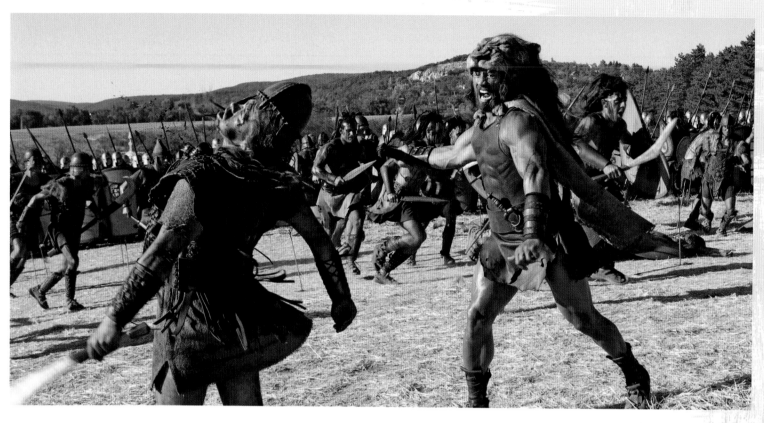

...HURLS KNIVES & JAVALINS INTO...

CUT

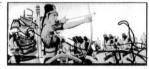
...RHESUS CAVALRY TAKING DOWN EVEN MORE.

CUT

ANGLE ON ATALANTA AS SHE FIRES ARROWS...

SAME SHOT

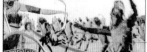
...THIS WAY & THAT AND USES HER BOWS...

SAME SHOT

...BLADE TO SLICE UP THE ENEMY ONE OF WHICH FLYS TOWARDS CAM AND...

SHOT CONTINUES.

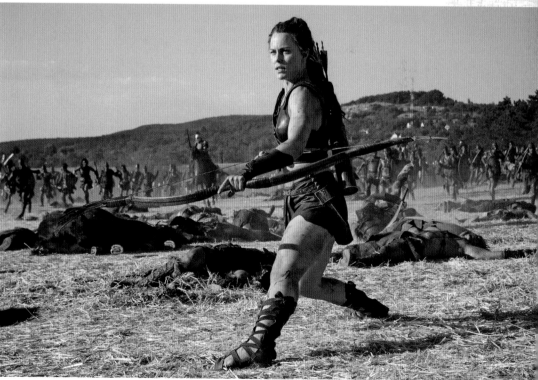

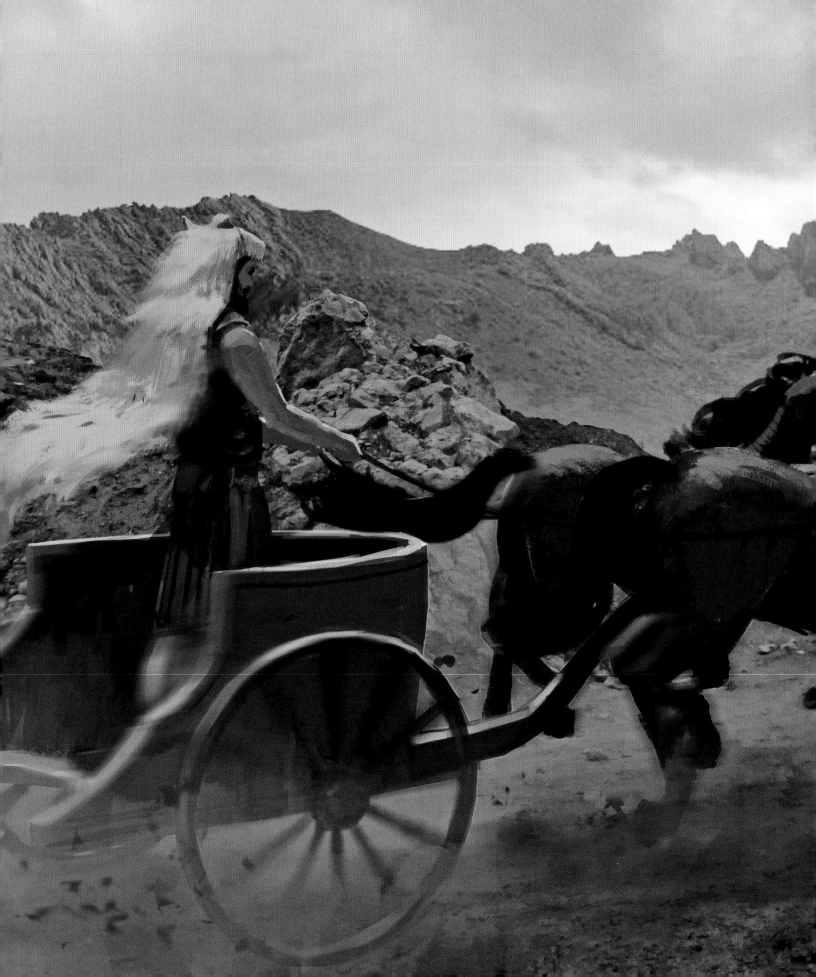

ATTACK AT THE CITADEL

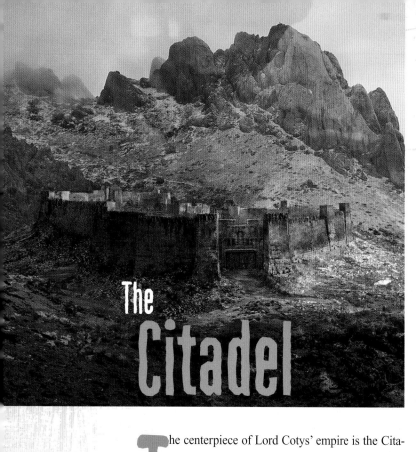

The Citadel

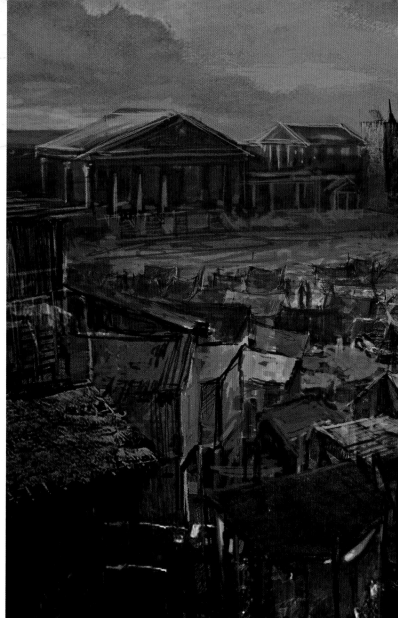

The centerpiece of Lord Cotys' empire is the Citadel, which rises like a phoenix from the earth. "The concept behind the Citadel set was that it was built into the side of a mountain," explains production designer Jean-Vincent Puzos. "The courtyard was carved out like a crater in a volcano. I wanted to give the impression that they used the stone of this mountain to build the Citadel and the city."

Constructed at the Origio studios on the outskirts of Budapest, the set was also the largest structure built for the movie, approximately seventeen hundred square meters with thirty-five-foot walls. "The scale is massive," explains Puzos. "You have to create levels using thousands of steps, literally. I felt like a kid with a Lego set. It was very exciting to construct."

The centerpiece was a magnificent altar to the goddess Hera that sat at the top of a huge staircase lined

PREVIOUS PAGE: Digital negative painted with Hercules and his chariot, artwork by Simon Gustafsson from Double Negative Special Effects. ABOVE and ABOVE RIGHT: Concept art of the Citadel and the Citadel courtyard by Mathilde Abraham. RIGHT: Cross section of the Citadel facade by Kamen Anev.

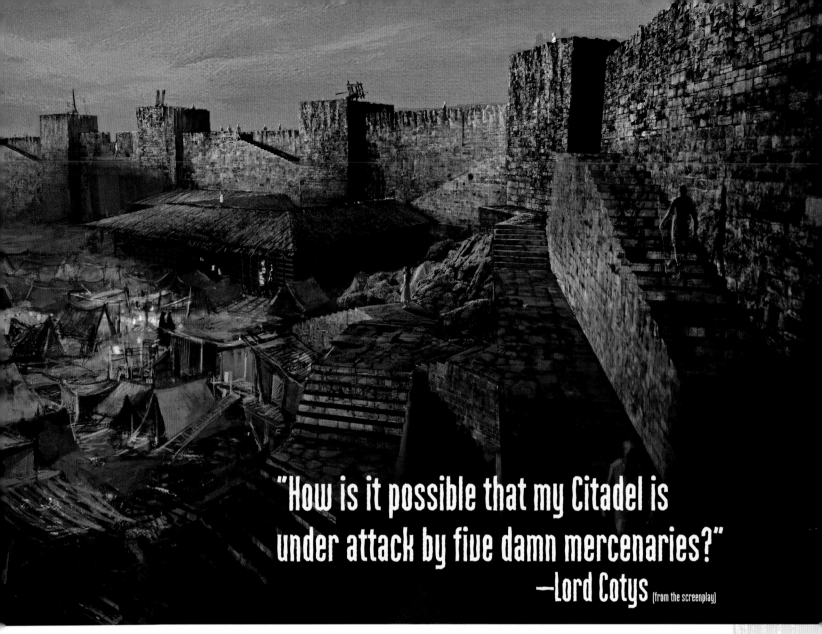

"How is it possible that my Citadel is under attack by five damn mercenaries?"
—Lord Cotys [from the screenplay]

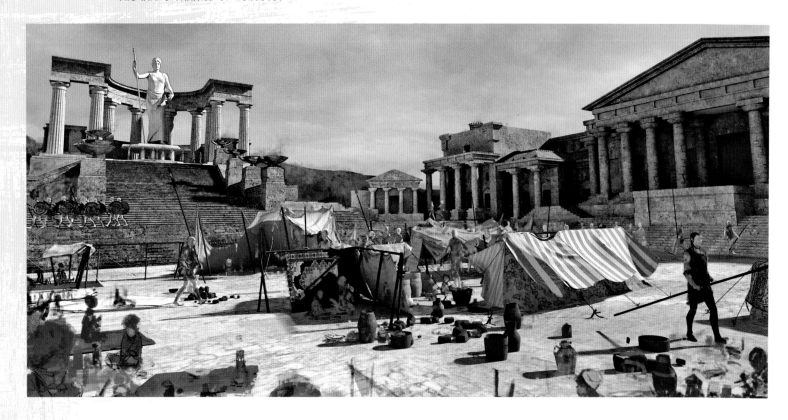

"A century and a half before our story, the kings of Thrace selected the spot of a dormant volcano for their Citadel. Two reasons: 1) its height and location allowed it to dominate the surrounding countryside, plus the natural volcanic walls enhanced by human construction made it impregnable; and 2) the natural hot springs running and streaming beneath the ground provided heat in the cold Thracian winter months."

—EVAN SPILIOTOPOULOS, SCREENWRITER

with flame-filled braziers. The classical white marble beauty of her statue was a sensational contrast to the grittiness of the set.

On the left side of the massive set, Puzos constructed a refugee camp designed to house thousands of people. There was a stable for hundreds of horses. The attention to detail was stunning; even though there were no plans to shoot inside the dwellings, the interiors of those rooms were nonetheless camera-ready.

Color played a major role in the set design. "We wanted it to be very dense, gritty, and dark so to do that we had to go to monochrome, which can be boring, so we played with many different layers of brown, purple, and brown stone. I decided to paint all the wood red," adds Puzos. "In Greece they used to paint everything in bull's blood because it is very dense. It connected everything to the primitive feeling that the bull was pro-

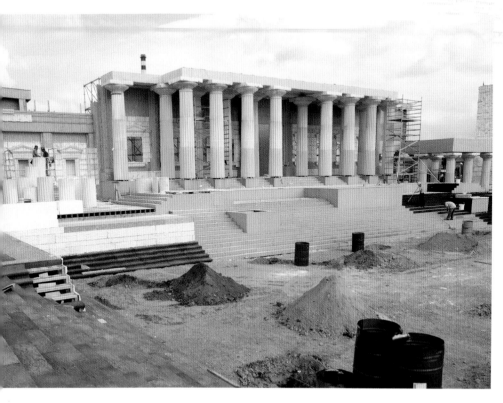

tecting the people and was a way for me to define the texture of the walls. This was beautiful because all of the actors are moving in front of this like a jewel box." The muted colors and dark patina also helped age the look of the set.

"The Citadel set felt as if it had been there for centuries," says Brett Ratner. "It was nothing like walking onto a set on the back-lot of a studio. It looked and felt real, and the audience will feel that when they watch the film."

Before building began, the construction department hauled in hundreds of tons of rock and soil to serve as the foundation and create the surrounding mountain

OPPOSITE ABOVE: 3D render of the Hera statue and Cotys'
courtyard. ABOVE: The Citadel under construction. RIGHT: Special
effects supervisor Neil Corbould, director Brett Ratner, production
designer Jean-Vincent Puzos, and set decorator Tina Jones.

backdrop to the fortress. "I brought the black soil from another part of Hungary because here the soil is too light," explains Puzos. "It was better to have darker soil to connect to the color of the mountains."

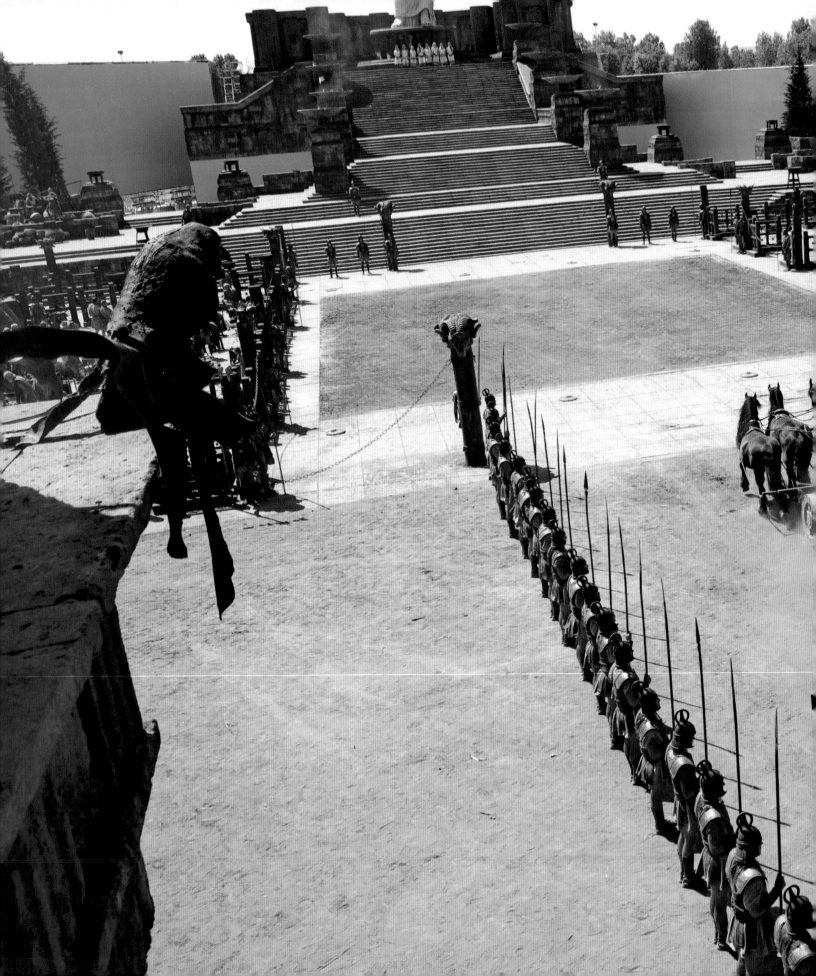

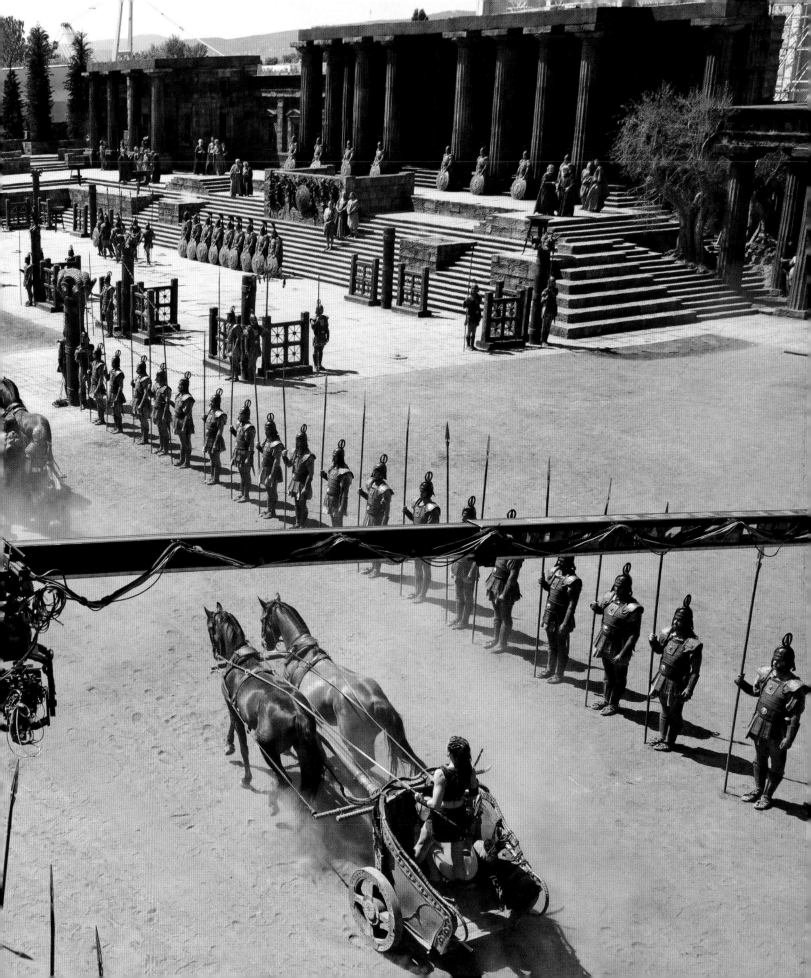

THE CROW AND THE LION

Two gigantic carved wooden gates framed the imposing entrance to the courtyard. In decorating the interior, Jean-Vincent Puzos wanted to avoid using the kinds of flags, banners, and drapes seen in so many period movies. Were these decorations historically accurate? "In our research, we didn't see much of that in Greece," admits set decorator Tina Jones. "So we decided to use metal standards for the army and battalions to carry."

It was decided that the strong visual image of the crow would be used to symbolize the empire of Lord Cotys. "The ancient Greeks—the Thracians, Macedonians, and Spartans—were fighters," explains Puzos. "They didn't carry a lot with them. What was important to them was the emblem that could be used on their armor, or carved into a rock. I used this idea that is accurate for the period, but turned it into something more poetic and creative, to give the impression of being surrounded by animals."

The production department created hundreds of metal crows and then left them outdoors to naturally weather and rust. Then the metal crows were integrated into the walls of the Citadel, and eerily looked down from the top of the giant gateways. "There are so many crows it looked like a dramatic pattern," says Puzos. "The symbolism is that they are there to watch out for the kingdom."

The theme was continued in everything related to Cotys; crows can be found watching over every camp and every tent, as well as on the shields of Cotys' army and on his chariot. "I think the imagery works really well for Cotys," explains Jones. "We were able to use the crow with open wings on his chariot and then repeat the symbol within the Citadel."

PREVIOUS PAGE: Behind-the-scenes shot of Hercules and Atalanta entering the Citadel set. ABOVE: A crow watches over Lord Cotys and the Citadel. RIGHT: Detail of the elaborate Citadel entrance.

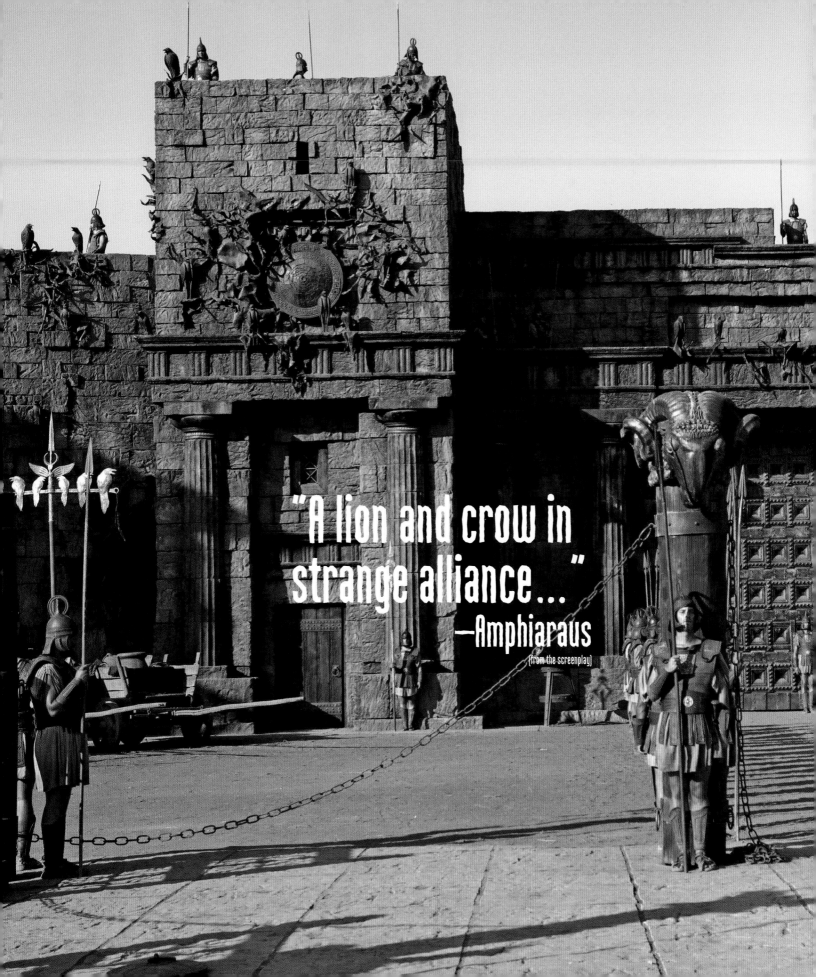

"A lion and crow in strange alliance..."
—Amphiaraus
(from the screenplay)

Inside the Citadel

THE THRONE ROOM

On the stages adjacent to the exterior Citadel set, Jean-Vincent Puzos built Cotys' enormous throne room. The design incorporated classical lines using columns, stone, and fire to create the atmosphere. The room is dominated by a massive throne and a huge map made of animal skins where Hercules and Cotys plot their campaign. Corridors surrounding the room lead to the dungeon.

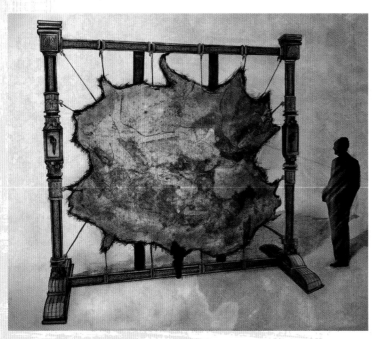

ABOVE: Concept drawing for the map in Lord Cotys' throne room by Hungarian artist Renátó Cseh. RIGHT: The throne room set dressed and ready for shooting.

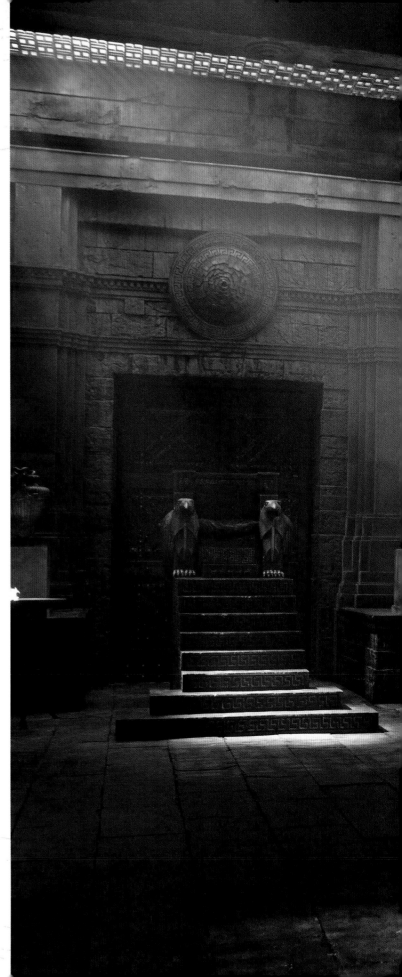

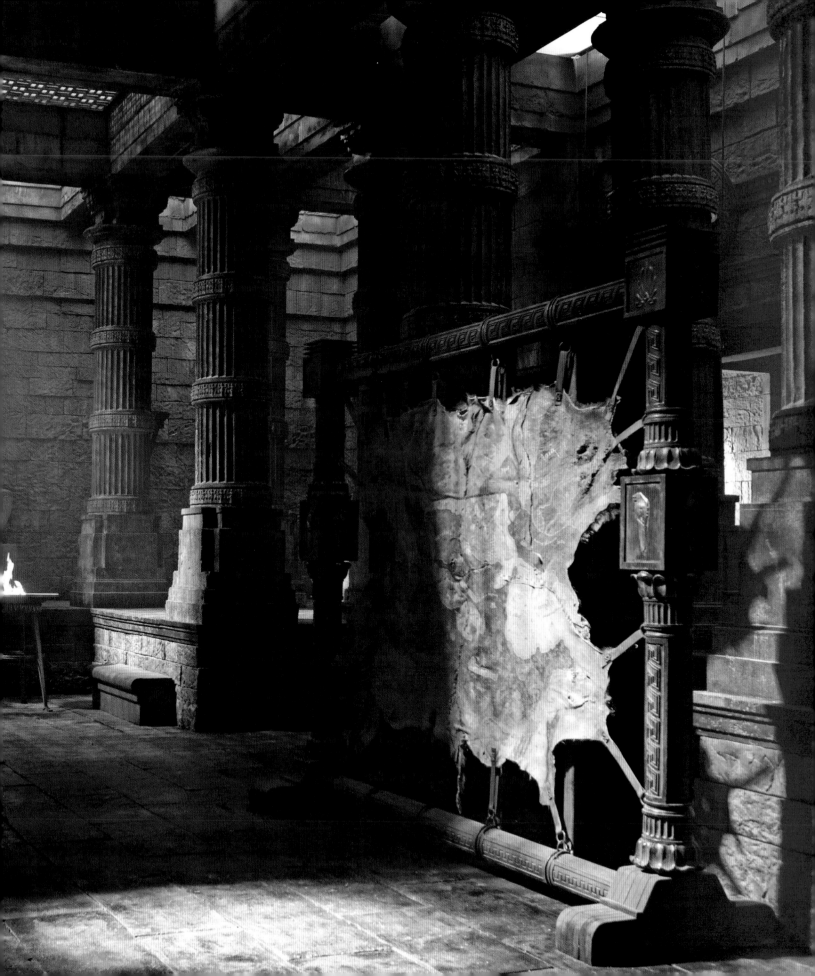

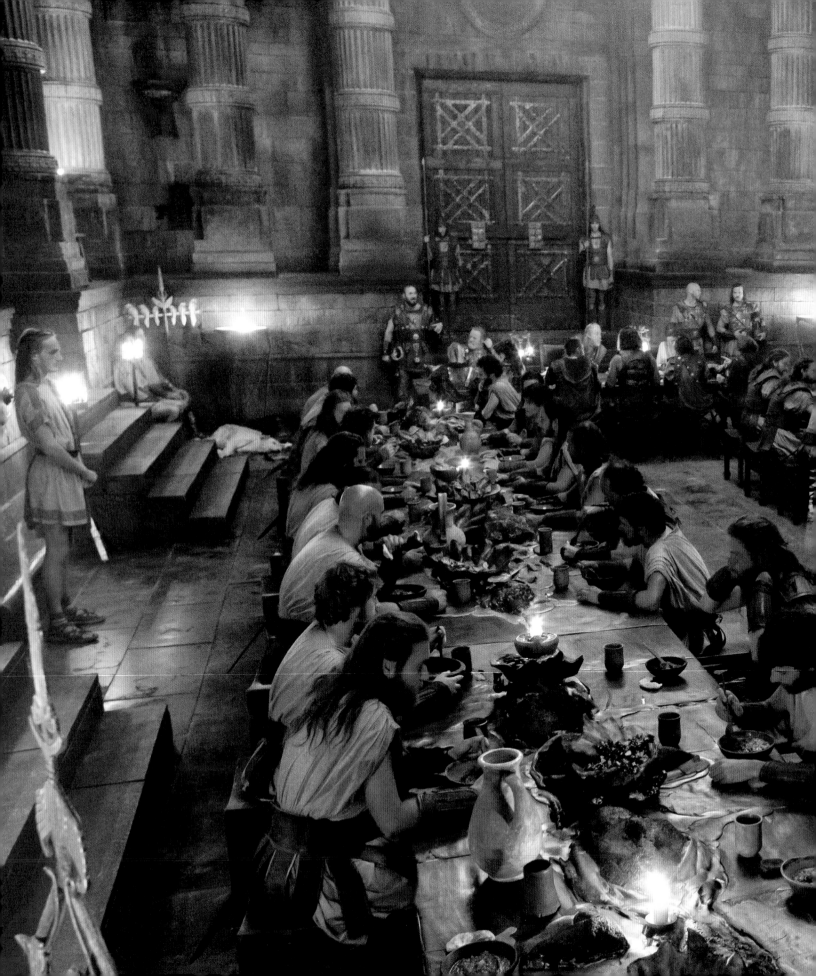

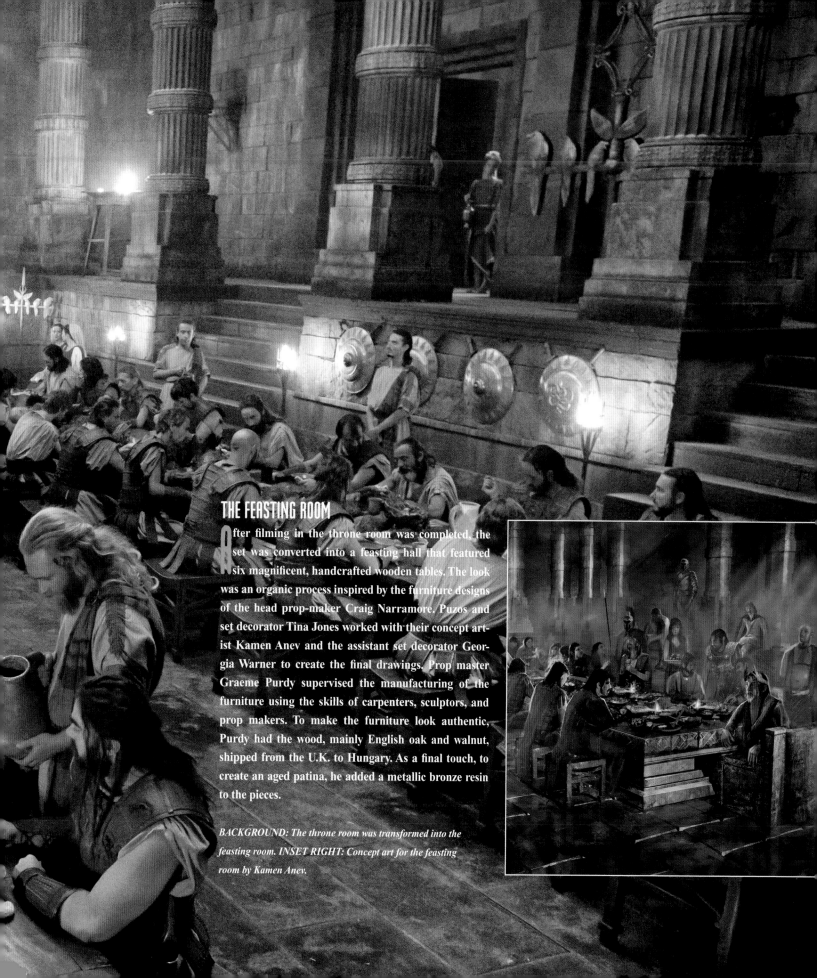

THE FEASTING ROOM

After filming in the throne room was completed, the set was converted into a feasting hall that featured six magnificent, handcrafted wooden tables. The look was an organic process inspired by the furniture designs of the head prop-maker Craig Narramore. Puzos and set decorator Tina Jones worked with their concept artist Kamen Anev and the assistant set decorator Georgia Warner to create the final drawings. Prop master Graeme Purdy supervised the manufacturing of the furniture using the skills of carpenters, sculptors, and prop makers. To make the furniture look authentic, Purdy had the wood, mainly English oak and walnut, shipped from the U.K. to Hungary. As a final touch, to create an aged patina, he added a metallic bronze resin to the pieces.

BACKGROUND: The throne room was transformed into the feasting room. INSET RIGHT: Concept art for the feasting room by Kamen Anev.

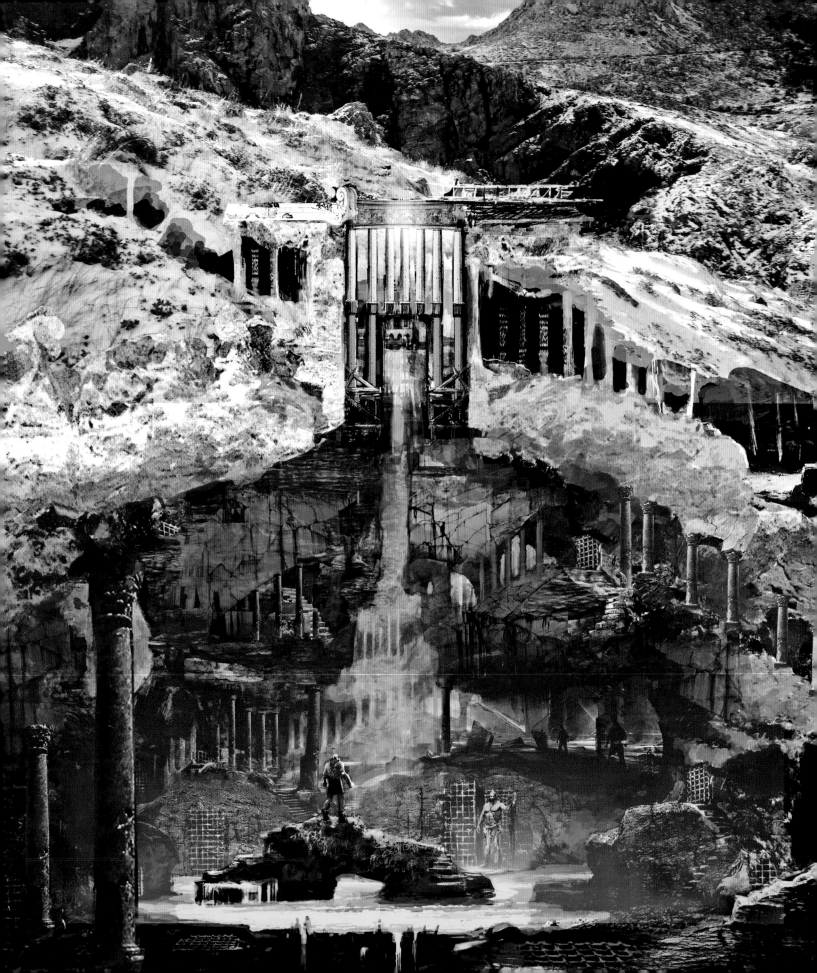

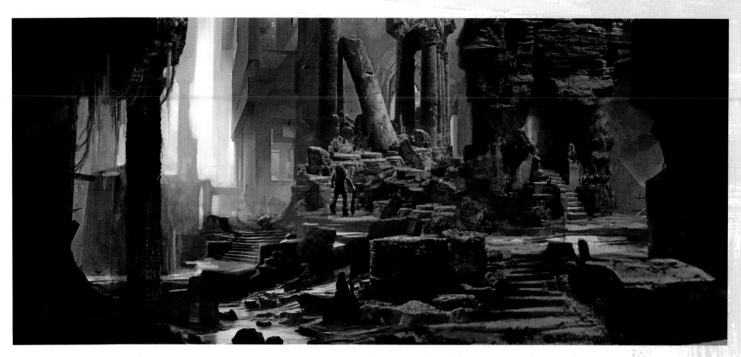

THE DUNGEON

The dungeon set was perhaps the most intriguing and fun set for the designers. "The dungeon was like the inside of a volcano," explains Puzos. "I think it is the most impressive of all the sets because of the pattern we created with the stones, the fire, and the green river of sulfur that flows through it."

Decorating the set was a joy for Tina Jones. "There were a lot of cages with skeletons of prisoners who'd been there for a long, long time. We also had bits of decomposing bodies," she says enthusiastically, "an executioner's block, and ropes and chains everywhere. The centerpiece is where Hercules is chained up and taunted by King Eurystheus and Cotys."

Both Puzos and Jones were extremely impressed with the skills of the Hungarian artists who worked on the set. "Shooting in Budapest was a very good choice," says Puzos. "Budapest has a great tradition of building sets. There are a great many painters, sculptors, plasterers, and construction technicians."

Jones agrees. "There is an amazing pool of talent here. I had a couple of people from the U.K., but the rest of my team was Hungarian."

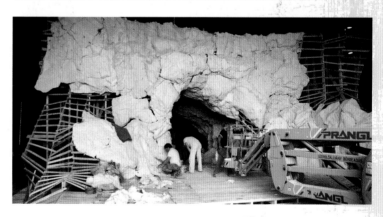

OPPOSITE, TOP and FOLLOWING PAGES: Concept drawings of the dungeon by Mathilde Abraham. ABOVE: Scale model of the dungeon set and the set construction. PAGES 150-151: Shooting on the final dungeon set.

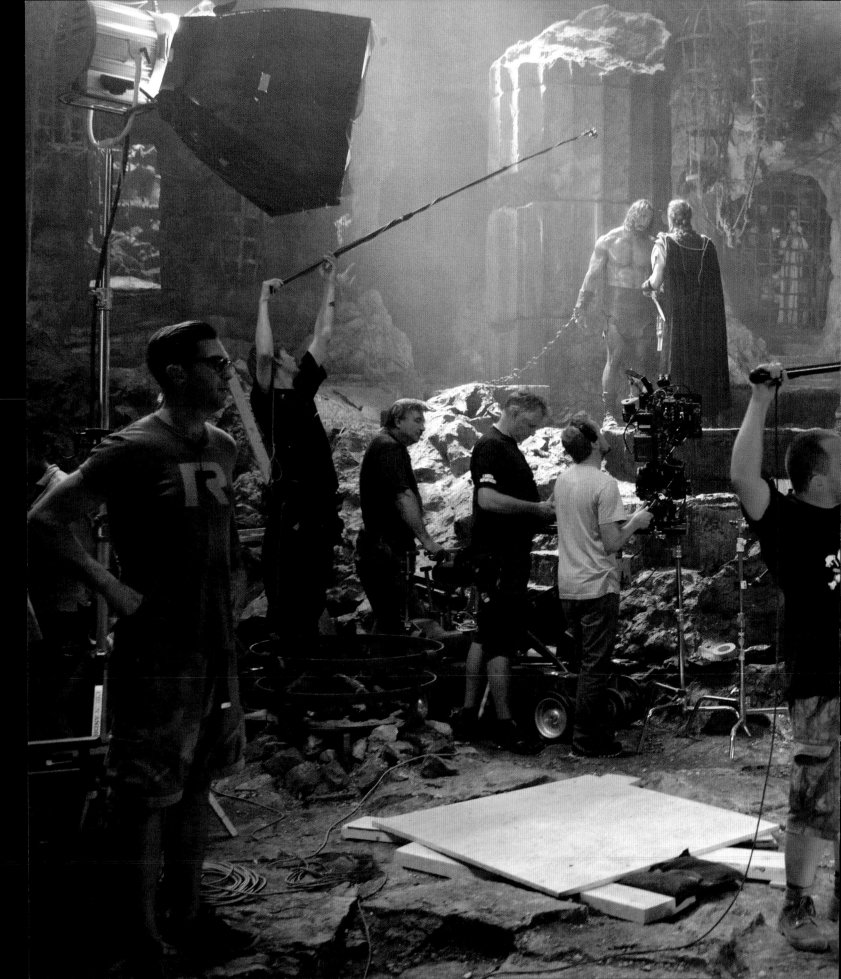

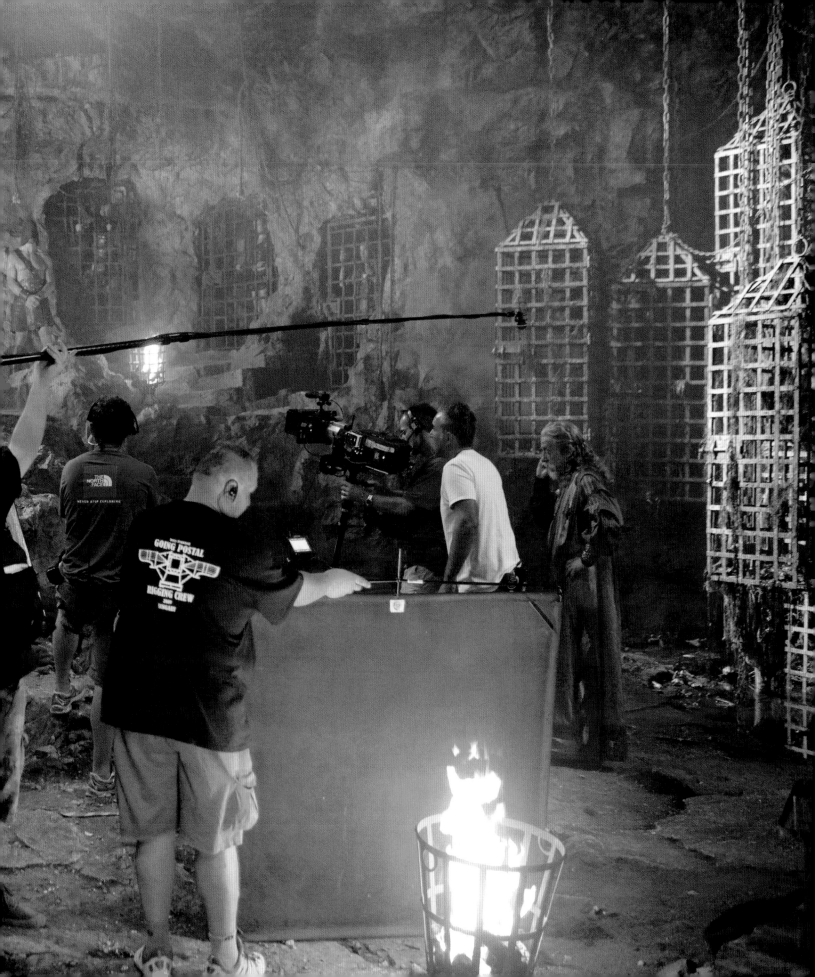

JANY TEMIME
Costume Designer

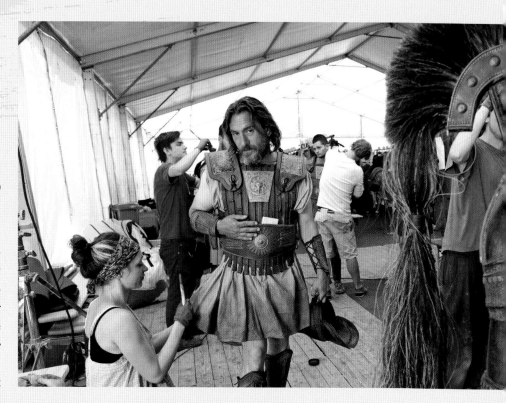

To design the costumes for *Hercules*, the filmmakers hired Jany Temime, who designed the costumes for six of the blockbuster *Harry Potter* movies and, more recently, Alfonso Cuaron's *Gravity* with Sandra Bullock.

"One of the most important things we impressed on Jany was that Hercules and his band should not wear more than one outfit. Brett was really adamant that everything had to feel real and lived in. These guys don't come out of a catalogue," chuckled producer Beau Flynn. "There were no washing machines back then."

Each of Jany Temime's costumes was carefully conceived to reflect the personality of the character for whom she was designing. "She could show off all day long and design the most flamboyant, most beautiful, most magnificent costumes ever, but she designs for the character," explains Brett Ratner. "Jany creates a whole back story for each person before she even begins to sketch."

After her initial talks with Ratner, Temime immersed herself in images of ancient Greece. One of the first things she discovered was that very few movies actually covered the period of 350 B.C. "Most of our mental images come from the written word," she explains. "There was a lot of poetry and plenty of archaeological data to pull from, but I had quite a lot of freedom since the film takes place in the Kingdom of Thrace instead of Athens." The two cities had very different cultures.

"Our image of Greece is that everything is white and pure," she says, "so it was very interesting for me to design the different tribes and to have to establish the cultures between the Thracians who are now Bulgarians, and the Athenians who were much more elegant and sophisticated." Temime was keen to show the many facets of Greece during that period.

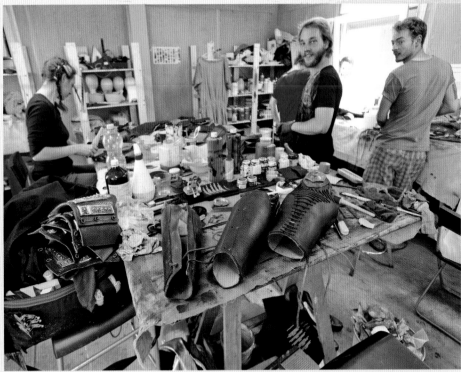

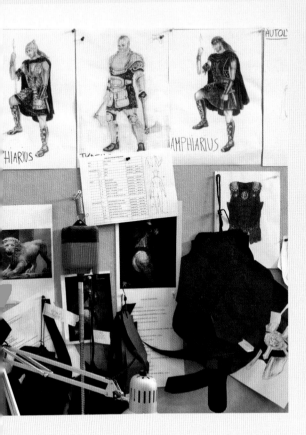

ARMOR

The armor worn by the actors continued to evolve as they rehearsed the fight sequences. "The armor could look fantastic on paper, but when actors start working, problems begin to show themselves," explains Temime. "It could be a plaque on the front that doesn't allow them to bend or a piece that doesn't allow a certain movement. So you need to re-design, re-mold, and remake the shape of the piece until you find the perfect one."

The armor also needed to look as if it had been used. "In theory, each of the mercenaries assembled their armor over the years, picking up pieces here and there on the battle field," explains Temime. "They created something that was very personal for them to enhance the choreography of the way they fought. There is a sort of symbiosis between the armor they wear, and the weapons they use."

ABOVE LEFT: Working in the makeshift dressing rooms set up in the middle of an empty field in Hungary. TOP: Wardrobe technicians aging leather. ABOVE RIGHT: Director Brett Ratner and costume designer Jany Temime. LEFT: Costume designs on display in the workroom.

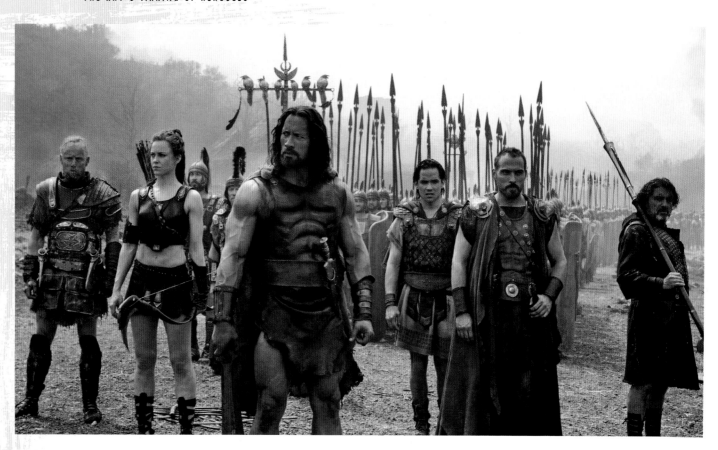

THE MERCENARIES

Jany Temime began by designing for Hercules and his band of mercenaries. "They fight for a living so they have different needs," she explains. She created the lion cape for Hercules, a long leather cape for Autolycus, and a skimpy but fierce two-piece leather outfit for Atalanta (Ingrid Bolsø Berdal), which was a particular joy.

"Ingrid has an amazing body," says Temime. "It's like a sculpture. I wanted to give her the least possible costume to show it off. In the beginning, I was concerned because I didn't see how she could fight with so little protection, but as the character evolved it became apparent. Atalanta is a very spiritual person who always prays before she fights; she believes that her mind protects her."

Because of the outfit, Berdal found herself standing straighter and walking taller. "I'm not wearing that much so you can't really relax in this costume," admits the actress.

A blue cape was a major part of the costume for Iolaus and proved to be quite a useful prop for the actor. "I had Iolaus use the cape for all kinds of things," says Reece Ritchie. "For drama when he's telling stories and, when he's at battle he throws it back so it's out of the way, presenting himself as a different kind of soldier. Also it was a blanket when he slept. That cape really represented the character for me."

Temime dressed Amphiaraus to honor his spiritual status. "Amphiaraus is a priest and a seer," says the designer. "He has seen his own death and thinks he is invincible so I gave him the shortest and softest armor because he doesn't believe he needs it. I put him in

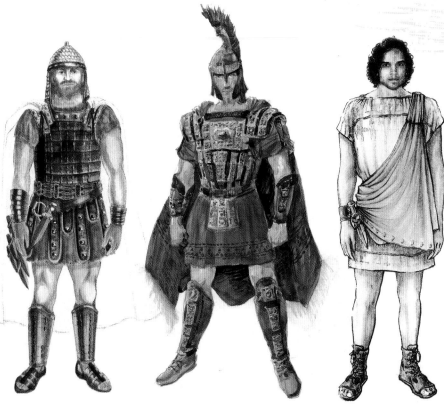

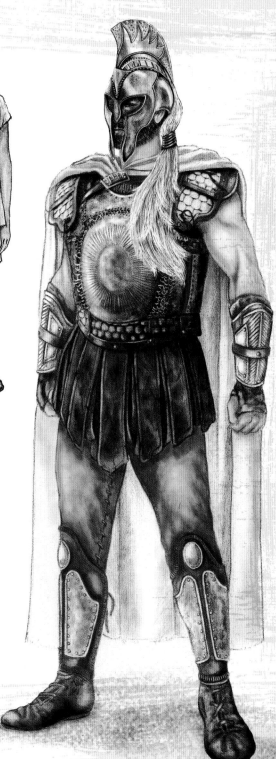

dark purple which is the color of a priest." Actor Ian McShane enjoyed wearing his outfit. "This movie is a classic cat and mouse story except it's set three thousand years ago and we get to wear these wonderful costumes," he said.

To dress Rhesus, played by Tobias Santelmann, and his army, Temime used a lot of leather. "Rhesus' army is mostly made up of tribal groups," she explains. "So we used many handmade things including animal skins and lots of fur. The warriors are really wild, with painted skin and platted hair. When you first see Rhesus, he gallops in on a stunning horse with his long hair flowing behind him; he looks very beautiful."

OPPOSITE: The mercenaries on set in full costume. ABOVE: Early concept ideas for their costumes, which of course had to look appropriate to the times but also function during the battle scenes.

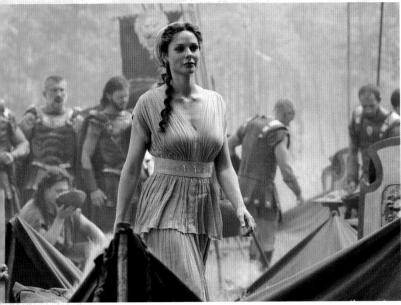

Temime spared no expense in creating an outfit for Joseph Fiennes, the other king in the story. "Eurystheus is a very cruel man; he's all elegance with a slight tinge of sadism," says Temime. "He wears dark blue and gold with lots of medals to show everyone that he thinks of himself as a super king. We made a cape with peacock feathers inside, and we used a thousand feathers cut out of silk. I wanted to see the eye in every feather. It was very hard work and the worst part was that when we finished that cape, we needed to make two more."

NOBILITY

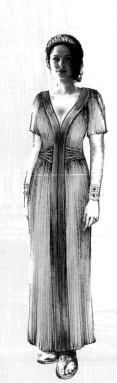

Dressing the kings and queens in the movie presented different challenges. Temime decided to use earth tones of ochre, browns, and yellows for the Cotys' kingdom so that the characters would seamlessly blend into the Citadel and throne room sets. Ergenia's costumes, for example, were designed to be earthy while still reflecting her status as nobility. "I made Ergenia's costume yellowish, like all the costumes in the Cotys' kingdom, to match the walls of the Citadel," explains Jany Temime. "Ergenia belongs to the Citadel because Thrace is what she is fighting for."

At first, Ergenia's costumes have an earthy tone but then change color as she, like everyone else, realizes who is the real enemy of Thrace. Ergenia learns she doesn't think the same way as her father. She falls in love with the enemy. Once she discovers her real personality, she becomes a queen and her costumes reflect that evolution.

Costumes for the nobility, including Ergenia and King Eurystheus, were more elaborate and elegant than those of the mercenaries.

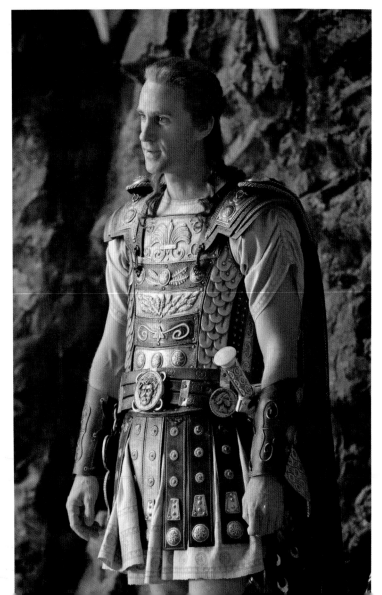

HAIR
Classic Yet Modern

Aldo Signoretti has had a distinguished career as the hair stylist for such epic and historical movies as *Capote, Gangs of New York, Troy,* and *Apocalypto*. "For each movie I had to create a look that reflected my personal vision yet was coherent with the historical context of the story," Aldo says, adding that, "for *Hercules* I wanted characters that were striking and clearly defined by their hair. I didn't want to create a Greek world made of traditional 'pretty and curly blond' hairstyles. I asked Brett if he preferred a more imaginative or realistic/epic look. He opted for epic yet unconventional which was a starting point for my imagination."

Signoretti brought a modern interpretation to his vast visual knowledge of the period. Atalanta's hairstyle, for example, recalls her belligerent and cold-blooded nature, exemplified by the color red, which matches her personality and contrasts with her light skin. "Her non-conven-

tional look falls somewhere between an Amazon and a Greek divinity," explains Aldo.

Lord Cotys wears a long white wig to symbolize his longevity and wisdom. "The producers rejected my first test and imagined Cotys with short hair as being more appropriate to his age," says Aldo, though they eventually came around to agreeing with his interpretation of the character.

Inspired by the nobility of Ergenia, daughter to Lord Cotys and a healer for the sick and injured, Aldo chose a dark color hair to contrast with the actress' fair skin. "I opted for longer hair with lighter strips," he says. "Ergenia's hairstyle falls in between the Roman and Greek culture."

As for Hercules himself, Aldo claims that, "Brett wanted Dwayne to have long hair and a full beard and, in the end, Dwayne inspired his own look. His style was a consequence of his personal image."

Aldo Signoretti at work on Rebecca Ferguson (above) and on set with Brett Ratner (left).

DANTE SPINOTTI
Cinematographer

Born in 1943 in Tolmezzo Italy, Dante Spinotti has been nominated three times for an Academy Award® for his work on Curtis Hanson's 1997 period drama *L.A. Confidential*, Michael Mann's *The Last of the Mohicans,* and the acclaimed true-life drama *The Insider*. The world-renowned cinematographer has worked with Brett Ratner on several previous pictures including *X-Men: The Last Stand*, *After the Sunset*, and *The Family Man*, among others. Interestingly, Spinotti shot Michael Mann's 1986 *Manhunter*, based on the Thomas Harris novel, *Red Dragon*, and then, in 2002, he filmed Brett Ratner's *Red Dragon*, another adaptation of the same Harris novel.

For Ratner, the importance of cinematography is never far from his mind. "We're telling stories for the camera, and many filmmakers forget that," says the director. "Naturally you need a great script and wonderful actors, but it is the camera that tells the story. Dante makes you forget the camera exists. He really loses you in the world. He shot a classical movie, and he'll tell you that he's never filmed a movie like this before. It's an honor to work with him."

Everyone on set agreed that Spinotti brought a wealth of experience and talent to the project. "Dante is a master," says producer Beau Flynn. "He paints with light. He is one of the best cinematographers that ever lived. Working with him is a privilege. Brett has such respect for the camera and for light. The two of them work together hand-in-hand. I don't think I've ever seen a director and DP work that closely. They have incredible respect for each other, but what creates great art is friction and the two of them were constantly butting heads in a very healthy way. Brett wanted giant shots but Dante pushed back about composition, lighting, framing, and time of day. Once they merged, it was beautiful."

Cinematographer Dante Spinotti and a still from one of the dungeon scenes.

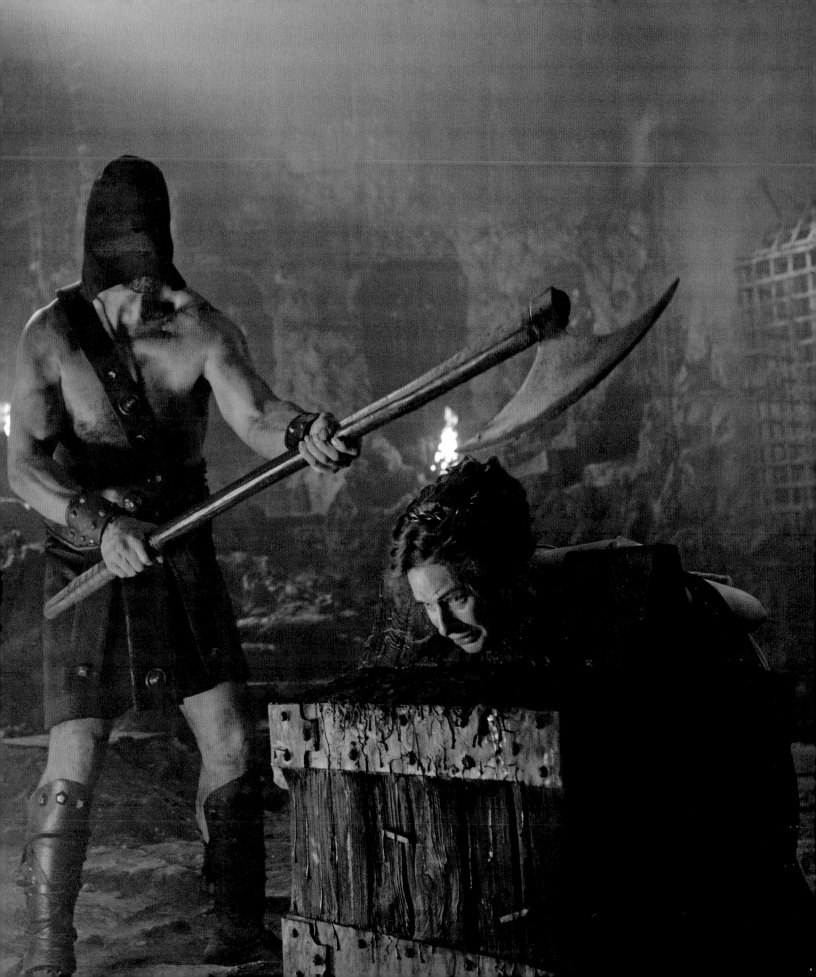

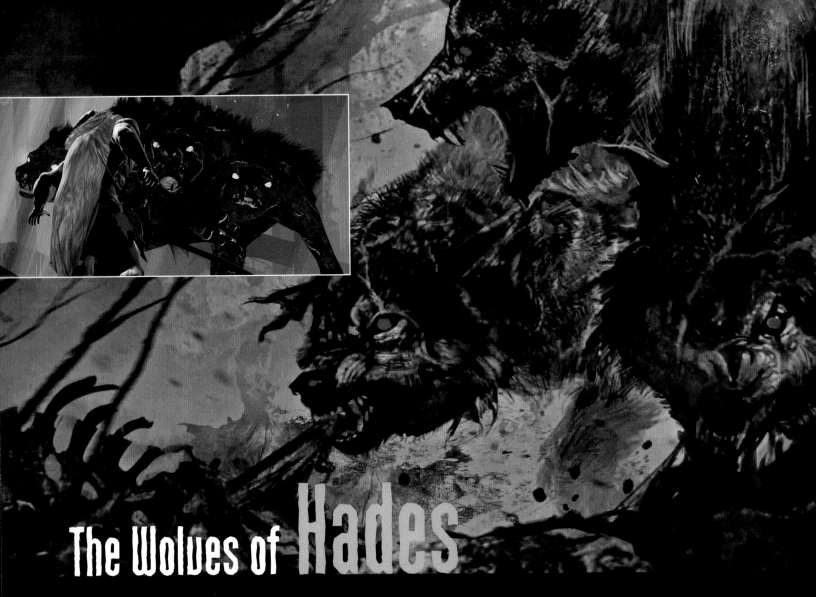

The Wolves of Hades

In a flashback scene towards the end of the movie, we see Hercules complete the last of his Twelve Labors, killing the Cerberus with his bare hands.

In Greek mythology the Cerberus was depicted as a three-headed watchdog that guarded the gates of Hades, the underworld. Some sources report that the three heads were meant to represent the past, present, and future; others believe they symbolized birth, youth, and old age. In any case, this final Labor, assigned to Hercules by King Eurystheus, was to capture the Cerberus and kill him without using any weapons.

This feat was recreated in the film by using three actors to substitute for the wolves. "For the scene with the three wolves, we had three guys in green screen so they could grab a leg or an arm, getting the right reaction from Hercules," reports Greg Powell, stunt coordinator. "We call that making the moment. Then they can do their trickery in post-production." Part of that trickery involved photographing real wolves and substituting their images for the green screen actors. This was one of the few but necessary—and quite spectacular—special effects in the movie. "I have no objection to working with a green screen or a blue screen," adds Powell, "but it makes my job better when I have an actual set to work on, instead of a make-believe something."

TOP INSET: Previs panel of the Cerebus. TOP: Concept image of the three-headed wolf from Weta Workshop, art by Gus Hunter.

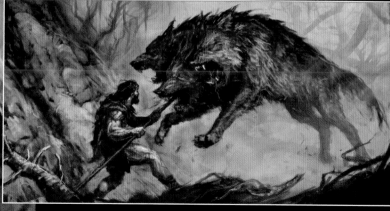

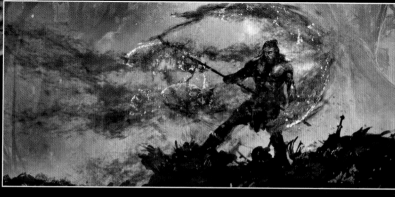

ABOVE: Concept images of the three-headed wolf from Weta Workshop; top by Nick Keller, below by Gus Hunter. LEFT: VFX idea by John Bruno. BELOW: Green screen actors were used to represent the wolves during shooting (below); to be replaced with digital SVX, seen here in development.

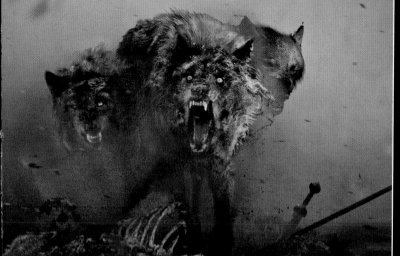

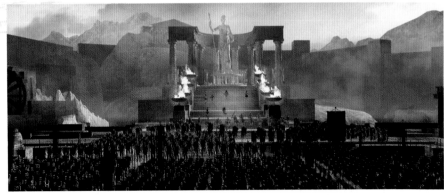

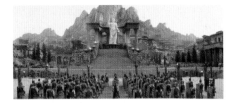

TOP: Previs panel. ABOVE: The Hera set before and after the application of special effects. LEFT and BELOW: Behind the scenes photography of the Hera/ Citadel set. OPPOSITE: Concept painting by Haley Easton-Street.

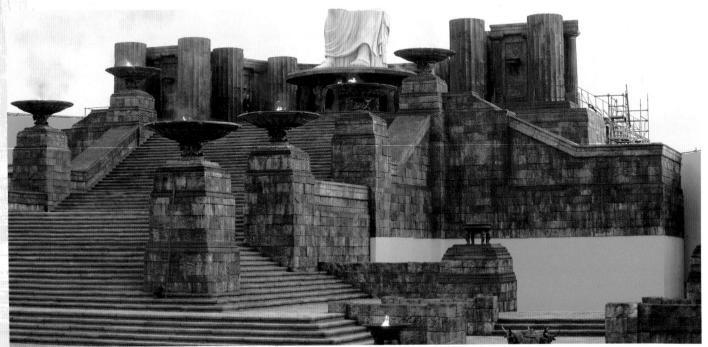

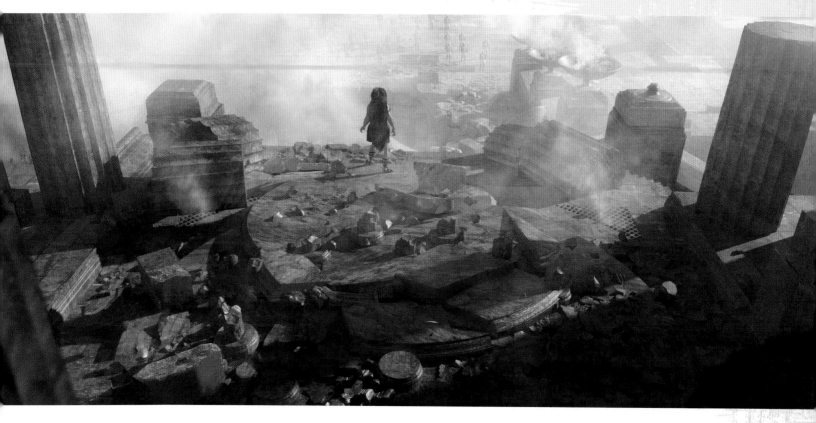

HERA FALLS AND THE CITADEL BURNS

A forty-foot statue of the goddess Hera dominates the entrance to the Citadel; the white marble popping out against the blood-red walls. Hera was the perfect symbolic goddess to use as the centerpiece for this final, climactic scene. In mythology, Hera was known as the goddess of women and marriage. She was a strong, powerful woman who greatly influenced the life of Hercules. The jealous wife of Zeus, Hera punished Hercules because of his unfortunate birth from a human woman. In mythology, she was usually depicted very regally, wearing a crown and holding a pomegranate as a symbol of fertile blood.

In this final scene, Hercules has just escaped from the underground dungeon. He has broken the chains that bound him to the stone wall. He lands on the top of the stairway to the Citadel, where he confronts the army of Lord Cotys. Can one man stave off an entire army?

He begins with fire, tipping over the flaming braziers and sending waves of liquid flame cascading down the stairs. "We used a lot of fire in the scene where Hercules topples the Hera statue," explains stunt coordinator Greg Powell. "Special effects worked on showing the chains coming out of the concrete. We worked on the fire when Hercules tips over the trays of flaming oil, which spills down the stairs. The soldiers standing on the stairs catch fire. We had to run a lot of tests with their costumes."

When the flames begin to die down, Hercules circles the statue of Hera, which is held aloft by smaller versions of the goddess that form support columns. With his club, Hercules smashes the small statues and Hera begins to wobble. Hercules pushes her, using all his legendary strength to topple the enormous statue. Hera crumbles like a boulder, wiping out the front of

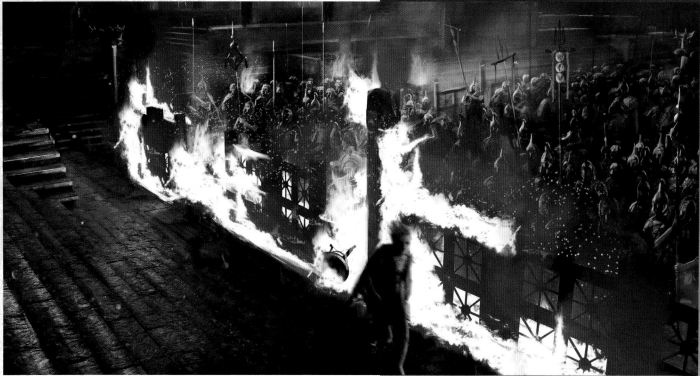

the temple and squashing Cotys like an ant. His formerly disciplined army scatters in terror; those remaining surrender to Hercules.

The scene is the culmination of all the action packed into this film; a tribute to the brute strength that is the essence of Hercules. "A cloud of fine dust hangs around the temple," reads the script. "Something stirs in the mist. Hercules emerges and stands tall at the top of the temple stairs. Covered in marble dust, he resembles a Greek statue."

Is he human or is he a god? Whatever he may be, by the end of the movie he has accepted his fate and his place in the world. He has become a new Hercules for a new generation.

ABOVE: Concept drawing by Kamen Anev of the Citadel on fire, the last climactic scene in the movie. RIGHT: Dwayne Johnson on the last day of shooting.

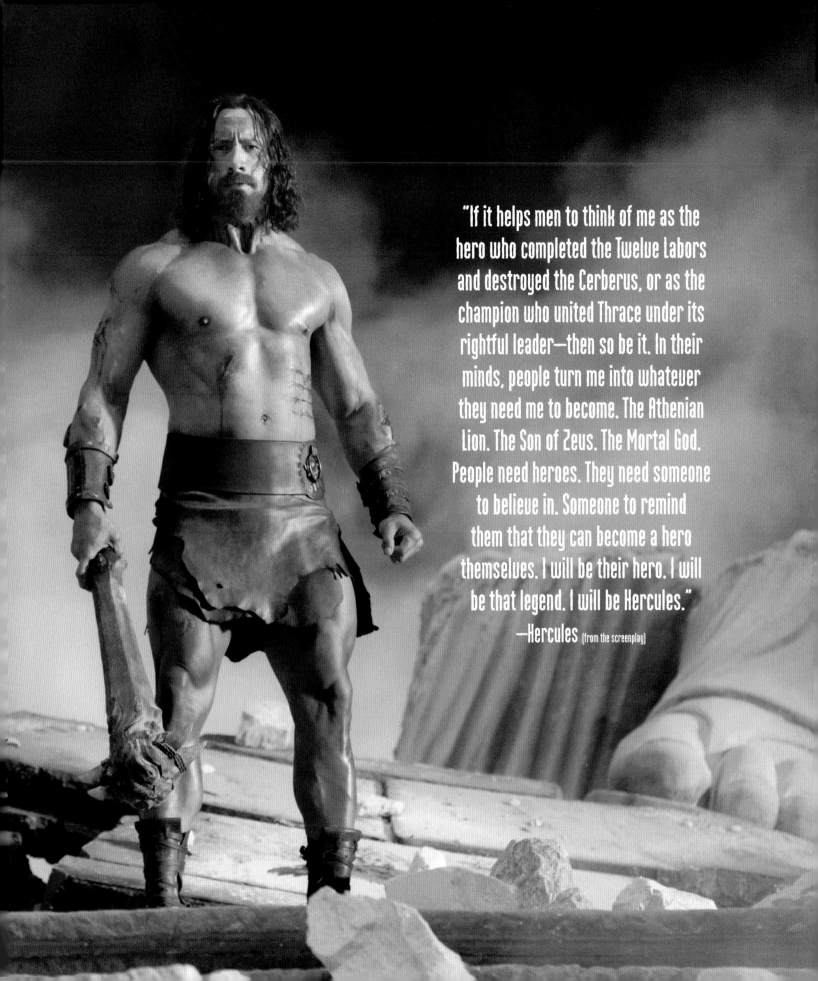

"If it helps men to think of me as the hero who completed the Twelve Labors and destroyed the Cerberus, or as the champion who united Thrace under its rightful leader—then so be it. In their minds, people turn me into whatever they need me to become. The Athenian Lion. The Son of Zeus. The Mortal God. People need heroes. They need someone to believe in. Someone to remind them that they can become a hero themselves. I will be their hero. I will be that legend. I will be Hercules."

—Hercules (from the screenplay)

The Birth & Death of Hercules in Mythology

Most people know at least a little of the legends of Hercules that have come down to us. He was the son of the human woman Alcmene and the chief Olympian god, Zeus, who took the form of Alcmene's husband, Amphitryon, king of Argos, while the latter was absent. Unfortunately, Zeus' infidelity aroused the anger of his wife, Hera, and Hercules suffered from her jealousy throughout the rest of his life. When he was still in the cradle, Hera sent two serpents to destroy him, but the infant Hercules strangled them before they could strike. Later, again as a result of Hera's malice, Hercules had to perform the Twelve Labors, a series of tasks that included killing the rampaging Nemean Lion, whose skin he later wore, and the seven-headed Hydra, as well as traveling in search of the golden apples of Hesperides, and journeying to the underworld to bring back Cerberus, the three-headed dog of Hades. Later he took ship with Jason in search of the Golden Fleece, had numerous other adventures, and fought a large number of military campaigns.

His death came when a Centaur called Nessus tried to rape Hercules' wife, Deianeira. Hercules killed the Centaur, but before he died, Nessus persuaded Deianeira that his blood would make a potent love-potion. Later, when Deianeira suspected Hercules of being unfaithful, she gave him a tunic dipped in Nessus' blood, which turned out, after all, to be poisonous. When Hercules put on the tunic, he found himself in such pain that he was forced to climb Mount Oeta and burn himself to death. Zeus raised him to heaven and he became one of the Olympian gods. He was widely worshipped throughout the Greek and Roman world, as a patron of warriors, a protector of cities, and an averter of evils in general. And, of course, he's lived on as a hero to the present day, in books and comics, in movies, and on television.

—STEVE MOORE, AUTHOR OF THE GRAPHIC NOVEL,
HERCULES: THE THRACIAN WARS

ABOVE: Concept art for a mosaic of Zeus by Renató Cseh.
OPPOSITE: Concept art of a Hera statue by Kamen Anev.

Origins:
The Graphic Novel

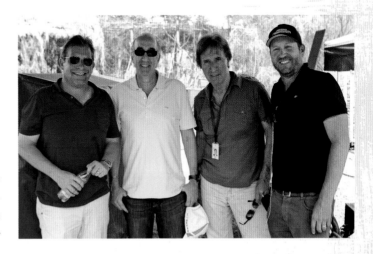

ercules: The Thracian Wars began as a graphic novel created by Radical Studios, a multimedia company headed by Barry Levine and Jesse Berger. From the beginning, Levine and Berger wanted to create an original version of Hercules, focusing on the story that takes place after Hercules completes his famous Twelve Labors. They concentrated on grounding the story in reality, and making it character driven. They also wanted it to look radically different from other books on the market by using a fully painted art style as opposed to the pencils, ink, and colors of classic comic books.

They brought in iconic illustrator Jim Steranko (who had created the look of Indiana Jones for Steven Spielberg, among many other brilliant assignments). Steranko created a cover that made Hercules appear more human and less god-like than his usual image.

In marketing the book, Berger and Levine spent a lot of time working on the characters with the WETA workshop, British comic book writer Steve Moore, art

OPPOSITE: Radical Studios, Inc. cover of the graphic novel by Jim Steranko. ABOVE: (L to R) Executive producer Ross Fanger, chairman and CEO of MGM Gary Barber, producer Barry Levine, and producer Beau Flynn.

director Jeremy Berger, artist Admira Wijaya, and a team of colorists and painters. Their intention was to eventually interest a high caliber director and movie studio in the project.

"We conceived this idea about six years ago. It's obviously very close to my heart, because I defiled my body with a tattooed image of Hercules," producer Barry Levine says with a grin, showing off the elaborate illustration on his left shoulder. "Our initial concept was not to make the typical sword and sandal type of movie but something more akin to *The Magnificent Seven*, *Seven Samurai*, or *The Wild Bunch*. Once you establish that you can buy into any of the fantastical elements you want to integrate into that world."

Hercules was the first project for Radical. "Barry and I talked about the mythology, but we knew that if we were going to tell that story in the form of a comic book and eventually as an entertainment property, we would need to do it differently from what had been done before," explains executive producer Jesse Berger. "We wanted

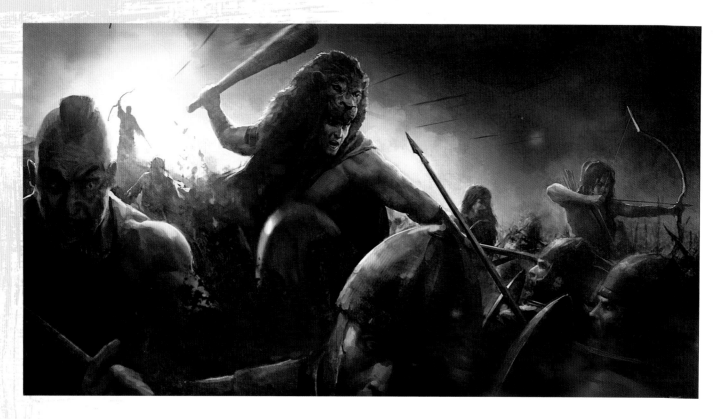

to tell a story about Hercules as a character driven story where Hercules surrounds himself with mercenaries and refuses to use his super powers. All of the mercenaries have uniqueness to their character, but they complement one another. They love Hercules completely and each one of them would give their lives for him."

The first edition of the comic book, published for $1.00 in May of 2008, sold 40,000 copies in one month, propelling Radical Comics to become a top ten comic book company in regards to market share. Five issues in total would be published in comic book form before they were combined into a hardcover and then a trade paperback edition. Combined sales for all editions of the story topped 300,000 units and would eventually be translated into five languages. Ultimately, Levine and Berger achieved their goal by attracting both a film studio and a high caliber director to their unique vision of Hercules.

"Our Hercules would be someone who refutes his superpowers and instead becomes a mercenary, using weaponry and surrounding himself with a band of mercenaries who find solace in battle. The idea was to make Hercules and his team feel relatable and real, but equally fantastical. We wanted our Hercules to be seeking redemption in the wake of having completed the Twelve Labors, but at the same time questioning his lineage and everything in his life, since he had lost so much."

—BARRY LEVINE AND JESSE BERGER,
CO-FOUNDERS OF RADICAL STUDIOS

ABOVE: Radical Studios, Inc. artwork by Darren Tan and Garrie Gastonny. OPPOSITE: Radical Studios, Inc. artwork by Weta Workshop's Greg Broadmore.

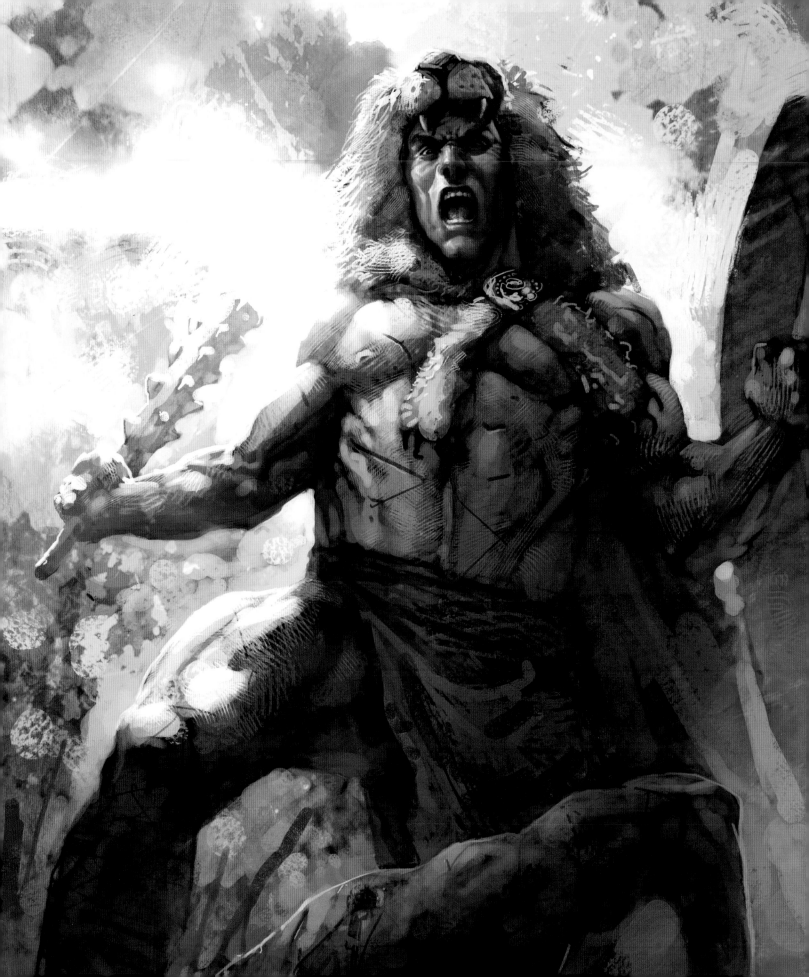

Hercules, The Human Warrior

by Steve Moore, author of the graphic novel
Hercules: The Thracian Wars

Thousands of years ago, before writing was invented, wandering storytellers moved from place to place entertaining both rich and poor with tales of the gods and heroes, usually for nothing more than a little food and a place to stay. Mostly these tales were told in verse, not only because it made for a richer and more satisfying entertainment, but also because it meant the stories were easier to remember. Some storytellers knew thousands of lines of poetry by heart; others knew a multitude of story elements and character types, and improvised them together in the course of an evening's oratory. Back then, before there were books, before there was theatre, the storyteller provided just about the only form of narrative entertainment that was available to people. Centuries went by before those tales were written down, to preserve the myths of the gods and legends of the heroes that we have today.

Among all the heroes these old storytellers spoke about, few were more famous than Hercules. Frankly, few of today's heroes are more famous than he, even now. (Can you imagine any of the present crop of celebrities being remembered 3,000 years from now?) So what made Hercules special?

The ancient people took him as their personal protector because, while he was the son of a god, and a god himself, he was also very obviously human. Unlike other gods and prophets who led perfect lives and tried to persuade people to be good, Hercules married and had children, had numerous affairs, fought his enemies, went adventuring, and was subject to murderous rages. One of the gods he may have been, and a powerful protector against misfortune but he also had the same human frailties as those worshippers who sought his assistance. Here, at least, was someone who would understand the sort of troubles that would make you want to pray to him.

NOT NICE AT ALL

I've had a lifelong interest in classical mythology and the ancient world, which is why I agreed to work on this version of Hercules. In my story, Hercules has a little band of mercenaries with him; all are characters from the myths, with their own stories. There's Iolaus, who was Hercules' nephew and charioteer, and who accompanied him during most of the Twelve Labors. Amphi-

araus, the oldest of the characters, is both a seasoned warrior and a seer. Tydeus is a murderous, brain-eating cannibal—a berserker who's the group's "shock-weapon." Autolycus, the son of Hermes, is a notorious thief; he's the sly thinker of the group. Atalanta, the swift-footed heroine of the tale of the golden apples, was once vowed to virginity and Artemis, until tricked into marriage; now she just wants to die in battle, so she can be reunited with Artemis in the afterlife, though deliberate suicide would only consign her straight to hell. All these characters are developed out of their original mythical stories.

The setting is the Bronze Age where, in Greece, civilization's quite advanced. If you're an aristocrat, life is quite nice—beautifully decorated palaces, gorgeous

ABOVE: Radical Studios, Inc. interior artwork by Admira Wijaya, colorist Sixth Creation and Imaginary Friends Studios.

clothing, good drainage, etc. Unfortunately, our story takes place in Thrace, which is a cold, barbarian area north of Greece, full of tattooed savages. And this really isn't very nice at all. When the story opens, Hercules has tired of being used by the various petty princes of Greece, who keep pestering him to eradicate robbers, destroy monsters, and other "heroic" things, and has decided to try his luck in Thrace.

MY HERCULES

My Hercules is different because I'm not trying to turn him into a "comic book hero," in fact most of the time he's far from heroic. Being a pagan myself who is devoted to one of the Greek deities, I've done my best to treat Hercules and the other characters with respect.

To me, Hercules is a god who deserves to be treated in the same way as Christ, Odin, Krishna, or any other deity that the human race has taken to its heart in its

long and turbulent history. And everyone in the story naturally believes in the absolute reality of the gods. Here there are no characters that are snide, post-modern "advanced thinkers" who believe the gods are only for the superstitious. So I'd like to think that if there were anyone out there who's actually a Hercules-worshipper, they wouldn't be offended by what we've done. That said, though, in the ancient stories, Hercules was a murderer, a rapist, a womanizer, subject to catastrophic rages, and plainly bisexual, and I've tried to accommodate all those aspects in my characterization. So if there

ever was a human being behind the Hercules stories, I'd like to think he was something like the character portrayed here, rather than the cleaned up "hero" of other comics and TV. Mind you, I wouldn't have wanted to spend much time in his company.

We took a slight liberty in making Hercules and his companions about forty years old, when according to the myths Hercules died and ascended to heaven at a rather earlier age. Apart from that, though, I tried not to violate the original cycle of myths, some of which

are told about Hercules by other characters which can then be believed, or not, because we're saying they're *stories*, not facts. So, as far as we're concerned, the Twelve Labors probably did take place, pretty much as described; Hercules just doesn't talk about them, though others do.

Overall, this story is pretty much a meditation on fate and destiny, which I find increasingly interesting as I get older and start to look back at the way things have turned out. Of course, it's also an adventure story with lots of action, betrayal, and surprises, but the mood is dark and generally anti-heroic. Warfare with edged weapons is brutal and unpleasant, and I've wanted to get that across; similarly, I've tried to make the battle-scenes and warrior training as authentic as possible, without "Hollywood frills" or anachronisms so no one knows Kung Fu.

The Hercules we tried to portray was not the stereotyped "strongest man alive," but the human warrior, carrying the burden of his descent and his destiny, as he tried to make his way through a strange and violent world in the company of a few companions in every way as flawed as he was himself. Whether there ever really was a man called Hercules, way back in the mists of time, we'll probably never know, and really it doesn't matter, the only important thing is the stories that have grown up around his name.

As for the audience, I really don't like labels like "adult" or "mature" as they suggest a prurient interest in sex and/or violence. "Grown-up" is probably more what I'm looking for. Yes, there's sex and violence, but the story is basically about people behaving, hopefully as realistically as possible, in a very grim situation. In the end, though, I wrote the sort of adventure I'd like to read myself and hoped everyone would go along with me.

LEFT: Radical Studios, Inc. artwork by Kevin Chin, Kai, and Garrie Gastonny. OPPOSITE: Radical Studios, Inc. cover art by Kevin Chin.

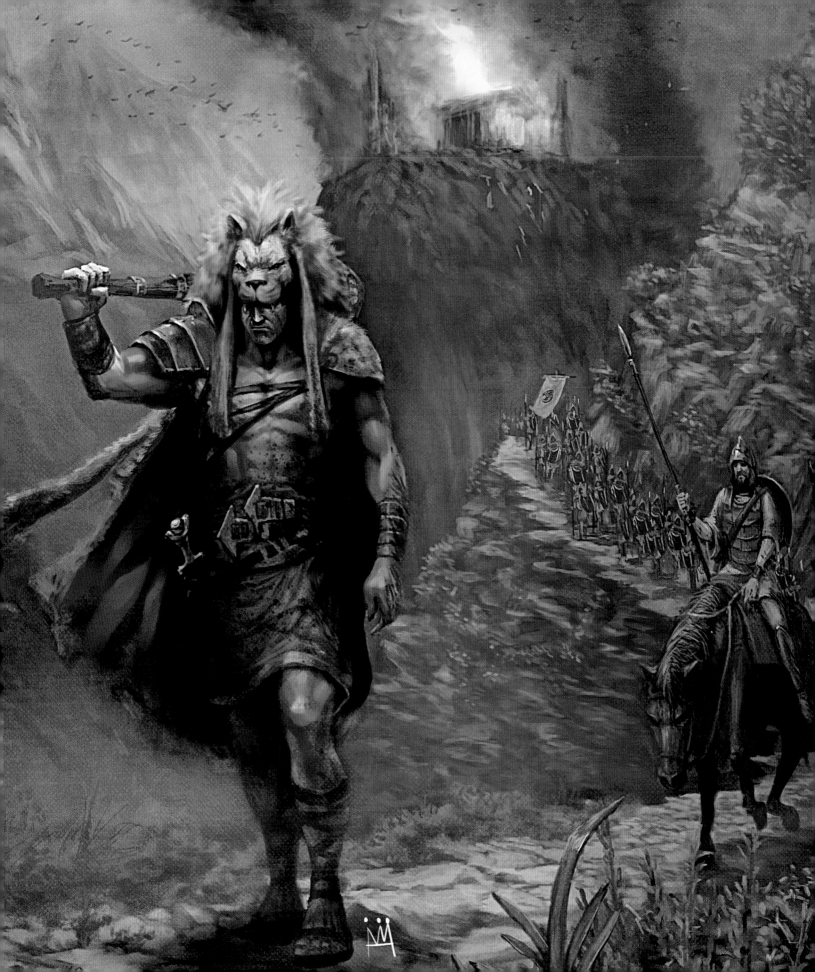

ACKNOWLEDGMENTS & CREDITS

Project director Esther Margolis, writer Linda Sunshine, and book designer Timothy Shaner wish to thank the following for their special contributions to this book:

First and foremost, director and producer Brett Ratner, who supported this book from the outset to celebrate the accomplishments of the super-talented cast and crew who realized his vision for a new Hercules, starring Dwayne Johnson, that would require "everything from sets and costumes to the visual look of the film to be authentic—as if someone took a camera back to the year 358 B.C."; producer Beau Flynn, editor Mark Helfrich, and visual effects supervisor John Bruno, who were especially generous with their time, insight, and information; unit publicist Amanda Brand, whose production notes and suggestions for the book's organization and content were invaluable; screenwriter Evan Spiliotopoulos, who was also a great source of information and provided the excellent prologue about the Hercules legend, prior film incarnations, and the unique take of this new version; artists Renató Cseh and Simon Atherton and the art department's Jason Knox-Johnston for their assistance in providing the wonderful artwork and images so vital to capturing the visual splendor of the film; and, in Brett Ratner's office, Anita S. Chang and Kasia Nabialczyk, who were always available and ready with the exact information we requested.

Radical Studios, especially cofounders Barry Levine and Jesse Berger, and art director Jeremy Berger, who provided useful background information and permitted use of the Steve Moore articles, art, and extracts from the graphic novel, *Hercules: The Thracian Wars*, that was the basis and launching point for this new movie version; Richard Athorne at Weta Workshop in New Zealand and Kara Misenheimer and Lauren Moore at Third Floor, who reviewed the concept art selections and accompanying credits; unit photographers Kerry Brown and David James for their illuminating behind-the-scenes and exciting production stills; Paramount Pictures for providing early access to transcripts of the EPK interviews produced by Blue Collar Productions; and especially MGM's VP of Global Licensing, Tricia Samuels Laudisa and colleagues Karol Mora, Lynn Abdi, and Matthew Miller, who managed the processes of contracts, deliverables, communication, and clearances with patience and consideration.

HarperCollins Publishers for its support of this book and special assistance in its development and production, especially HarperDesign publisher Marta Schooler, assistant editor Paige Doscher, and production, design, managing editorial, and legal staff Lynne Yeamans, Susan Kosko, Karen Lumley, Dori Carlson, Keith Hollaman, Kanako Nakamura, and Angela Encarnacion.

———

MGM would like to thank Esther Margolis, Timothy Shaner, Linda Sunshine, and HarperCollins; Brett Ratner, Beau Flynn, and Amanda Brand from *Hercules* production; Gary Barber, Jon Glickman, Adam Rosenberg, Kacie Kane at MGM; Riki Leigh Arnold, Alison Quirion, and our friends at Paramount Pictures.

———

Unless indicated otherwise in the book, all production photographs are by Kerry Brown, except those by David James that appear on pages 22, 28, 41, 165, courtesy of Metro-Goldwyn-Pictures Inc. and Paramount Pictures Corporation.

Comic book art by Admira Wijaya, articles by Steve Moore, and concept drawings by Weta Workshop appearing on pages 4–5, 48, 168, 170, 171, 172–3, 174, 175, courtesy of Radical Studios, Inc., copyright © 2008, 2009 Radical Publishing, Inc.

A BRETT RATNER Film

DWAYNE JOHNSON

HERCULES

METRO-GOLDWYN-MAYER PICTURES and PARAMOUNT PICTURES Present A FLYNN PICTURE COMPANY Production
In Association with RADICAL STUDIOS "HERCULES"
IAN McSHANE RUFUS SEWELL JOSEPH FIENNES PETER MULLAN and JOHN HURT
Visual Effects Supervisor JOHN BRUNO Music by FERNANDO VELÁZQUEZ Costume Designer JANY TEMIME Edited by MARK HELFRICH, A.C.E.
Production Designer JEAN VINCENT PUZOS Director of Photography DANTE SPINOTTI, ASC, AIC
Executive Producers ROSS FANGER JESSE BERGER PETER BERG SARAH AUBREY
Produced by BEAU FLYNN, p.g.a. BARRY LEVINE BRETT RATNER, p.g.a.
Based on RADICAL COMICS "HERCULES" by STEVE MOORE Screenplay by RYAN J. CONDAL and EVAN SPILIOTOPOULOS Directed by BRETT RATNER

www.MightyHercules.com
Not Yet Rated